This book
is a gift for the
Italian American Collection
created
in memory of
Celia and Salvatore Vuocolo.

They,
along with other
Charter Trustees,
built the
Raritan Public Library.

D1131335

RARITAN PUBLIC LIBRARY
54 E. SOMERSET STREET
RARITAN, NJ 08869
908-725-0413

TINA MODOTTI
Photographs

TINA MODOTTI
Photographs

Sarah M. Lowe

Harry N. Abrams, Inc., Publishers
in association with the
Philadelphia Museum of Art

Tina Modotti: Photographs has been organized
by the Alfred Stieglitz Center of the Philadelphia
Museum of Art and is made possible by a generous
gift from Madonna
Additional support has been provided by The
Pew Charitable Trusts and the National
Endowment for the Arts

EXHIBITION ITINERARY

Philadelphia Museum of Art
September 16, 1995–November 26, 1995
The Museum of Fine Arts, Houston
December 17, 1995–February 25, 1996
San Francisco Museum of Modern Art
March 28, 1996–June 2, 1996

*To My Parents
Charles U. and Eileen J. Lowe*
—SARAH M. LOWE

FRONTISPIECE:
1 *Stadium Exterior.* 1927. Gelatin silver print, 9½ x 7½″.
Collection Thomas Walther, New York
PAGE 6:
2 *Calla Lilies.* 1925. Platinum print, 9³⁄₁₆ x 7″.
The Detroit Institute of Arts. Founders Society Purchase,
Abraham Borman Family Fund
PAGE 8:
3 *Hands with Marionette (Mildred from "The Hairy Ape").*
1929. Gelatin silver print, 9½ x 5⅜″.
The Museum of Modern Art, New York. Anonymous gift
PAGE 11:
4 *Palm Trees.* c. 1926–29. Gelatin silver print, 9⁷⁄₁₆ x 7¹⁄₁₆″.
National Gallery of Australia, Canberra
PAGE 12:
5 *Woman with Olla.* c. 1926. Gelatin silver print, 7 x 9″.
Private collection, San Francisco

Editor: Eric Himmel
Designer: Judith Michael

LIBRARY OF CONGRESS CATALOGING-IN-PUBLICATION DATA

Lowe, Sarah M.
Tina Modotti : photographs / Sarah M. Lowe.
p. cm.
Includes bibliographical references (p.).
ISBN 0–8109–4280–1 (Abrams: cloth)
ISBN 87633–095–2 (Museum: pbk.)
1. Modotti, Tina, 1896–1942—Exhibitions. 2. Photography,
Artistic—Exhibitions. 3. Mexico—Social conditions—Pictorial
works. I. Philadelphia Museum of Art. II. Title.
TR647.M554.L69 1995
779'.092—dc20 95–889

*Text copyright © 1995 Sarah M. Lowe
Photographs copyright © 1995 Harry N. Abrams, Inc.*

*Published in 1995 by Harry N. Abrams, Incorporated, New York
A Times Mirror Company*
*All rights reserved. No part of the contents of this book may
be reproduced without the written permission of the publisher*

Printed and bound in Japan

Contents

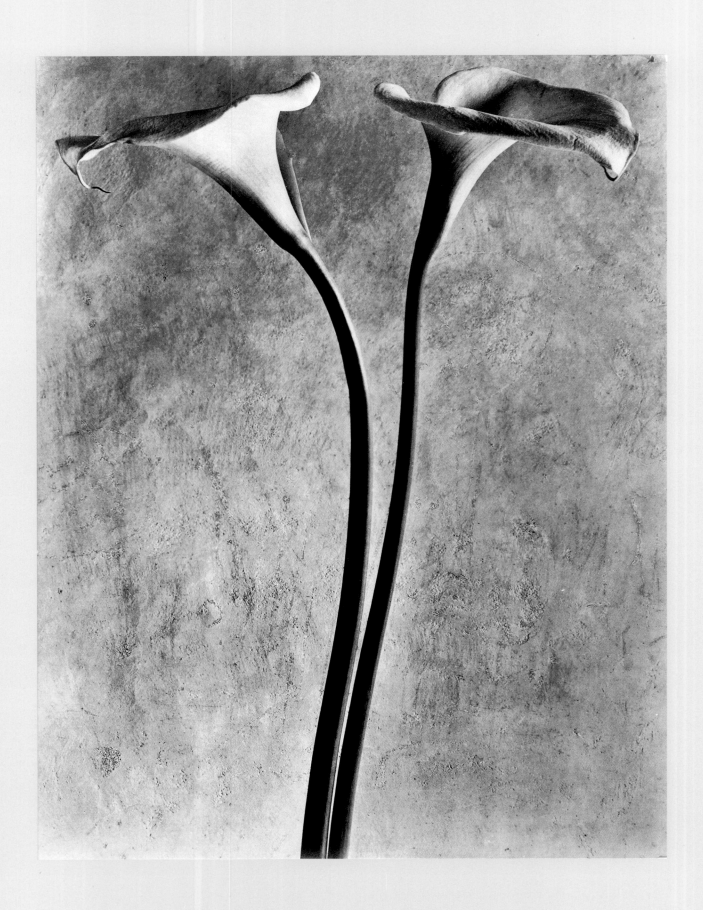

Foreword

It is astonishing to realize that Tina Modotti's life in Mexico was so brief: less than seven years between 1923 and 1930. But those years coincided with an extraordinary period of artistic exuberance and profound social change, as Mexico's artists and intellectuals sought to transform their country by drawing upon the ancient and popular traditions of its Indian peoples. It was a time when many creative men and women from other countries came to live and work in Mexico. Although Modotti was born in Italy and spent most of her last decade moving between Germany, Russia, France, and Spain, her identity as an artist and a passionate political being was forged during her Mexican years. That identity is perhaps nowhere so vivid as in the pages of *Mexican Folkways,* the quarterly review published from 1925 to 1937 in Spanish and English that devoted itself to capturing the creative spirit of the people, in "art, archaeology, legends, festivals, songs," as each cover boldly stated. Even during an era that produced a wealth of "little magazines" in many countries, combining the talents of artists and writers to promote one stylistic and ideological revolution or another, it is difficult to think of a journal devoted to the popular arts of any nation whose "contributing editors" in one year included artists of the distinction of Diego Rivera and Miguel Covarrubias, scholars such as the philologist Pablo Gonzalez Casanova or the archaeologist Enrique Juan Palacios, influential government officials such as Moises Saenz from the Ministry of Education, and a photographer of the caliber of Tina Modotti.

Modotti's emblematic photographs of village people and folk art objects, rendered with a clarity and sympathy quite individual to her vision, illuminate many pages of *Mexican Folkways* between 1927 and 1930. They serve their immediate purpose (illustration of a text) admirably and in their resolute modernity they also give quiet notice that something of international importance is afoot in the magazine, and in Mexico. She was only one among a close circle of friends and fellow enthusiasts that included the heroic figures of the great muralists Rivera, José Clemente Orozco, and David Alfaro Siqueiros, and yet from their almost overwhelming midst she emerges with her own voice.

It is that artistic voice which Sarah M. Lowe so thoughtfully seeks to explore and to characterize in this book and the exhibition it accompanies. Bringing such a project devoted to Modotti's photographs to completion necessarily draws upon the research, the patient reminiscences, and the enthusiasms of several generations of scholars, colleagues, and friends, in the United States and in Mexico. We are grateful to them all and hope they will find a suitable tribute to their subject in these pages. To the lenders of the photographs, a number of which have not been exhibited or published for many decades, if ever, we owe our profound thanks for permitting the public a wider view of Modotti's achievement. We are especially grateful to the George Eastman House in Rochester and to the J. Paul Getty Museum in Malibu for their loans; the Museum of Modern Art, New York, which owns the largest public collection of her vintage photographs, was particularly generous in this regard.

The Philadelphia Museum of Art's interest in the art of Mexico and of the international group of artists who worked there in the heady post-revolutionary era of the 1920s and 1930s dates back at least to 1931, when the first one-man show in the United States of the work of Diego Rivera, organized by the Museum of Modern Art, was among the first international exhibitions to be shown in the Philadelphia Museum's vast new building. Since that date, thanks to the energetic efforts of curators such as Carl Zigrosser and Henry Clifford, and collectors such as Mrs. Herbert Cameron Morris, the museum has mounted a number of exhibitions and built a strong collection of paintings, drawings, and prints from that heroic period. It was the presence in the collection of several powerful images by Modotti, the gift of Carl and Laura Zigrosser in 1968, combined with the museum's long and lively tradition of presenting major retrospective surveys of photographers, that led inevitably to this project, and we are delighted to be joined in its public presentation by our colleagues at the Museum of Fine Arts in Houston and the San Francisco Museum of Modern Art, which will ensure it a broad audience across the United States.

ANNE D'HARNONCOURT
The George D. Widener Director
Philadelphia Museum of Art

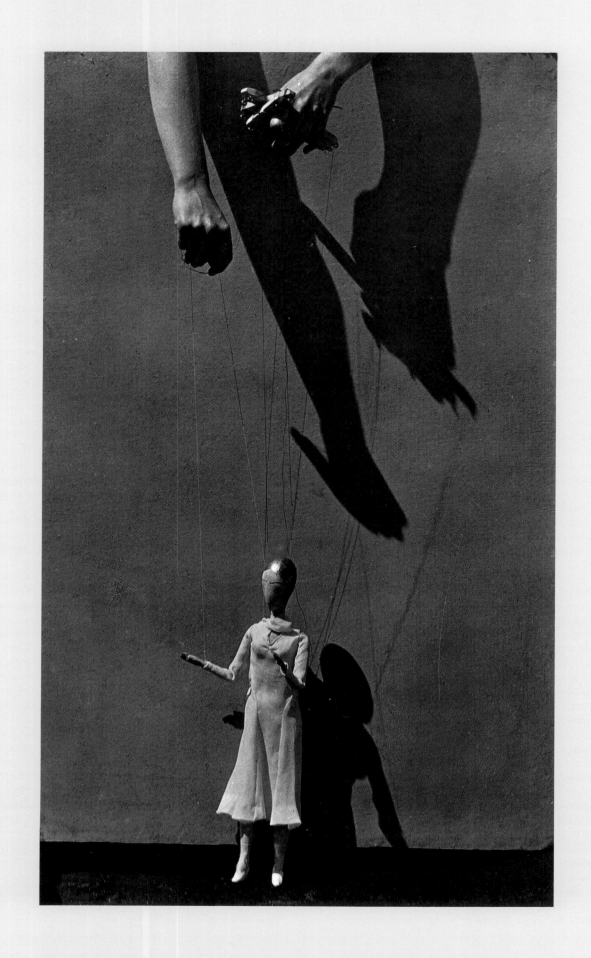

Introduction

Tina Modotti is the best-known unknown photographer of the twentieth century; now over fifty years after her death, this is the first comprehensive study of her photographs. The fascination with Modotti's biography—her many professions, her unconventional romances, her dedication to radical politics—is the result of an extraordinary life, one that intersected with many of the most significant artistic innovations, social upheavals, and political conflicts that occurred in the West during the first half of the century. It is Modotti's career as an artist, her original esthetic, that is the focus of this book. Her photographs are distinguished by an extraordinary formal clarity coupled with incisive social content. They constitute an important component of the modernist movement in post-revolutionary Mexico, and can be viewed in relation to international trends in photography during the decades of the twenties and thirties. Modotti's work reveals an intensity of purpose and a graphic power that is evident in the two hundred and fifty known images she produced during her short career as a photographer, from 1923 when she moved to Mexico, until 1930, when she arrived in Moscow as a political refugee.[1]

Though collectors for years have treasured her work, Modotti's photographs received little scholarly attention until very recently.[2] The pertinent English-language literature was uneven and centered on Modotti's life to the exclusion of her photographs, which were used only to illustrate her biography or reproduced without comment.[3] In many books, images *by* Modotti were eclipsed by images *of* her—not only formal and informal portraits by artists but daring photographic studies for which she modeled, nude and clothed—and they inevitably called attention to her as "woman." As a result, Modotti's art was seen through the filter of gender. She has been represented as a muse, an inspiration and helpmate to her lovers, both the artists and the activists, and often characterized as a "femme fatale," in part because of her professional careers as a stage and film actress and model. By emphasizing the (passive) role of muse and model, earlier writers effaced Modotti's achievements as an (active) artist.

Other factors have delayed recognition of Modotti's artistic contribution, including the fact that she worked outside the most active centers of photography (the United States and Europe), and the absence of any comprehensive archive of her photographs and papers. The two most decisive hindrances to serious consideration of Modotti's work, however, were her commitment to the Communist Party (and its reflection in her photographs), as well as the way she figures in art historical and biographical writing about the photographer Edward Weston.

Modotti joined the Communist Party in 1927, and her social conscience found one outlet in her work for MOPR (Mezhdunarodnaia organizatsiia pomoshchi revoliutsioneram), best translated as the International Red Aid, an auxiliary organ of Comintern, whose directive was to render material and moral aid to victims of political oppression. Her fifteen-year association with party functionary Vittorio Vidali, her *compagno di vita,* which lasted until her death in 1942, makes him one of the best sources of information on her life. Unfortunately, he deals with her photography in a perfunctory way, charting instead her Red Aid work, her writing and translating in Moscow, the missions she was sent on throughout Europe, and her elevated position in Spain during the Civil War where she organized evacuations of children and was active as a nurse, among other duties. Vidali's first-hand account presents a number of problems, first, by its lack of corroboration, and second, by the ambiguous way it handles Modotti's role in some of the significant events of her political career.[4] Vidali paints a picture of Modotti as an unquestioning party worker, a silent pillar of strength in moments of distress, and he pays her the dubious compliment, "she knew how to harmonize her work as a translator with domestic affairs and with political activity."[5]

Vidali and Modotti began their "political marriage" in Moscow by 1932, although they had known one another for several years in Mexico.[6] From the age of seventeen, Vidali dedicated himself to fighting fascism in his native Italy, and after several arrests and incarcerations for his activities, he left his homeland and traveled in Europe and Africa, coming to the United States in 1923. Five years later he arrived in Mexico via Moscow, having fled the United States under the threat of deportation. He had spent two months in the Soviet Union; the country that had disillusioned many had inspired Vidali. The trip marks his absolute commitment to "revolutionary necessity," the directive of Comintern, an organization within whose ranks he swiftly and deftly rose. As a trusted and high-level Soviet agent, Vidali gained a reputation as a man of decisive, if cold-hearted, action.

Vidali's hand in shaping Modotti's biography is evident from the moment she died, and he was one among the several Spanish Civil War refugees in Mexico that put together a fifty-two page booklet published in 1942 as a memorial to her.[7] Following Vidali's short bio-

9

graphical sketch and fellow Stalinist, Pablo Neruda's paean, "Tina Modotti is Dead," are statements and testimonials by seventy-five individuals, among them artists María Izquierdo, Lola and Manuel Álvarez Bravo, Pablo O'Higgins, architect Hannes Meyer, and writers Anna Seghers, Egon Erwin Kisch, and Simone Téry. Sixteen political organizations from Argentina, Cuba, Mexico, Spain, and the United States sent their acknowledgments, and excerpts from her obituaries in seven international newspapers and periodicals were included. Her large circle of friends, acquaintances, and advocates measured her sphere of influence at the time of her death.

In the case of photographer Edward Weston, it was less his own actions than interpretations of his life and work by others that have diminished Modotti's artistic status. Modotti met Weston in 1921; they become lovers, and then partners; he taught her photography and she ran his studio. It has been argued that had it not been for Weston, Modotti would never have received notice as a photographer. On the contrary, Modotti's association with Weston has inhibited critical evaluation of her photographs. As his nude model, Modotti played mistress to Weston's status as a "master" of modern photography, posing on the wrong side of the camera, the subject of art, not its creator. Weston's decision to move with her to Mexico is invariably recounted as a symbolic choice between two women. His wife, Flora Chandler Weston, represents bourgeois convention, an obstacle in Weston's artistic destiny. Modotti, his "Latin" lover, embodies an exotic alternative: her sexuality is inseparable from the idea of "primitivized Mexico." The telling of this story inevitably recalls Paul Gauguin's trajectory, which has served as a model for (male) avant-garde artists. Weston's trip to Mexico invokes Gauguin's flight from Paris (and his marriage) to Brittany and then to Tahiti, where he set up a new household with a "native" woman. Modotti the photographer is missing from the story.

Conspicuous by its absence in most literature on Modotti is mention of artistic influences on her work beyond that of her teacher. Modotti's relationship to the Movimiento Estridentista, the Mexican response to Futurism, a short-lived but notable force in the cultural scene of the 1920s, has gone virtually unnoticed.[8] Neither has Modotti's artistic lineage been linked with the tenets of modernist photography beyond its American manifestations. Modotti's work bears the hallmarks of the innovations of photographic practice known as the "New Vision." She was also aware of the work generated by the German Arbeiter-Fotograf movement, though she subscribed to its style only briefly.

In the case of Modotti, a powerful set of political associations and social conventions resulted in an impoverished depiction of her capabilities as an artist and go a long way toward explaining her virtual disappearance from the annals of photography. Although fifty of her photographs were exhibited two months after her death at the Galería de Arte Mexicano in Mexico City, Modotti was eulogized primarily as a political activist, not as an artist. The mistrust of openly political art made by an avowed Communist dampened interest in Modotti's photography: with two notable exceptions Modotti's name

and her photographs went virtually unnoticed for the next thirty years.[9]

In 1971, interest in Modotti's photographs was kindled and eventually ignited in her native Italy. When the commune of Udine, where Modotti was born, held a conference recognizing its citizens who had participated on behalf of the Republicans in the Spanish Civil War, she was, of course, included. Her artistic career was then rediscovered, and in Italy over the next decade, several paperback books were published and a number of small exhibitions appeared. Ironically, efforts to revive Modotti relied on Vidali's memories and his collection of Modotti's photographs (then the most comprehensive, now dispersed). Not until 1982, when the Whitechapel Art Gallery in London, stimulated by the feminist movement of that decade, organized *Frida Kahlo and Tina Modotti,* did Modotti come into the public eye and international consciousness. The provocative essays by Laura Mulvey and Peter Wollen in the catalogue were the first to consider Modotti's photographic output seriously and to discuss her work critically, and they became models for subsequent feminist inquiry.

Art historian Herbert Molderings' review of the catalogue was critical of the Whitechapel show on political grounds. It was the linking of Modotti and Kahlo that he found objectionable; he deemed it unconscionable to place the Trotksy-supporting Kahlo in the same political arena as Modotti, a committed Stalinist.[10] Moldering asserted that Modotti was an agent of the GPU, Stalin's secret police, and addressed issues that heretofore had been overlooked or purposely obscured, in part because Vidali has been the main source of information on Modotti's post-Mexican political life. The pro-Trotsky camp long held that Vidali was a murderer who did Stalin's bidding. They charged Vidali with the politically motivated assassinations of Spanish Communist Andres Nin (chairman of the Marxist Workers' Party, the POUM during the Spanish Civil War) and that of Italian Anarchist Carlo Tresca, they linked him indirectly to Trotsky's murder, and they even suggested that he may have been responsible for Modotti's death.[11]

Modotti's life story is the stuff of legends: it has inspired poets and novelists who use her biography as a point of departure.[12] Yet the very elements that lend themselves to legend and too easily to caricature—the ardent Stalinist, the femme fatale—also distort perceptions of her, and we lose sight of both her humanity and the material reality of her life. One remedy for this inadequacy is—to paraphrase Carol Zemel—to read Modotti's photographs using biography and thus to normalize Modotti's life and her work. To acknowledge those biographical dimensions allows us to retrieve Modotti from the margins of artmaking, to dislodge her from the center of her legend, and to place both her art and her experience within a social and photographic context.[13]

This selective account reconstructs Modotti's "cultural biography." It brings to bear new material that presents the social, political, and artistic factors that played on the creation of Modotti's work and illuminates the many art worlds she occupied.

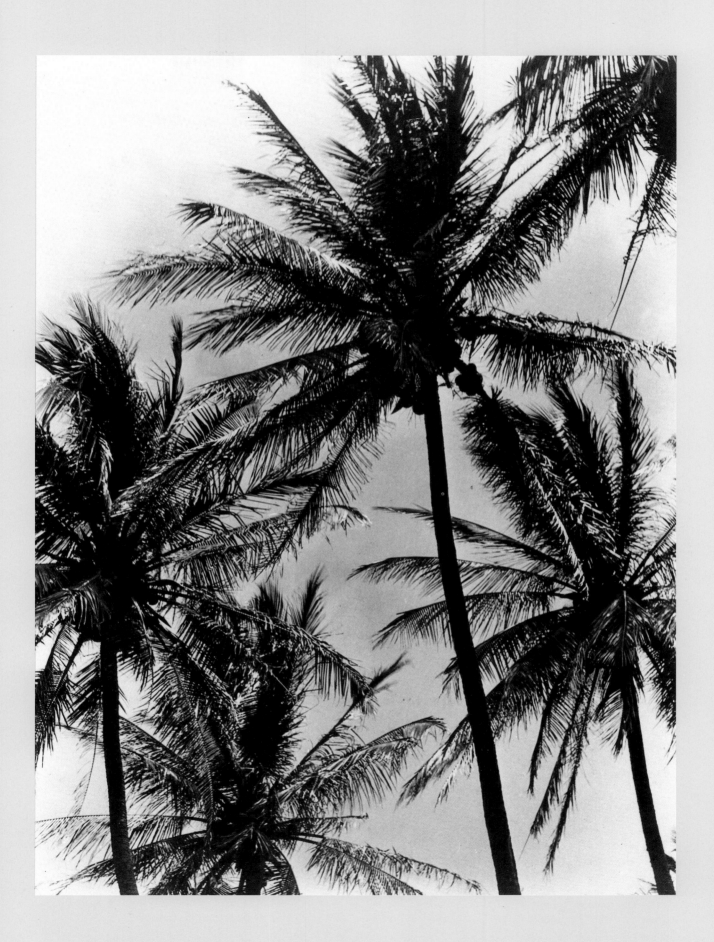

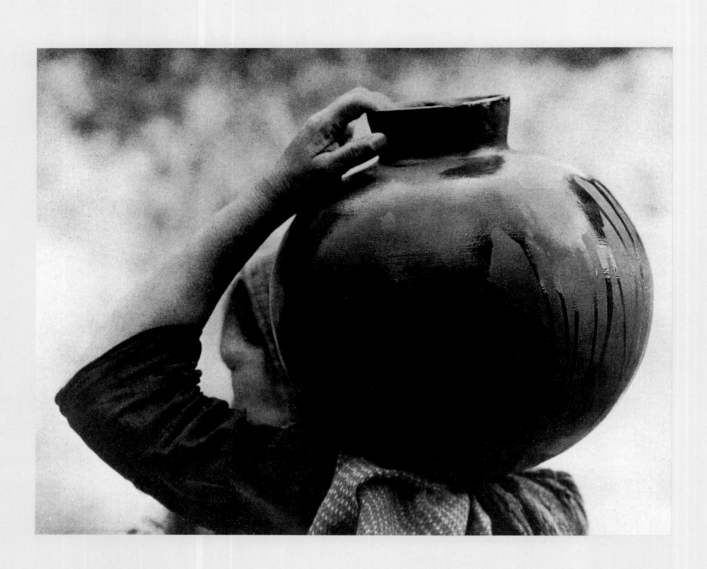

TINA MODOTTI
Photographs

Tina Modotti was born in the town of Udine, in northern Italy, on August 17, 1896,[1] the second daughter (and third child) of Giuseppe Modotti and Assunta Mondini. Named Assunta Adelaide Luigia, she was called Tina, short for Assuntina, a diminutive of her first name.[2] The commune of Udine lies on a high, furtile plain below the Austrian Alps, an area known for hunting. The narrow streets of the ancient town are laid out in concentric circles as protection from invasion, and medieval piazzas and Renaissance palazzos proclaim its affluent past. At the turn of the century, Udine was a prosperous municipality known for the production of fine cloth; a conservative and strongly Catholic town, whose leading families maintained social stability in the face of political change.

Among the working and lower classes of the city there were tendencies toward socialism and radicalism. The register of the parish church where Tina was baptized names Demetrio Canal, a noted socialist organizer, as one of several witnesses to the rite. Still, while the family struggled to make ends meet, they were not the impoverished peasants some sources make them out to have been but skilled craftsmen with a radical orientation. Giuseppe Modotti was a mechanical engineer, as was his brother Francesco, younger by a year.[3] Pietro, born seven years after Giuseppe, was a successful photographer in Udine. Tina inherited a social conscience from her family as well as the mechanical skills her father shared with his brothers: her technical aptitude and her mastery of the camera some years later confirm this.

Udine is the capital of the Friuli-Venezia Giulia region of northern Italy; Italian and German are both spoken there today. Shortly after Tina's birth, her father, like thousands of other Italians, crossed the nearby border to Austria in search of a better paying job.[4] In 1898 the whole family—Giuseppe and his wife Assunta, and their three children, Mercedes, six years old, Ernesto, four, and Tina, aged three—emigrated to southern Austria, where they remained until 1905.[5] The Austrian peregrinations of the Modottis can be traced by the births and deaths of their children. Ernesto died in 1898 in St. Ruprecht[6]; Valentina Maddalena was born in January 1899 in Ferlach, near the frontier of Yugoslavia[7]; and both Iolanda

(also called Yolanda) Luisa and Pasquale Benvenuto were born back in St. Ruprecht in July 1901 and May 1903, respectively.[8]

The hardships endured by migrants—both the brutal trek and the harsh, sometimes inhumane living and working conditions in Austria—generally dissuaded whole families from emigrating.[9] That the Modotti family did has led one writer to conjecture that Giuseppe left Italy for political reasons; that his socialist activities may have impeded his ability to earn a living in Udine, or that he was fleeing the local police.[10] Despite the loss of their eldest son, the Modottis may have fared slightly better than most in Austria because of Giuseppe's skills. He was employed as a mechanic in a bicycle factory in Ferlach.[11] This is a marked contrast to the experience of Italian migrant laborers who were employed in the construction of roads and railways.

Tina lived in Austria from age three until she was nine, long enough to account for her later aptitude for languages: she spoke at least four—Italian, German, English, and Spanish (she may have picked up Russian or French when she lived in the Soviet Union and France in the 1930s)—and regularly provided translations for publications, including *El Machete* (Mexico) and *New Masses* (New York) during the 1920s, and *Arbeiter Illustrierte Zeitung* (Berlin) and *MOPR* (Moscow) during the 1930s.

Italian and Slavic immigrants in Austria found themselves the objects of blatant discrimination—politically organized and racially motivated—that was more pronounced than elsewhere in Europe.[12] This created a common cause between two groups with a long history of animosity toward each other, and would have served as Tina's first lesson in class consciousness.[13] Family legend has it that the grinding poverty she witnessed in Austria and the immigrants' treatment at the hands of the Austrians kindled Tina's devotion to social causes. As they grew up, several of her brothers and sisters came to share Tina's commitment to political activism.[14]

The family returned to Udine in 1905, a date marked by another birth in the family: Giuseppe Pietro Maria was born in Udine in August 1905.[15] That same year Giuseppe Modotti emigrated to America.[16] He left Eu-

rope from the French port of Le Havre in mid-August and arrived in New York on August 27; his final destination was Turtle Creek, Pennsylvania, where his brother Francesco lived.[17] What occupation the brothers found is unknown, but Turtle Creek was full of opportunities. It was in a rich coal-mining region, as well as the site of major industries, including Carnegie's first steel mill and a Westinghouse air-brake factory.[18] Around 1907, Giuseppe moved to California and opened a photography business in North Beach, the heart of San Francisco's Italian colony.[19] An advertisement in the San Francisco Directory lists "J. Modotti and A. Zante, artistic photographers and all kinds of view work." Joseph Modotti & Co. was not a success, and the following year Giuseppe advertised a new business—"machine shop, marble working, machinery made and repaired"—on Montgomery Street in an industrial area adjacent to the residential North Beach.[20]

Details about this period of Tina Modotti's life are extremely scarce. Life for Assunta and her six children without Giuseppe in Udine was spare, but she was a skilled seamstress and her needlework brought in income.[21] She taught her daughters how to sew, and three of them later earned a living thanks to their mother's instruction. Tina attended school from October 1905 to December 1907, her only recorded formal education.[22] In 1913, when she joined her father in America, Tina identified herself as a "student" to immigration officials. She must have been taken to Venice as a child: she mentioned having been there in a 1920 interview and reading Dreiser's *A Traveler at Forty* several years later brought back memories of the city.[23]

Family lore has it that Modotti began work in a factory in Udine at the age of twelve, and that she was the sole breadwinner for the family in Udine. While it is not unreasonable to assume that like many young girls she did some factory work—the likely site was Domenico Raiser e Figlio silk factory[24]—the second contention is suspect.

Another example of family lore used to give evidence of Tina's strong character and her early selflessness (a theme especially evident in accounts of her life that emphasize her commitment to the Communist Party), and to highlight the poverty out of which the family rose, was related by Yolanda, Tina's younger sister. Their aunt Maria, the wife of Pietro Modotti, gave Tina a beautiful blue scarf, which she raffled off to the girls at the factory in order to raise money to buy bread, cheese, and sausage, enough food for her family to eat for a week.[25] Yolanda's anecdote suggests that a relationship existed between Giuseppe's family and that of the photographer Pietro, who took formal portraits of Tina's siblings.[26] Pietro Modotti ran one of Udine's most successful portrait photography studios, as well as a school of photography. He was an effective teacher and mentor to several distinguished photographers of the Friuli region.[27] In 1896 he perfected a lighting technique that blocked the direct light source and created a diffused illumination, a useful effect for a pictorialist photographer. Pietro wrote extensively about his experiments. His impassioned articles, which appeared in journals in Italy and abroad, entered an ongoing discussion about the status of photography as an art form and the merits or wrongheadedness of creating photographs that imitate pictorial

models in painting.[28] If the families were once close, Tina's siblings did not mention it in interviews after her death, which may be explained by Pietro's having been a supporter of Mussolini.[29] Recent research suggesting that Tina did work in Pietro's atelier before emigrating to America in 1913 is tentative at best: a current resident of Udine recalls speaking with her father who saw Tina in Pietro's studio in 1908 when his portrait was taken.[30]

It is somewhat difficult to reconcile the often repeated stories of impoverishment, debilitating factory labor, and lack of education with the sophisticated actress, bohemian opera lover, reciter of poetry, and sensitive photographer that Tina Modotti was to become after a few years in California. Modotti is often portrayed as a working-class Italian immigrant, an undereducated, struggling seamstress whose "natural genius" was "discovered" by older (male) artists—her husband, Roubaix de l'Abrie Richey, and the photographer Edward Weston. She is sometimes viewed virtually as Weston's creation. What we know about Modotti's formative years, however, suggests the possibility that the seeds of her vocations—art and politics—may have been planted then.

Tina Modotti left Italy by way of Genoa on June 24, 1913, and arrived in New York on July 8. She had $100 and a ticket to San Francisco paid for by her father.[31] Giuseppe Modotti had settled in the city's Italian community, at 1952 Taylor Street, and a working telephone was the symbol of his success in his adopted land.[32]

Modotti was almost seventeen years old when she arrived in San Francisco and, given her skills, probably found work in the garment industry doing piece work, either at home or in a small factory. Yolanda remembered variously that her sister worked in a hat shop and that she worked with their sister Mercedes in a sewing room at I. Magnin.[33] Modotti's experience as a seamstress would stand her in good stead a few years later, when she was living and working in Los Angeles.

On the eve of World War I, the garment industry was a hotbed of union activity, and Modotti cannot have been untouched by the shop meetings and numerous strikes that marked the labor movement on the Pacific coast. There was a strong Italian presence in unions, both in membership and leadership, especially in the garment trades. A year before Modotti's arrival in the United States, the strikes in the textile mills of Lawrence, Massachusetts, had marked a turning point for the Italian-American community. The arrest and trial of Joseph Ettor, East Coast organizer for the International Workers of the World, and Arturo Giovannitti, an Italian-American poet, editor of *Il Proletario,* and secretary of the Italian Socialist Federation, galvanized the movement. For nine months, Ettor and Giovannitti made national and international news, and meetings were held in their support, including one at the Washington Square Theatre, in San Francisco's Italian colony, where Modotti would perform several years later.[34] The events of 1912 united the fractious Italian-American labor community, while demonstrating the significance of Italians in the American labor movement as a whole.[35]

In July 1917, Modotti's name appeared in a theater advertisement in the local Italian-language newspaper. The route Modotti took from the factory to the stage, and

later, to Hollywood, in all likelihood involved sewing costumes for the theater. One event, however, had a significant impact on her artistic growth: her encounter, at the Pan Pacific International Exposition in 1915,[36] with a poet and painter who called himself Roubaix de l'Abrie Richey.

Richey, known as Robo to his friends, was born Ruby Richey in March 1890 in Oregon and grew up on a farm near Portland.[37] Farm living did not suit him (although Modotti wrote that it "helped to develop his inborn gift for refinement and beauty and his understanding for those rare substances which are realities only to the dreamers and visionaries") and by the time he was twenty-three, Ruby had remade himself into Roubaix and left the rustic Oregon life for good. So effective was he at covering his tracks that posterity has endorsed Modotti's speculation that he was descended from Louisiana Creoles.[38] In reality, he was of good pioneer stock, with only a maternal grandfather from the French-speaking part of Canada as a clue to the birthright that he identified with.[39]

The air of mystery that surrounded the figure of Robo was self-created, probably in collusion with Modotti. If a Jack London ruggedness figured at one end of San Francisco's literary spectrum, then Richey embodied bohemianism at the other end. As if by spiritual conversion, he "cast [his] lot with beauty": "Suddenly I conceived the beautiful life as never before. It appeared to me not as a thing itself which required ease and wealth, but as a matter of selection—yes, a matter of selection—and I came to realize that I too live . . . as beautifully as my present soul will permit."[40] Robo found public venues for his poetry, prose, and drawings, and he designed and created beautiful—and marketable—batik fabrics. Much of his artistic output was assembled by Modotti in the posthumous *Book of Robo,* a collection of his poetry, aphorisms, an unfinished short story, and reproductions of several paintings. Richey was also an illustrator and cartoonist and, as early as 1912, had published several short stories in *Overland Monthly,* a prestigious West Coast literary magazine.[41]

He was also a man of political principle, probably an Anarchist: Edward Weston photographed him wearing a black four-in-hand tie, the badge of Anarchism.[42] He appears to have been a literary radical, like the critic Sadakichi Hartmann and many others in his circle; that his beliefs may have run deeper is suggested by cartoons that he published in 1920 protesting United States intervention in Mexico.

By 1917, Modotti had become a self-employed modiste and had begun to act on the stage. Indeed, within a year, at the age of twenty-two, she was a minor celebrity. Theater, from opera to comedy to tragedy, played a prominent role in the cultural life of the Italian colony.[43] The professional *teatro Italiano* developed not from the traditional opera that had thrived in San Francisco since the 1860s but out of popular amateur groups, or *compagnie filodrammatiche,* that put on shows on behalf of political societies and social clubs. Such amateur performances occurred sporadically until 1905, when Antonietta Pisanelli founded the first professional troupe. She also refashioned a local theater by removing the orchestra

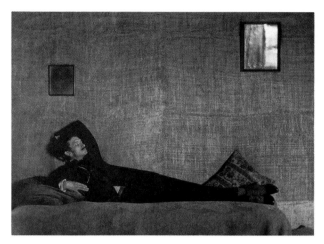

Figure 1 Edward Weston. *Robo de Richey.* 1920.
Lane Collection

and introducing tables and chairs, transforming it into "a combination café-chantant, theatre, opera house and club" offering the Italian community "an endless potpourri of opera, comedy, farce, tragedy, duets, solos and song fests."[44]

After peaking between 1909 and 1914, the Italian variety theater went into serious decline. The impact of World War I and the enactment of harsher immigration laws stemmed the flow of new arrivals hungry for a taste of their native culture, while the younger generation was turning away from the world of their parents in their eagerness to assimilate. Meanwhile, movies drew audiences away from live entertainment: San Francisco's first theater dedicated to showing films, Grauman's Imperial, opened in December 1912. Two years later, over thirty full-time movie houses were in operation; by early 1917 San Francisco boasted one hundred. In the Italian colony too, many theaters began to offer nickelodeon-type entertainment, and Italians were lured to films by Charlie Chaplin and D. W. Griffith through advertising in the Italian-language newspapers.[45]

Interest in Italian variety theater was rekindled in 1917, however, with the reopening of the Liberty Theatre and the appearance of the Compagnia Città di Firenze. The following year saw the arrival of the comic-dramatic Bruno-Seragnoli Company at the Washington Square Theatre. Modotti performed with both companies.[46] Throughout the 1918 season, the Italian daily *L'Italia* singled out Modotti's performances in its reviews, applauding her "intelligent and decisive artistic inclination."[47]

Modotti's greatest triumph came near the end of the season, when she played in Dario Niccodemi's *La Nemica.* The reviewer for *L'Italia* made a point of bringing Modotti's performance to the attention of its readers: "Tina Modotti, whom all in our colony have so often admired, and whom we may say, we all love, as much for her goodness as for her brilliant artistic qualities. She is still at the beginning of her career . . . and yesterday surprised even her warmest admirers by the dramatic intensity of her acting, especially in the great final scene of the second act. Always careful, conscientious, Signora Modotti has already obtained—if we may so phrase it—her

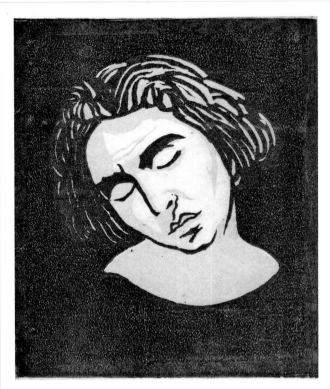

Figure 2 Franz Geritz. *Tina Modotti.* 1922. Woodcut.
Collection of the Center for Creative Photography

diploma as an artist and continuing to study as she does her career is assured."[48]

It is worth considering what Modotti's success in the theater may tell us about her artistic sensibility and development. With its roots in the popular Commedia dell' Arte of the late Renaissance, modern Italian theater demanded players who could make rapid adjustments to accommodate different roles each week. Memorization was not as important as an ability to enter the spirit of a new character and a flair for improvisation.[49] Furthermore, Modotti would have acquired a good deal of informal education through her participation in and attendance at theatrical productions presented to the colony. In March of 1918, for example, she played in Paolo Giacometti's 1861 *La Morte Civile,*[50] a social drama that Emile Zola had praised as a brilliant example of realism. She was singled out in the press for her performance in *Gli Spettri,* a popular translation of Henrik Ibsen's *Ghosts.* And in August 1918, she drew praise for her role in Gerolamo Rovetta's *I Disonesti,* a play that exemplified the realist theme that men are made good or evil by circumstance, not by principle.[51] This first-hand experience with literature is surely only one facet of Modotti's cultural education, but it remains one of the few for which there exists unassailable proof.

In 1918, Modotti was naturalized, as clear an indication as any that she was seeking a less insular and more urbane world.[52] She may have been known and beloved in the colony, but Robo proved to be her ambassador into the literary and artistic milieu of bohemian San Francisco as she distanced herself from the parochial Italian

quarter. Richey's Golden Gate Avenue address placed him just south of the many studios located at 1625 California Street, a gathering place for artists, writers, and journalists, as well as the society types of the famed Bohemian Club who patronized the arts.[53] The literary allusions that fill Modotti's letters from just a few years later confirm that she was familiar with current trends in poetry, art, music, dance, as well as classical music and, especially, opera.

Through Richey, Modotti would have met Sadakichi Hartmann, one of the most colorful and flamboyant figures in San Francisco.[54] A painter, poet, dramatist, and art and photography critic, Hartmann arrived in San Francisco around 1916, and soon had "society matrons swoon[ing] . . . at studio teas;" he staged theatrical productions, lectured, and made himself indispensable to the bohemian community.[55] Although he showed no disposition to engage in political activism, Hartmann joined Anarchist Emma Goldman and others in founding *Mother Earth,* and in December 1916 he contributed an article called "Art and Revolt" to *Blast,* a radical magazine edited in San Francisco by Goldman's close friend and colleague, Alexander Berkman.[56] It was also probably Richey who introduced Modotti to the society photographer Arnold Schröder, who took at least two undated photographs of her, "glamour shots" that she could use to promote and advertise her acting career.[57] Their existence points to the likelihood that Modotti had set her sights on a professional career in acting, not just on the stage, but in film.[58]

Modotti may have been encouraged to pursue a career as a movie actor in Hollywood by friends in the thriving film industry in San Francisco. A number of actors, actresses, and directors active in the Bay Area were to be involved in the films Modotti made. Lawson Butt, who played opposite Modotti in *The Tiger's Coat,* her first film, could have introduced her to that film's director, Roy Clements, after hearing about her stage successes. Or Clements, himself a bit actor for the Essanay Studio, one of the more prominent studios in the Bay Area, may have gotten wind of her compelling stage presence.[59]

In the fall of 1918, Modotti and Richey left San Francisco: August saw Modotti's last stage performance, and a notice in the October 16 issue of *L'Italia* announced their marriage in Santa Barbara.[60] Modotti and Richey moved to Los Angeles, where they lived with Rose Richey, (Robo's widowed mother), his grandmother, and his younger sister, Marionne, who, like her brother, had gallicized her given name, Mara An.[61] While they lived in Los Angeles, they found diverse ways to support themselves. Robo's handmade batiks were used as stage settings, mural decorations, and wall hangings, as well as for the costumes and gowns that Tina sewed (her small fabric dolls were much in demand as well).[62] One source states that Robo also worked in the checkroom of a Hollywood cabaret.[63] Modotti may have thought of herself as an actress but it appears that she supported herself by modeling as well and was much sought after: many images of her have survived that are not so much portraits as studies.[64] Richey himself used Modotti as a model for several drawings in 1920.

In 1919, they both modeled for photographer Jane Reece, who had come to Los Angeles from Dayton, Ohio,

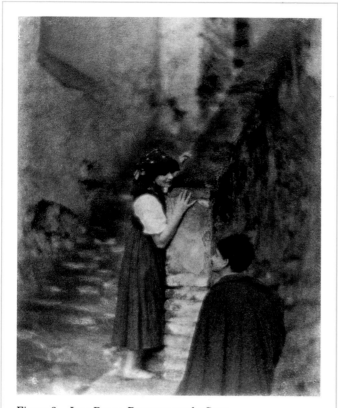

Figure 3 Jane Reece. *Romance on the Steps*
(On San Gabriel Steps). 1919–20. The Dayton Art Institute,
Gift of Miss Jane Reece

presumably to supervise three exhibitions she had there
that year.[65] Although Reece is considered primarily a por-
trait photographer, her oeuvre included a great many im-
ages that are more allied to the traditions of genre and
tableau vivant than to true portraiture, and in Modotti
and Richey she found willing collaborators. Some of
the photographs that survive show Modotti in Spanish
costume, and suggest that she was a cast member in
John Steven McGroarty's *Mission Play*—the story of the
founding of the San Gabriel Mission by a Franciscan
priest from Mexico—that had been performed annually
since 1911 at the mission.[66] One tableau of the two of

Figure 4 Jane Reece. *Have Drowned My Glory in a Shallow
Cup.* 1919. The Dayton Art Institute, Gift of Miss Jane Reece

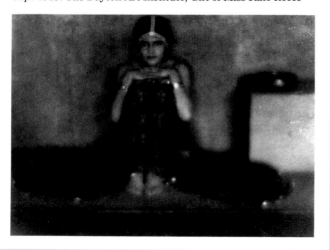

them is called *Romance on the Steps (On San Gabriel
Steps)* (figure 3), and it further connects Modotti's cos-
tume with the theatrical production at San Gabriel. In
another photograph, this time of Modotti alone, she is
seen, through a pictorialist haze, dressed in exotic garb
as befits the title, *Have Drowned My Glory in a Shallow
Cup* (figure 4). The line comes from Edward FitzGerald's
1859 translation of Omar Khayyám's *Rubáiyát*, a fa-
vorite, if overused, source for bohemian inspiration, but
the only instance of so literal a narrative in the work of
Reece.[67]

By mid-summer of 1919, Modotti had begun work on
her first film, *The Tiger's Coat,* which premiered in Octo-
ber 1920.[68] Modotti's coup was to land the movie's star-
ring role: she played a Mexican "peon" who, through a
series of mistaken identities, is taken for the daughter of
a close Scottish friend of the protagonist. He falls in love
with her but, upon discovering her true "racial" identity,
breaks off their engagement. She leaves town. In the end
they are reunited after Modotti's character makes a rous-
ing return as the star of a dance company. The film was a
bit daring for its day, defending miscegenation and allow-
ing love to triumph over racial prejudice.

The Tiger's Coat was the highlight of Modotti's film ca-
reer. Although not an exceptional film, it was a good vehi-
cle for Modotti to show her dramatic abilities. The
pantomime and improvisational skills she honed for the
Italian theater in San Francisco had been good prepara-
tion for the overacting required by the silent film. After

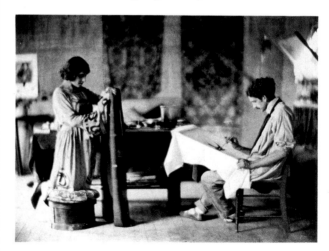

Figure 5 Wallace Frederick Seely. *Tina Modotti
and Robo de Richey.* 1921. Vidali Collection

The Tiger's Coat, however, Modotti was cast in only
minor parts. Her two later films were *Riding with Death,*
which appeared the following November, and *I Can Ex-
plain* (also known as *Stay Home*), released in March
1922.[69]

Robo and Tina de Richey made an irresistible pair. A
1921 photograph by Wallace Frederick Seely evokes their
West Coast bohemian surroundings (figure 5). Both are
working intently: Modotti—dressed in her seemingly
handmade clothing—is sewing, while Richey paints in a
loose artist's smock and open shoes. On the studio wall
hang textiles (perhaps Richey's batiks) and what appears
to be a portrait of Modotti.[70]

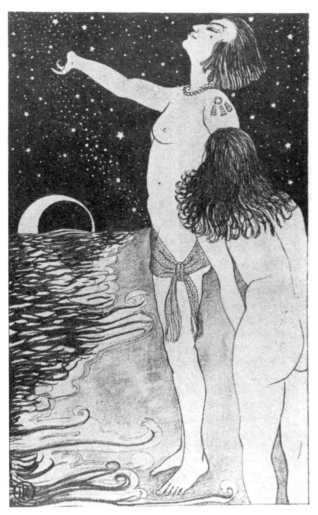

Figure 6 Robo de Richey. Drawing from *Satiros y amores.* 1920.
Courtesy Dan Miller, Berkeley

In 1920 they met the exiled Mexican poet, art critic, and archeologist Ricardo Gómez Robelo. So sympathetic was this meeting that Gómez Robelo asked Richey to illustrate his collection of poems, *Satiros y Amores,* which was published that year in Los Angeles.[71] Given his self-proclaimed "disregard for the modern spirit of this age," Richey was an astute choice for Gómez Robelo.[72] The nineteen drawings he executed for *Satiros y Amores* are ideally suited to the tenor of the book, harking back to Symbolism and Aubrey Beardsley (figure 6). These drawings share with the British fin-de-siècle illustrator both a highly stylized, black-and-white Art Nouveau esthetic and a turgid erotic content that suited the poems they accompanied.[73]

Richey's contact with Gómez Robelo may have sparked the American's interest in Mexico. If the expatriates of the 1920s were drawn to Europe for its culture and Russia for its politics, then Mexico offered both, and during World War I it had been a refuge for slackers who hoped to avoid the draft. The newspaper editor A. E. Gale, who provided Richey with another Mexican connection, was among the latter: *Gale's,* founded in 1917 and subtitled "A Journal of the New Civilization, Socialism, New Thot.,

Internationalism," was published in Mexico City. Gale was eccentric but devoted to radical politics: by the January/February 1921 issue, his paper's title was *Gale's International Journal for Revolutionary Communism.*[74] Although predisposed to promote off-beat causes, Gale consistently published articles on a range of radical thought, from the orthodox Socialism of Lenin to the revolutionary Syndicalism of the I.W.W., and included regular contributions by Margaret Sanger and other supporters of birth control.

The stories reported in *Gale's,* which listed Richey as a contributing editor/cartoonist on the masthead of the May 1920 issue, set the stage for Modotti's seven-year stay in Mexico and almost certainly provided her with information that informed her later politics. There was, for example, an account of the founding in September 1919 of the Mexican Communist Party (Partido Comunista Mexicano or PCM).[75]

Gale's also ran several articles about Mexico's ongoing struggle to regain control of its natural resources, especially oil, in the face of heavy investments on the part of American corporations. This conflict, which dated back to 1912, came into sharp focus with the ratification of Mexico's revolutionary constitution of 1917. The constitution had come about as a result of the eventual dissolution of the Porfirio Díaz government, also called the Porfiriato, which had lasted some thirty-odd years, from 1876 until 1910. The Porfiriato was marked by an effort to modernize Mexico, to push the country into the twentieth century, a project that backfired and brought on the Revolution instead. The ideological backbone of this effort was formulated by a group of influential bureaucrats known as the Científicos. Their positivist philosophy saw Mexico's future in the continued domination of the *mestizos* and pure Indians, who made up a majority of the population, by the minority of white Mexicans. A landless, uneducated peasantry was to provide the cheap labor pool necessary for modernization.

The Revolution that broke out in 1910 was fueled in part by organized labor. Díaz quietly sought exile in Europe, and a protracted civil war ensued: seven bloody years of fighting subsided with the ratification of the constitution and ended in 1920 when General Álvaro Obregón was named president of Mexico. Two constitutional provisions in particular had a profoundly negative affect on United States–Mexican relations: Article 27, which restored proprietary ownership of subsoil resources to the government, and Article 123, which established better working conditions for Mexican labor.

At the heart of the oil controversy was the notion, inherited from Spanish law, that the state held subsoil rights to all natural resources.[76] Díaz had reversed this concept, issuing decrees that granted landowners these rights. Although such measures encouraged foreign investment in Mexico, they ran deeply counter to assumed national rights, and had been, in no small measure, a direct cause of the Mexican Revolution. In spite of the capital that the decrees brought in, the Díaz government was perceived to be literally "giving away" the country's natural resources.

During World War I, the issue of oil became an international affair, and the United States worried that Mexico,

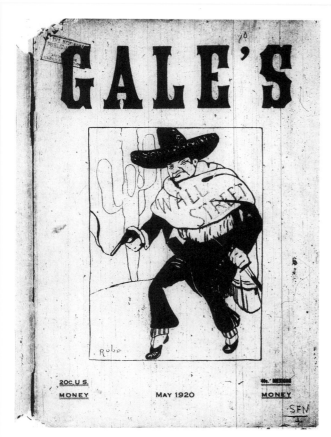

Figure 7 Robo de Richey. "Wall Street," cover drawing
for *Gale's*. May 1920.

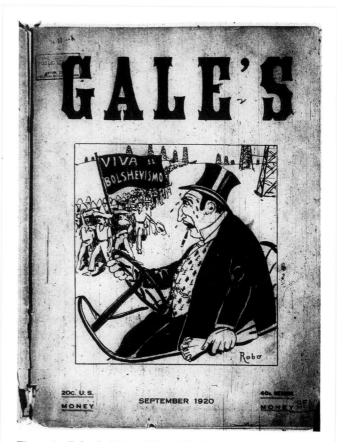

Figure 8 Robo de Richey. "Viva el Bolshevismo,"
cover drawing for *Gale's*. September 1920.

despite its stance of neutrality, might not only cut its own
supply of oil but support the German war effort. Al-
though President Wilson tried to keep relations with the
Mexican government cordial (at the expense of protect-
ing American nationals and companies in Mexico), then-
leader Venustiano Carranza sought to use anti-American
sentiment for his own political advantage. At the end of
the war, the United States turned its attention almost
immediately to Mexico and a more decisive battle ensued,
bringing the controversy into the foreground, and the
mainstream and radical press paid attention to it. Robo's
two bluntly anti-capitalist, anti-American intervention,
and anti-imperialist cartoons appeared on the cover of
Gale's in May and September 1920 (figures 8 and 9).

Most likely, it was Gómez Robelo who brought Richey
and Gale together.[77] By the early 1920s, the Richeys had
a wide circle of friends and were known for their all-night
parties: they provided food and saki, music and dancing.
Gómez Robelo greatly enjoyed these occasions with their
array of writers, actors, musicians, dancers, and artists,
and after returning to Mexico he remarked in a letter to
Edward Weston, who also frequented the Richeys, how
he longed for a party at Robo's.[78] By the time Modotti and
Weston met in early 1921, she had become, as one friend
recalled, "the most cultivated person."[79] The few letters
of hers that exist from the period are peppered with liter-
ary and musical references, suggesting not so much
scholarship as wide reading and an inquiring mind.

In 1921, Weston was thirty-five years old and running

a successful portrait-photography business that support-
ed him, his wife, and his four sons. Born in Highland
Park, Illinois, Weston had enrolled in the Illinois
School of Photography at the age of twenty, in 1907,
but had left without a diploma after six months. Ac-
cording to photographic historian Weston J. Naef,
"Trade schools typically taught specialized photographic
skills. . . . Indoor photography was stressed and lessons
were aimed at imparting the skills needed to work in the
kind of professional portrait studios that thrived in al-
most every town of any state. Weston learned the tried
and true methods of creating photographs that would
satisfy the customer."[80]

In 1908, he had moved to Los Angeles, where his sister
lived, and a year later had married Flora Chandler, of the
powerful and wealthy Chandler family. Between 1908
and 1911, Weston was apprenticed in two commercial
photographic studios and then left to open his own shop.
In spite of his determination to be successful and his am-
bition, he was still trying to shed his conventional Mid-
western background when he met Modotti. Los Angeles
bohemia intimidated him: "I was suddenly thrown into
contact with a sophisticated group,—actually they were
drawn to me through my photography which had gone
steadily ahead. . . . They were well-read, worldly wise,
clever in conversation,—could garnish with a smattering
of French: they were parlor radicals, could sing I.W.W
songs, quote Emma Goldman on freelove: they drank,
smoked, had affairs."[81]

Modotti and Weston became lovers sometime after Mo-

19

dotti posed for him in April 1921: he took over a dozen photographs of her before the end of the year.[82] Weston also photographed Richey, and they remained friends despite the affair. At this point in his life, Weston aspired to be an artist, but was still "a very naive, provincial man, that hadn't seen the world, but . . . had a taste, an inclination, an intuitiveness."[83] With limited formal training and no artistic education, Weston found esthetic guidance in the person of Margrethe Mather, whom he met sometime after 1912. By all accounts, including his own, Mather was his first important artistic influence: she was exceptionally sophisticated and had been a practicing photographer before they met.[84] Mather and Weston were business partners for several years and worked together from about 1916 until 1923, the year Weston moved with Modotti to Mexico.

Modotti was Mather's successor as far as offering Weston entrée into the world of art, not to mention her glamorous Hollywood circles, while Weston introduced her to his friends, mostly photographers, whom she would turn to for encouragement over the years.[85] Through Weston, she met the photographers Dorothea Lange, Johan Hagemeyer, Consuelo Kanaga, and Imogen Cunningham, and Cunningham's husband, etcher Roi Partridge.

The idea of moving to Mexico was most likely Robo's, and when he invited Weston to share a studio, Weston was eager to go. It is impossible now to understand fully the arrangements the three had worked out.[86] Weston believed that Modotti and Richey had never legally married[87]; this is what one would expect given Richey's Anarchist beliefs, which precluded state sanctioning of a union between two people. Modotti never married any of the men she lived with during the rest of her life, and when her name was dragged through the press as a loose woman who took lovers, she answered her detractors by referring specifically to the men she lived with as her companions. One might guess that when Richey was confronted with the deeply passionate romance between Modotti and Weston, he bowed out of the relationship and got on with his life.

In the early fall of 1921, Modotti made a trip to Mexico, probably to shoot her second film, *Riding with Death,* which premiered that fall to lukewarm reviews. Richey left for Mexico at the end of November, and Modotti, already at work on her next film, *I Can Explain,* planned to go with Weston to meet up with him later.[88] Richey went to Mexico to paint, and he wrote exuberantly to Weston that the country was an "artists' paradise": "This is the 'Land of Extremes.' Great wealth and great poverty move side by side but there is little that is devoid of its beauty."[89] In early February of 1922, he contracted smallpox and died in a matter of days.[90] Modotti and her mother-in-law, Rose Richey, went to Mexico to bury him. Modotti remained there for two months (February–March 1922) and made contacts that may well have influenced her decision to move there a year and a half later. She saw Gómez Robelo and through him met other notables, as Robo had within the first two weeks of his arrival. Gómez Robelo had been recently named chief of the Education Ministry's Department of Fine Arts by José Vasconcelos, secretary of education and architect of Mexico's vast post-revolutionary educational reforms, of

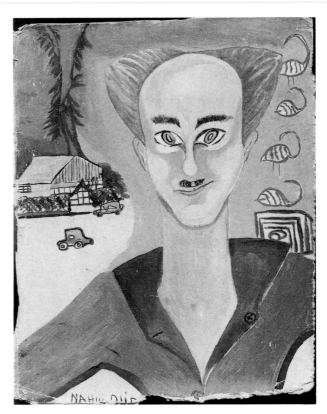

Figure 9 Nahui Olín. *Edward Weston.* c. 1924–26. Private collection, Mexico City, courtesy of Museo Estudio Diego Rivera, Mexico City

which the mural movement was a vital part.[91] In that capacity, Gómez Robelo had agreed to mount an exhibition that materialized as a group show shortly after Robo's death. It was a familiar circle: Robo, Weston, Jane Reece, Margrethe Mather, and Arnold Schröder. Modotti was in Mexico when it opened and wrote to Weston that his work had sold well.[92]

Modotti was devastated by Richey's death, which was followed in a few weeks by the death of her father. From Mexico, she wrote a friend, "Oh! How bitter I feel against life & nature! But I must defy it & smiling ask to it: What next? I must look at nature as an enemy not as a conqueror." Mexico was completely associated in her mind with her lost husband: "I walk the streets & go places he used to go to—recalling his beloved figure & I torture myself imagining him at my side . . . unseen—or better yet he is in me—I am filled with his wonderful love & influence. I am just part of him it seems!" Recalling their shared life, Modotti felt that it would be impossible to return alone to their studio in Los Angeles: "how can I ever live again there—where so many memories will haunt me?"[93]

In the aftermath of Richey's death, Modotti's relationship with Weston seems to have deepened into a long-term commitment, for by the fall of 1922, it appears they had already decided to move to Mexico, though it took them nearly a year to get their lives in order and leave. Weston got to know her family during this time, and he made a tender, evocative image called *Mother & Daughter (Tina and "Mamacita")* in which Tina's disembodied

head hovers like a muse above Assunta, both widows dressed in mourning.[94]

Modotti's decision to move to Mexico coincided with her decision to become a photographer, and she looked back on this time in her life with gratefulness to Weston for offering her the opportunity to learn photography.[95] In April of 1923 Weston left her in charge of his business, evidence that Modotti's familiarity with the workings of a photographic studio may have already developed beyond her purported childhood experience with Pietro Modotti. For Modotti, Mexico held the promise of an exciting political as well as artistic environment, and she left California with an already-heightened sense of political consciousness.[96] The extent to which she was able to integrate her political and esthetic ideals at this point in her life explains why, in spite of her Italian birth and American upbringing, Modotti is known to posterity as a Mexican photographer. Her photographs and Mexico were inextricable.

When Modotti arrived in Mexico with Weston in August 1923, she came not as a tourist but intending to live and work there permanently, and she came with a good deal of knowledge about her newly adopted country. Reading Gale's (and, one may suppose, other radical journals that circulated in California) she gleaned information about the vicissitudes of Mexican politics. Modotti had also been involved in the Mexican community of Los Angeles, where her reputation as an actress preceded—by eight months—the opening of her first film, The Tiger's Coat. A local Spanish-language paper, El Heraldo de Mexico, had featured an article on Modotti's life and career in a piece entitled "A Star of the Cinema Who Loves and Knows Mexico."[97] Moreover, before she left California, Modotti established friendships with several Mexicans whom she met again during her years in Mexico.[98]

Weston, too, had met a number of Mexicans in Los Angeles, and was encouraged by the warm reception his photographs received in Mexico. After the particulars of finding a suitable residence were resolved, Modotti and Weston set about getting their darkroom furnished and began seeking clients.[99] Before the end of September, they were in business and by early October, they had several sittings pending.[100] Weston aimed to earn money in Mexico by society portraiture, the very source of income that tormented him in California. Though it has been argued that in Mexico, Weston "was finally dedicating himself to self-expression," his Daybooks and letters are strewn with anxieties related to the portraiture that supported the Mexican household.[101]

From the start, Modotti proved extremely useful to Weston.[102] She managed the household, which consisted of Weston, his eldest son Chandler, then just thirteen, and Llewellyn Bixby Smith (stepson of Weston's friend Paul Jordan Smith, who was taking photography lessons from Weston[103]), and her command of the language was invaluable. With remarkable alacrity, she provided introductions to the small but active artistic circle that he treasured during his few years there. Within weeks of arriving in Mexico, Modotti had brought Weston to meet Diego Rivera and see his latest murals (although Weston regretted that he was unable to converse easily with Rivera because he did not speak Spanish). Shortly after

their arrival, she arranged an exhibition of Weston's work, and she seems to have agreed to sit in the gallery, either as receptionist or perhaps sales person.[104] The fact that Modotti was also beautiful and charming was immensely helpful as well, although Weston harbored deeply mixed feelings about this "blessing"; for while her presence afforded him advantages he might not otherwise have enjoyed, he tended toward jealously, whether or not Modotti reciprocated the admiration of other men.[105]

Their professional relationship was governed by a contract. Certainly, one of the reasons Modotti moved to Mexico was to learn photography from Weston, and while they were there, it was agreed that she was to be his darkroom assistant. Weston spelled out their understanding: "[Tina] has so far gotten room and board from this proposition—and a lot of responsibility—worry and hard work—but she prefers to take a chance on the future—if she left—I would fail and she would lose too—she wants to learn photography and is doing well—she has no wish to return to the stage and photography would make her to some extent independent."[106] And, while at this point, friendship, romance, and mutual respect were strong, Modotti thought of herself as a free agent. She had her own room, she took an active role in the daily business decisions, and she felt her responsibility for the financial well-being of the group as keenly as she felt the need to support herself.[107]

With her husband and father recently dead and opportunities for screen-acting dwindling, Modotti followed the example of her uncle Pietro and her father before her and became a professional photographer. From 1924 until 1930, she earned a good living from the trade, achieving economic independence. In some measure, this independence must have unsettled Weston no matter how supportive he might have been of her aspirations. Evident throughout his letters and even in his heavily edited Daybooks is Weston's cynicism toward women, although his misogyny is rarely commented upon.[108]

Modotti's earliest dated image is a portrait of Weston from February 1924 and is one of four photographs of Weston with his camera (plates 6–8). The staginess of Weston's poses in these images suggests they were a collaborative effort between two photographers. This funny, self-conscious suite depicts performances by the "master" photographer for his "student." The photographs embody Weston's lessons and technical guidelines that Modotti adopted in much of her work. Both photographers used large-format cameras: Modotti took her earliest photographs with a 4 x 5" Corona, a stationary view camera that required a tripod. A few years later, during a trip to San Francisco, she shopped for a 3¼ x 4¼" Graflex, a hand-held, single-lens reflex camera that freed her from the tyranny of the tripod, which she felt restrained her. After 1926, she used both: she found the precision of the Corona was ideal for formal portraiture and for documenting murals, and the Graflex gave her more flexibility and allowed for more spontaneous images. Nevertheless, like Weston, Modotti subscribed to the all-importance of composing an image on ground glass and to rigorous formal construction, as is evident in much of her work.[109]

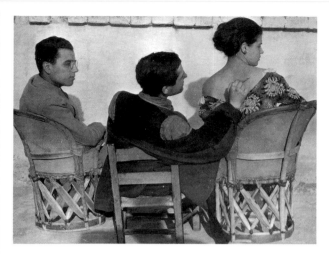

Figure 10 Edward Weston. *Federico Marín, Jean Charlot, and Tina Modotti.* c. 1924–26. Robert Mann Gallery, New York

Modotti's printing technique matched Weston's, and, for the most part, she made contact prints, placing a negative directly on sensitized paper and exposing it to light. In Mexico, she used sunlight; in Germany, it became immediately apparent to her that Berlin lacked sufficient natural light, and she found it was impossible to print without an enlarger.[110] In part, the practice of contact printing was not a choice but a necessity for Modotti: the platinum paper that she (and Weston) preferred required ultra-violet light waves, which are present in sunlight but not in the artificial light produced by enlargers. By 1926, Modotti began to use gelatin silver paper, but she continued to print by the contact method.

It is axiomatic that in contact printing, the size of final image is identical to the size of the negative. To overcome this limitation, both photographers used an enlarger to make interpositives to the size they required, and then used the contact printing method to make an enlarged negative. In this way they were able to make photographs of all sizes from original 4 x 5" and 3¼ x 4¼" negatives.[111]

The four portraits of Weston demonstrate Modotti's aptitude for portraiture, for which her experience as a model and actress probably stood her in good stead. The technical and esthetic aspects of picture-making were not completely foreign either, and from the start, Modotti set to work on discovering the physical limitations and artistic possibilities of the camera.

Among her earliest photographs are several that appear to be exercises in tonal composition and that explore the abstracting property of camera angle. Two interiors, *Staircase* (plate 10) and *Open Doors* (plate 9) both probably dating from 1925, are carefully constructed out of a series of angular shapes in varying tones of gray that lead the eye through the spaces depicted. In the case of *Staircase* the spiral effect suggestive of a nautilus shell is flattened by the high point of view. Stepping out-of-doors, Modotti made *Tree and Shadows* (plate 11) and *Laundry*. Intent on studying tonal variation as a function of transparency or shadow, their lack of narrative links them to the modernist strategy of emphasizing the objectivity of photography. At the same time, they display Modotti's maturing photographic competence and her interest in abstraction—especially in the one taken from a rooftop—and point to her determination to ground her images in her own reality.

Without Modotti's first-hand reactions to Mexico, one must read between the lines of Weston's *Daybooks* and turn to her photographs for evidence of her life there. The *Daybooks* record their many activities: meetings and parties, discussions and debates, and above all, the artists and patrons, writers and archeologists, who populated their social life. Before the year was out, they had met (or become reacquainted with) most of the friends whom they saw regularly over the next few years, among them the painters Dr. Atl and Nahui Olín, Diego Rivera and his wife Guadalupe Marín, Ricardo Gómez Robelo, Adolfo Best Maugard, painter Xavier Guerrero and his sister Elisa, Spanish painter Rafael Sala and his wife Monna Sala, and French expatriate Jean Charlot (figures 9–11).

During the first few months, the Modotti-Weston household went out touring the city and its environs, sometimes exploring as a foursome and sometimes with friends as guides. They visited the Floating Gardens of Xochimilco just south of Mexico City, where ancient Aztecs raised vegetables and flowers, but which were now islands connected by canals that reminded Modotti of Venice; they sought out colonial churches El Convento de Churubusco and Convento de la Merced; and they attended a Sunday bullfight at the Plaza de Toros, finding seats in the bleachers—the cheapest ones—and contending with the blazing sun.[112]

Often the outings were occasions for photographing.

Figure 11 Edward Weston. *Tina Modotti and Miguel Covarrubias.* c. 1924. © 1981 Center for Creative Photography, Arizona Board of Regents

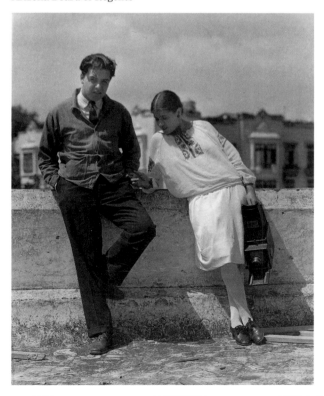

Together with several friends, Modotti and Weston spent a productive week in April 1924 photographing and exploring Tepotzotlán, a town lying twenty-five miles northwest of Mexico City. Through the auspices of Jorge Encisco, curator of the National Museum, the group was given "permission to sleep and live in the convent."[113] The central square of the town is dominated by a church built by Jesuit missionaries in the 1580s, which offers one of the finest examples of High Baroque Churrigueresque style. In contrast to the ornate facade and interior, the convent that adjoins the church is austere and plain. It was here that Modotti took a photograph of Weston sitting in a window writing a letter, which makes a joke on two art conventions: in place of the traditional image of a woman writing, Modotti gives us a man, and not just any man, but an artist framed (figure 12). The photograph appears to have been taken in the convent, and we may imagine that it is the window of the room they stayed in, given Weston's domestic chore.

For a few years, architectural subjects held Modotti's interest, probably for their formal qualities. Revisiting Tepotzotlán, sometime the same year, she made three photographs in the convent (plates 13–15), with their unexpected sources of light and their sculptural thresholds. Despite their disciplined design, they have a mysterious allure that draws the viewer in: one imagines the previous inhabitants of the convent passing silently through the doors and across the patios, moving from shadowed obscurity to dazzling sunlight and back to shade. Her friend, the artist and critic Jean Charlot predicted that these "whitewashed adobe walls will be rediscovered in time as precursors of the minimalists."[114]

As much as the awe-inspiring pre-Columbian sites and the elaborate ecclesiastic and government buildings constructed during Mexico's colonial era appealed to Modotti, however, contemporary spectacles and festivals with roots in both cultures held her real interest and pointed the way toward a truly personal style. Here was to be a source of mounting tension between Modotti and Weston. For while the choreographed brutality of the bullfight fascinated Weston throughout his sojourn in Mexico, news of De la Huerta's violent uprising in late 1923 in the far reaches of the country gave Weston pause. The *Daybooks* chronicle Weston's growing wariness, a discomfort tinged with distaste, as the violent tenor of life in Mexico intruded into his consciousness. He seemed unable to reconcile himself to the Mexico of the present: "All the splendor of Mexico, aside of course, from nature, lies in its past; the present here is an imposed artificiality, lacking the crude and chaotic but vital and naturally functioning growth of the big American cities."[115]

Modotti, on the other hand, embraced both the culture and people of Mexico to such an extent that she and Weston seem to have experienced two different countries. When the Gran Circo Ruso came to town, Modotti and Weston each photographed under the luminous circus tent with markedly different results. Weston's response was intellectual (this despite his strong emotional reaction to the circus).[116] He avoided all social content, creating what he called an "experiment in abstract design" where space is ambiguous and scale unclear (figure 13). In contrast, Modotti's *Circus Tent, Mexico* (plate 16) acknowledges the dynamism of the space but also uses the

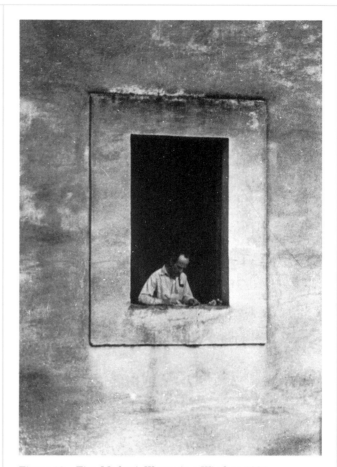

Figure 12 Tina Modotti. *Weston in a Window.* 1924. Jackson Fine Art, Atlanta

spectators to establish scale and give a sense of social context. This and *Exterior of Pulquería* (plate 17)—a bar that sells *pulque*—are the only two photographs in which Modotti depicts Mexicans at leisure.

At the same time that she was producing her architectural studies, exploring Mexican themes, and starting to take portraits, Modotti embarked on a series of intriguing photographs of plant forms.[117] Indeed, photographic still life suited Modotti. For one thing, her use of the large-format camera imposed certain restrictions on her mobility: it was simply impractical to take "snap-shots" with such an unwieldy machine. Historically, artists have used still-life painting (which embraces the sub-genre of flower painting) and still-life photography to study formal issues—light, pattern, composition, and tone. The genre is also a vehicle for conveying symbolic messages in which ordinary things take on a meaning beyond their morphology. Modotti's still-life pictures tell of studied framing on the ground glass of her camera and cropping in the darkroom, but, more importantly, they also incorporated objects chosen for their connotations, in contrast to Weston, who professed that his images had no meaning beyond their formal beauty. "The camera should be used for a recording of *life,* for rendering the very substance and quintessence of the *thing itself,* whether it be polished steel or palpitating flesh," Weston wrote in

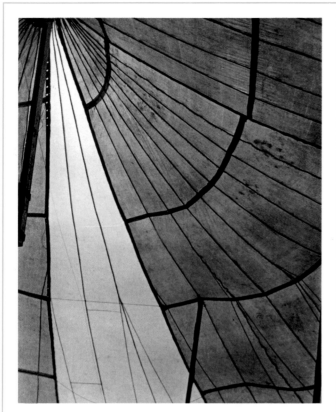

Figure 13 Edward Weston. *Circus Tent*. 1924. © 1981 Center for Creative Photography, Arizona Board of Regents

March 1924.[118] If his photographs had other meanings, Weston purported not to care.

Among Modotti's earliest photographs, *Flor de manita* (plate 18) and *Geranium* (plate 19) portray homely flowers with all their imperfections and individuality. She does not offer them as in any way exceptional, but rather, suggests their presence in her life and the lives of Mexicans. Modotti's flowers and plants have an emotional pull, stirring empathy in the viewer. It is easy to read *Flor de manita* as a desperate, wretched grasping hand—Weston was so taken with the plant that he mentioned it in his *Daybooks*: "We purchased too a weird flower, like a witch's claw, blood stained: flor de manitas."[119] Modotti's photograph of it is an example of "pathetic fallacy," the attribution of human feelings to nature.[120] *Geranium,* in its badly chipped pot, and *Calla Lily* (plate 23), beginning to wilt, also convey a sense of suffering, or rather, prompt a projection of human suffering onto the flowers, while reminding the viewer that death and decay are evident even in the most beautiful objects.

Still life as a genre in photography has received very little consideration. One of the most astute comments on the practice has been made by critic A. D. Coleman, who proposes that "still life is not a subject of art, it is a form of art."[121] By shifting the emphasis away from the literal content, Coleman pushes the boundaries of what still life is or can be. Still life as a procedure, as a "form of art," dominates Modotti's entire oeuvre; her photographs realize a transformation of the mundane into the realm of the symbolic. Almost without exception, Modotti approached all her subjects as she did these early flowers,

even when the content was not what is traditionally classified as still life.

Roses (plate 22), one of her more abstract images, can be read in straight, formalist terms. The luminous petals of four white roses animate the surface of the image with their curling edges and infinite variety of shadows. In addition to its visual beauty, the image is both a memento mori—the fading flowers symbolizing mortality—and a time-honored message of love.

Modotti's early still-life photographs are generally characterized as derivative of Weston's, this despite the fact that hers are not remotely like his.[122] Their student/teacher relationship intrudes on viewers' perceptions: neither chronology nor the photographs themselves bear out such an analysis. On the contrary, Modotti's close-up "portraits" of flowers preceded Weston's photographs of peppers, and her preoccupation with still life may have induced Weston to begin thinking about this form of art, which he pursued for the first time in Mexico.[123] After returning to California, Weston began a series of still-life photographs, producing dozens of images of shells that made his reputation. Modotti was bowled over by these photographs when he sent her a few. "They disturb me not only mentally but physically—There is something so pure and at the same time so perverse about them—They contain both the innocence of natural things and the morbidity of a sophisticated distorted mind. . . . They are mystical and erotic."[124] Weston was surprised at her response and denied they were anything other than "pure form."

As much as Modotti may have learned from Weston, she also made several experimental photographs at the very beginning of her career that were at odds with his most deeply held ideas about the medium. While these early works did not finally mark paths that she followed later, their diverse approaches suggest that she was not inhibited by Weston's proscriptions. *Interior of Church* (plate 24), for example, an extraordinary image of the inside of a tower taken in Tepotzotlán in 1924, was made with an enlarged positive, so that the image is a negative print. Modotti mounted it upside down, and Weston couldn't help but be impressed by her audacity, as well as by the final result: "I, myself, would be pleased to have done it." Weston wrote, "in truth, [it] may not be the best usage of photography, but it is very genuine and one feels no striving, no sweat as in the Man Ray experiments."[125]

Another notable departure from Weston's practice, *Experiment in Related Form* (plate 25), also of 1924, is a double exposure: the same image of five wine glasses appears twice in the print, but in different sizes.[126] The doubling creates a screen of floating reflections and elliptical shapes that fluctuate between legibility and abstraction. In its differing degrees of transparency, it alludes to another photo-based invention, the x-ray: by aligning the stems of the center glasses in both negatives, Modotti creates a kind of inorganic spinal column.[127] The repetition of the ordinary wine glasses visually evokes the rhythm of mass-production.

Modotti's overtly experimental photographs should be understood as part of an international phenomenon referred to variously as modernist photography, "new photography," or "the new vision." As a photographic

practice of the 1920s and 1930s, new vision was not a self-conscious movement so much as an innovative way of looking at the world predicated upon the introduction of new techniques that pushed the bounds of the medium. Among its more notable manifestations were the use of collage and photomontage, abstraction, experimentation with cameraless photography (such as photograms), and the use of distorted or unusual points of view, including the extreme close-up. American modernist photography, as practiced by Weston, Paul Strand, and Alfred Stieglitz, was characterized by its formalism and emphasis on the materiality of the object depicted, even when the resulting photograph verged on the abstract. In Europe, including the Soviet Union, the new photography could be seen as a visual response to the social upheavals that followed in the aftermath of World War I.[128]

Modotti is known for her political images, but she was not indifferent to the allure of abstraction. *Texture and Shadow* (figure 14), a photograph of draped fabric, and *Abstract: Crumpled Tinfoil* (plate 26), demonstrate her interest in exploring the monochromatic subtleties of the black-and-white medium as well as the abstracting properties of photography. Modotti's few abstractions illustrate the new vision tendency to adapt novel, sometimes jarring points of view. Moreover, her images bear out the notion that the camera is a tool and that the photograph does not simply issue from a machine but from the active intervention of a creative artist.

Modotti worked at a distance from the industrial centers associated with the emergence of the new vision, but she drew from tendencies characteristic of both the United States and Europe. In general, her subject matter—including crowd scenes and industrial sites—and her composition—strong angles, extreme points of view—synthesized modernist ideas, but from her own uniquely Mexican point of view. In this effort, she is allied with two strains of Mexican modernism, the mural movement, sometimes called the Mexican Renaissance, and the Movimiento Estridentista, whose genesis and unfolding coincided with the years Modotti lived there.

Experiment in Related Form is the earliest example of Modotti's esthetic link with the Estridentistas.[129] The Movimiento Estridentista was announced by Manuel Maples Arce in a 1921 manifesto issued as a broadside by *Revista Actual*.[130] Deliberately provocative and outrageous—predicated as it was on the type of manifestos published by the Italian Futurists—it denounced bourgeois taste and the stale formulas of academic practice, calling instead for a new, radically modern esthetic: "All Stridentist propaganda must praise the modern beauty of the machine . . . gymnastic bridges tautly stretched over ravines on muscles of steel." Stylistically, the Estridentistas favored the formal dynamism and fractured imagery of the Italian Futurists, with the intent of adapting it to a distinctly Mexican esthetic. (Eventually they distanced themselves from Futurism, especially as its fascist tendencies became more overt.) From 1921 until about 1927, when the political climate in Mexico became too hostile to their goals, the group published several journals and held exhibitions.[131]

Modotti became friendly with many of the Estridentis-

Figure 14 Tina Modotti. *Texture and Shadow* or *Cloth Folds.* c. 1924. The Museum of Modern Art, New York. Anonymous gift

tas. Their haunt, the café Europa, which they dubbed Café de Nadie (the Café of No One or Nobody's Café), was poetically described by the writer Arqueles Vela: "Everything [in the café] becomes hidden and patinaed, in its alchemist atmosphere of retrospective irreality. The tables, the chairs, the customers are as if beneath the mist of time, cloaked with silence."[132] Vela renders the necessary ingredients for artistic fermentation: a bar where intellectuals gather to argue about new ideas in a haze of cigarette smoke, over coffee or wine.

The Café de Nadie also functioned as a showplace, and the first "exhibition of Estridentism" was held there on April 12, 1924. All art forms—literature, music, and the visual arts—were presented, with none having a higher status than any other, creating an Estridentista environment that was, perhaps, nourished by the "alchemist atmosphere." Modotti certainly attended this festive event, since Weston had been invited to show six photographs, which he seems to have found a dubious honor.[133] In any case, Modotti already knew several of the participants.[134] Germán Cueto—she had been to his home for chocolate just a few months earlier—showed masks made of plaster and papier-mâché, innovative not only for their materials but for the way they married Cubist esthetics and a Mexican popular art form.[135] (One of Modotti's earliest photographs is an image of a puppet, probably one of Cueto's constructions [figure 15].) Jean Charlot, who showed his paintings, became a close friend of Modotti's, and she took his portrait on several occasions (plates 33 and 36).

A few months after the exhibition, Modotti herself was invited to participate in an Estridentista event. Luis

Quintanilla, a diplomat by profession, had published two books of poetry—under the homophonic name Kin Taniya—with typically Estridentista titles: *Avion* (Airplane) and *Radio*. His Teatro Mexicano del Murciélago

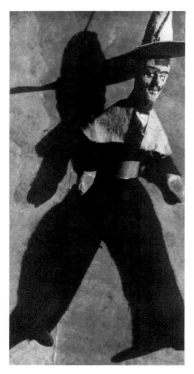

Figure 15 Tina Modotti. *My Latest Lover!* 1923. Collection of the Center for Creative Photography

(Theater of the Bat) was first performed in mid-September, with Modotti as one of the players.[136] Quintanilla was inspired by Nikita Balieff's *Chauve–Souris,* which had impressed him in New York a few years earlier and which Modotti had urged Weston to see when he visited New York in 1922. Just as the Russian impresario had created his production from an assortment of Russian folk motifs, Quintanilla incorporated elements of Mexican folklore in his, including ritual dances performed by dancers imported from the provinces. While Teatro Mexicano del Murciélago was not particularly modern in content, it did subvert conventional notions of theater, incorporating many forms of performance and including traditional Mexican culture in a "high" art setting. Although the Teatro Mexicano del Murciélago was vaguely reminiscent of the variety-type entertainment of the Italian theater in San Francisco, Quintanilla's production was intended as an experiment in vanguard theater. Thus, it would be a mistake to dismiss Modotti's return to the stage as a lark: her involvement speaks, at least to some degree, of her investment in the movement.

Modotti's *Telegraph Wires,* of telephone or telegraph poles, from about 1925 was admired by the Estridentistas (figure 16). In this image, and the better known *Telephone Wires, Mexico* (plate 28), Modotti conceived a new kind of "landscape" photography, one that literally bypasses the land, but uses elements springing from the ground that announce the modernization of Mexico. The acute angle from which Modotti shot this and a number of other photographs calls to mind the dynamism of Futurism and the lines of energy in paintings by Wyndham Lewis or Charles Demuth. Her friend, Germán List Arzubide printed the image in his 1927 history *El Movimiento Estridentista,* calling the poles "electrical antlers."[137] A few years later, the same image was published in Eugene Jolas's modernist journal, *transition,* alongside photographs by Man Ray and László Moholy-Nagy.[138]

Estridentismo was a crusade to modernize Mexico culturally. Artistic iconoclasm went hand in hand with political insurgency, and while their primary goal was overhauling the arts of poetry and painting, the social concerns of the Estridentistas were definitively expressed in the November 1926 issue of the journal *Horizonte,* thanks largely to the efforts of List Arzubide. In this issue, the Estridentistas decisively allied their work with the ideals of the Mexican Revolution, and Modotti was among the artists whose work was reproduced, along with Rivera, José Clemente Orozco, and Gabriel Fernández Ledesma.[139]

While the Estridentistas stimulated Modotti esthetically, it was the circle of politically active artists who, in late 1922, had rallied behind the manifesto of the Syndicate of Technical Workers, Painters and Sculptors, that had a powerful influence on her ideas about linking art and politics.[140] This famous document was published in the first issue of *El Machete,* a newspaper dedicated to workers and peasants that was to play a large role in Modotti's life. With David Alfaro Siqueiros as Secretary General, and Rivera, Guerrero, Fermín Revueltas, Orozco, Ramón Alva Guadarrama, Germán Cueto, and Carlos Mérida all cosigners and committee members, the formidable alliance was composed of the country's most influential artists.

The proposition advanced by the syndicate was, simply put, a call to reclaim Mexico—specifically its pre-Columbian culture and contemporary art by indigenous peoples—as a visual resource for artistic inspiration: "The art of the Mexican people is the most important and vital spiritual manifestation in the world today, and its Indian traditions lie at its very heart." Explicit in the relocating of these artists' esthetic allegiances was a denunciation of influences from abroad, especially Paris, paradoxically the mecca that had drawn many of the signatories of the proclamation earlier in their careers.[141]

The syndicate's relationship with the government was initially positive. During his term (1921–24) as education minister in the administration of President Álvaro Obregón, Vasconcelos put into place an ambitious reform plan, replete with messianic overtones, designed with the illiterate and rural populace of Mexico in mind. Under the banner of the Revolution and incorporating his own pedagogical and social philosophies, Vasconcelos fostered programs that relied heavily on the visual arts to improve the lives of the nation's poor. It was Vasconcelos who enlisted artists to paint the walls of public buildings throughout the country, and thus the Mexican mural movement may be seen as a direct consequence of this "cultural evangelism."[142]

The long history of mural painting in Mexico inspired the modern movement: wall paintings in both high

art and vernacular traditions could be found in pre-Columbian temples and palaces, colonial churches, and decorating *pulcarías* and other commercial establishments. Charlot, an astute cultural observer, commented years later on work he had performed in the Yucatán, where he "copied bas-reliefs and murals as they were brought to light, before their polychromies began to fade. Mayan art was truly meant for the community at large. It was exciting to thus compare frescoes done five centuries ago with those we painted in Mexico City with a similar aim."[143] Influence from abroad is nevertheless also evident in the modern Mexican murals, most conspicuously in the work of Charlot (who is said to have imported *buon fresco* technique to Mexico) and Rivera, both of whom had had the opportunity to study Italian frescoes of the Renaissance in situ.[144]

When the muralists began painting at the National Preparatory School (where the Syndicate was formed), they drew upon all of Mexico's history for their subject matter, using a diverse range of styles. From Revueltas's *Devotion to the Virgin of Guadalupe* (a symbol of Mexican nationalism), to Rivera's, Byzantino-cubist *Creation* (symbolizing the fusion of indigenous traditions with Judeo-Christian moral imperatives), to Charlot's *The Combat of the Great Temple* (depicting the Aztec defense of Tenochtitlán against the forces of Cortéz), to the biting political work of the late-comers to the Preparatory walls, Orozco and Siqueiros, the only themes the murals had in common was a recognition of the significance of ancient native culture and the contemporary religious and social life of the indigenous population.

Among the artists who were lucky enough to get commissions, Vasconcelos's bold experiment generated great excitement. The general public, however, was not as enthusiastic. The murals were ridiculed in the press, sometimes virulently, and in June 1923 students protested and then vandalized several of them. Given that this was an elite state-run high school, the students' rage was not misplaced: as the writer Salvador Novo aptly put it, the murals "aimed to awaken in the spectator, instead of esthetic emotions, an anarchistic fury if he is penniless, or if he is wealthy, to make his knees buckle with fright."[145]

Vasconcelos, like the artists of the Syndicate and the Estridentistas, was impelled to forge a uniquely "Mexican" art. The idea of an art that was exclusively Mexican was, of course, illusive. Artists could hardly aspire to be part of the modern movement and not draw from art centers abroad, just as it was impossible to be a Mexican and not acknowledge the nation's multiracial and syncretistic heritage. These inconsistencies aside, both branches of Mexican modernism were influenced by the social upheavals of the Revolution, and both turned their attention to Mexico's indigenous population, its culture, and its social conditions, as well as to the huge population of poor and working Mexicans whose material conditions the Revolution was intended to improve. There were, however, clear differences between the two movements: the Estridentistas fashioned an esthetic based on formal innovation while the muralists, though more politically radical, worked in a more conservative figurative tradition. As the decade of the twenties came to an end, conflicts inevitably arose between some muralists and the increasingly conservative Mexican government; after all,

Figure 16 Tina Modotti. *Telegraph Wires.* c. 1925. The Museum of Modern Art, New York

the artists were paid to propagandize in favor of, rather than criticize, the state. Along with her colleagues in the Syndicate, Modotti grew more acute in her condemnation of the government; some of her later photographs were acerbic attacks on what she referred to ironically as Mexico's "revolutionary" government.[146]

In November 1924, after a year of intense work, Modotti hung ten prints alongside Weston's at a group show at the Palacio de Minería in Mexico City. (Among some of the other artists who participated were their friends Rafael Sala, Jean Charlot, and Felipe Teixidor.) This exhibit marks Modotti's first public showing, as Weston noted in his *Daybooks,* and he wrote, "I am proud of my dear 'apprentice.'"[147] The quotation marks around apprentice hint at an uneasy joke between them. Just a week before, Modotti had signed herself "your apprentice of the past—present—& may she be of the future."[148] Modotti's accomplishment in so short a time reflected well on him, proof of his own abilities: "Tina's [photographs] lose nothing by comparison with mine—they are her own expression."[149] If he harbored fantasies of Modotti as his Galatea, he would have to be content with an independent-minded Shavian Eliza rather than Pygmalion's passive love object. The apprenticeship was ending. Indeed, by December Edward and Chandler were on their way to California, and Weston had left "his" portrait studio in Modotti's charge.[150]

Modotti was well-prepared for the task of running the studio: she had been making portraits steadily throughout 1924. Her modern portraits, like Weston's, sought to capture the individuality of the sitter, in sharp contrast

Figure 17 Unknown. *Staged Wedding Portrait of Tina Modotti and Edward Weston, Mexico*. 1924. Collection of the J. Paul Getty Museum, Malibu, California

to the old-fashioned tableaux-vivants with their artificial props and fanciful backdrops still favored by commercial portrait photographers in Mexico. (As a sentimental amusement, Modotti and Weston had several "anniversary" portraits taken in August 1924, commemorating their first year in Mexico [figure 17]. Weston was scornful of the hack who posed them, once with a plaster Christ against a background of church vaults, and, in another shot, with a "dusty, dirty bunch of roses.")

Modotti was a sensitive portrait photographer and her manner with her sitters contributed to her success. She worked, one of her friends recalled, with an "easy efficiency."[151] Among her earliest efforts are two that appear somewhat experimental and do not fit comfortably into the genre. In one, her friend P. Khan Khoje, an agriculturist from India, is seen standing by a table contemplating ears of dried corn, his pensive silhouette highlighted by a triangular shaft of light against the back wall (plate 30).[152] Here, she seems to have found inspiration in Dutch Old Master paintings, with their symbolic lighting (though she did not use this approach to portraiture again). Another shows Elisa Ortíz, who became part of the Modotti-Weston household in November 1923 as a *criada* or housekeeper (plate 34). In this disturbing image, Elisa's hands are set off against the expanse of black on her lap, emphasizing their twisted, disfigured forms. The photograph testifies to the trust that developed between Modotti and Ortíz: she had "hands like witches' claws" that had been burned in a childhood accident.[153]

Modotti was commissioned by friends and colleagues alike, and she was often able to seize on some integral aspect of her subject's character and personality. Compared, for example, to her modest portrait of Charlot (plate 36), who was a modest man, she had Carleton Beals (plate 37), a journalist with leftist sympathies, focus his piercing gaze directly at her lens and the viewer. With his bulky scarf up around his neck, Beals lacks any sense of vulnerability, which is one of the qualities that Charlot seems to possess in his portrait. She made two portraits of Federico Marín. In the earlier one (plate 31), he is striking a pose: he leans against a wall, restless and impatient. His youthful energy and his self-conscious demeanor are evident, as is the easy rapport between sitter and photographer. Just a year or two later, Modotti's quite different portrait of Federico (plate 49) records the transformation of a boy into a young man.

The portraits Modotti produced over her seven-year career range from rather formal, elegant likenesses to more casual pictures to some that demonstrate Modotti's interest in aspects of new vision photography. Given the fairly conservative role of women in Mexican society, she adapted an elegant but subdued manner of portraying women. This is evident even in her portraits of women who were in the public eye, such as the internationally known actress Dolores del Rio (plate 44) and Carolina Amor de Fournier (plate 45), who was influential in the arts. Modotti presented María Marín de Orozco, the sister-in-law of Rivera, as alluring but chaste: with eyes averted, she appears somewhat ethereal. In one of the series (plate 47), Marín's head is set off by a transparent black scarf flowing across her neck; in another (plate 46), the simple black dress she wears creates an undulating line that adds visual interest.

Several American women are depicted as being less demure than their Mexican friends. Modotti's portraits of Frances Toor and Anita Brenner (plate 48), each of whom fostered Mexican culture, are as different from each other as the two women were. Toor, an anthropologist and writer, promoted traditional Mexican folk arts in her influential magazine, *Mexican Folkways*. Her determination is readily apparent in Modotti's straightforward portrait, in which she has paused for a moment over her typewriter to look into the camera. In contrast, the not yet twenty-five-year-old Brenner poses in a more dramatic, self-conscious photograph: her triumphs, several indispensable books on Mexican history and the mural movement, were yet to come. Ione Robinson (plates 50 and 51), a brash young artist who came to Mexico to find a "wall to paint on," happened to fall in love with political journalist Joseph Freeman. In her portraits by Modotti, Robinson is openly radiant.[154]

Modotti took several portraits of artists at work, among them puppeteer Louis Bunin seated with one of his creations (plate 53) and muralist Máximo Pacheco atop his scaffold engaged in the act of creation (plate 35). Both artists utilized their skills to educate the illiterate, one through theater, the other with pictures. These portraits suggest the high value Modotti placed on art that is made for the good of others.

Among Modotti's most interesting portraits are several that she took of some of Mexico's cultural elite. She used one innovative pose a number of times and to good

effect. Writers Salvador Novo and her friend List Arzubide (figure 18)—as well as an unknown woman, perhaps a writer too (plate 52)—sit before the camera with their heads bowed forward and their features foreshortened. Rather than create a likeness, such insistently "modernist" portraits dramatically distort the sitters' appearance: their emphasis is on the site of the ego, and they seem to symbolize will and intelligence.

Eventually, it became quite fashionable to have one's family portraits taken by Modotti, and between 1924 and 1930 she photographed at least fifty subjects—some are known, while others are not.[155] They stand as a record of the many people who passed through her life, of the extent of her friendships, and of her reputation.

In Weston's absence Modotti changed profoundly. "I cannot," she wrote him in California, "as you once proposed to me—'solve the problem of life by losing myself in the problem of art,'" a declaration of independence that signals a new conviction in Modotti. Art was the highest goal for him. "In my case," Modotti wrote, "life is always struggling to predominate and art naturally suffers.... *I put too much art in my life* ... and consequently I have not much left to give to art."[156] The fault line between them is perhaps best seen as one of class consciousness: where Modotti felt a compulsion to identify with those less fortunate than herself, Weston felt none.[157]

Modotti's conflict between art-making and political action came into sharper relief as she became more involved in activities revolving around the Communist Party.[158] Her friends Siqueiros and Guerrero were active on the editorial board of *El Machete* when the paper was converted into an organ of the party for the May 1, 1925, issue.[159] It was about this time that Modotti became involved with the newly formed Mexican branch of the International Red Aid, a Communist version of the Red Cross founded in 1922 with a mandate to provide aid to all who were oppressed by political forces, regardless of political affiliation.[160] As its name implies, the Red Aid had sections around the world: in Spain it was Socorro Rojo; in Germany, Rote Hilfe; in France, Secours Rouge; in Russia, it was known by its acronym MOPR. Modotti would eventually be associated with each of these branches. The form of aid varied: campaigns were made in support of amnesty for political prisoners; agitation instigated to provide asylum for victims of political persecution; financial support and legal advice were offered to political exiles and their families. The IRA staked a claim on behalf of the entire left, and its declared stance as the enemy of all political oppression attracted international support, especially from cultural circles. At its height in 1929, the International Central Committee included among its members Albert Einstein and Henri Barbusse.

The Mexican section of the IRA was organized during the spring and summer of 1925.[161] Like the sections abroad, it attracted political radicals as well as cultural figures; here, however, the differences between the two groups were less noticeable, since art and politics were more closely associated. Within five years, the organizing committee included some familiar names: Rivera, Siqueiros, List Arzubide, and Modotti herself. Others were Miguel O. de Mendizabal, head of the department of ethnography at the National Museum, who joined the ed-

Figure 18 Tina Modotti. *Germán List Arzubide.* c. 1926. Private collection

itorial staff of Frances Toor's *Mexican Folkways* at the same time Modotti did in spring 1927; his wife, Carmen Herrera de Mendizabal, a singer with a reputation in Los Angeles and collector of popular songs; Renato Molina Enríquez, who wrote a glowing tribute to Modotti in *Forma* (the cultural journal started by Novo and Fernández Ledesma); and Ramon de Negri, who was named Mexico's ambassador to Spain during the Civil War (plate 40).[162] Also on board was Ella Wolfe, who had arrived in Mexico from the United States some six months before Modotti, entering clandestinely with her husband Bertram Wolfe, who subsequently helped found Mexico's Communist Party and was an active member of the Anti-Imperialist League, founded around this time. Modotti belonged to the league, which, as its name implies, sought to bring to light imperialist actions committed by the United States toward the countries of Latin and South America. Ella Wolfe saw to the practical aspects of publishing the league's organ, *El Libertador*—Rivera was officially the editor—which put out its first issue in 1925.[163]

Soon, Modotti's political activities were encroaching on her photography. In July, she lamented in a letter to Weston that since he left, she had produced "less than a print a month."[164] Modotti must be referring to her "art" photography, though she may have had doubts as well about her ability to earn a living as a commercial photographer. In April, she had decided to accept a full-time job working in a bookstore for $250 a month, a position that

lasted just five hours. Once home for lunch, she realized she could never go back. Laughing at herself, she wrote Weston, "I may be ridiculous absurd—a coward anything you want but I just had to quit—I have no other reasons in my defense only that during the first morning of work I felt *a protest of my whole being*."[165] With renewed vigor, Modotti rededicated herself to photography.

Weston returned to Mexico in August 1925 to attend the opening of an exhibition at the State Museum of Guadalajara that Modotti had arranged with the help of Carlos Orozco Romero: this time they showed as equals. Siqueiros reviewed the exhibition, calling it "THE PUREST PHOTOGRAPHIC EXPRESSION . . . the most impressive demonstration of what can be done and what MUST be done with the camera."[166] José Guadalupe Zuno, governor of the state of Jalisco, bought a number of prints by Modotti and Weston for the museum.[167]

If the presence and accolades of Siqueiros, who had recently dedicated himself to labor organizing, did not give Weston the hint, it became clear to him soon enough that Modotti's political commitments had become more pressing while he had been away. Toward the end of a long journal entry (in which he describes his arrival in Mexico and several day trips around Guadalajara), he becomes somewhat rueful, noting that the trip back to Mexico City was discomfiting because Modotti chose to ride in the second class carriage; Weston, with his first class tickets purchased in Los Angeles, spent the night trip shuttling back and forth between his sleeping son Brett and Modotti.[168] Weston's jealousies of other men seemed to pale before the tension that arose between them over Modotti's activism.[169]

While the romance between Modotti and Weston was inexorably deteriorating, they continued living in the same house and working together in their studio, and Modotti advertised their services in the August/September 1925 issue of *Mexican Folkways*. For the remainder of the year, she was diverted from her photography by Rivera, who asked her to pose for drawings that would become studies for his murals at Chapingo, and by her sister, Mercedes, who joined the Modotti-Weston household in the middle of October and stayed for six weeks.[170] Two weeks after Mercedes's departure, Tina's mother Assunta fell seriously ill and, in mid-December, Modotti left hastily for California.[171] From San Francisco, Modotti wrote revealingly to Weston about her experiences, startled and dismayed at her reception: "of all the old friends and acquaintances not *one* takes me seriously as a photographer—not one has asked me to show my work—only the new group met through you."[172] If her family took her seriously, it was because she was called upon to take portraits of them: surviving photographs of Benvenuto, Mercedes, and Yolanda were probably taken during this trip.

Weston's friends in California included the photographer Consuelo Kanaga, who provided Modotti with much needed professional advice and emotional support in San Francisco. As a self-taught photographer, Kanaga was extremely resourceful, and as a friend, she was especially warm and loyal. She shepherded Modotti to camera shops to find a Graflex and invited friends and potential patrons over to her studio one evening to view Modotti's work.[173] Imogen Cunningham and Roi Partridge were also friendly, and the latter was instrumental in placing Modotti's *Experiment in Related Form* at the art gallery of Mills College in Oakland (where Partridge taught). Dorothea Lange assisted Modotti and, in a gesture of camaraderie, lent her studio for portrait sittings and made her darkroom available.

It was during this trip to California that Modotti formed into words her own intentions and goals in photography. Her insight came at some emotional cost, for her several months abroad had shaken her confidence and events forced her to focus on her own future. While visiting Rose Richey, Modotti was faced with the decision of what to do with all of the things she had stored in the house, among them books and letters that inevitably recalled her past life in California and her time with Robo. She had to face the fact that she simply did not see herself returning to California. Writing to Weston in February 1926 as she was trying to set her life in order, Modotti proclaimed: "I have been all morning looking over old things of mine here in trunks—Destroyed much—It is painful at times but: 'Blessed be nothing.' From now on all my possessions are to be just in relation to photography—the rest—even things I love, concrete things—I shall lead through a metamorphosis—from the concrete turn them into abstract things . . . and thus I can go on owning them in my heart forever."[174]

Here she declares her commitment to photography and articulates her ambition: to transform the tangible into the intangible, to transmute matter into ideology. While some of Modotti's earlier photographs show evidence of these aspirations, her work after this turning point in her emotional and artistic life attests to her achieving her goal.

When she returned to Mexico in late February 1926, Modotti saw her decision further validated by Diego Rivera—himself no mean critic—who distinguished her photographs as "more abstract, more ethereal, and even more intellectual" than those of Weston.[175] Rivera's opinions were published in *Mexican Folkways*: he was now art director, having replaced Charlot.[176] The magazine also published one of her photographs, an image of a cardboard Judas that accompanied a short piece by Frances Toor about the custom of burning or shooting up effigies of Judas on Glory Saturday (the day that falls between Good Friday and Easter). Over the course of the next few years, Modotti contributed some forty-five photographs to *Mexican Folkways*, some credited, others not. Some images were published as examples of her artwork and others appear to be commissioned as illustrations for articles.

Relations between Modotti and Weston had cooled. Even so, they remained courteous, even attentive, to each other. Within six weeks of her return from California, they were planning an extended trip through Mexico to photograph decorative arts of the country. The expedition was organized by Anita Brenner, a young American with strong Mexican ties: she had been born in Aguascalientes, where her family owned a ranch, and she had studied anthropology and archeology in Mexico City. In 1925 the National University of Mexico commissioned Brenner to make a study of Mexican art; she contracted

Weston to photograph two hundred objects and deliver four copies of each print by the first of September. Weston turned to Modotti, whose help he felt essential to the success of the project.[177]

Brenner supplied lists of the objects to be photographed, from an inventory compiled during her own travels, and provided formal letters of introduction and official-looking certificates to facilitate access to museums, churches, and private collections.[178] It was, nevertheless, a formidable undertaking. Both Westons (Edward and his son, Brett, who had come to Mexico with his father) and Modotti left Mexico City with three cameras at the beginning of June, headed south to the states of Puebla and Oaxaca, and returned a month later with dozens of negatives. After two weeks of developing and printing, they set off again, this time west and north, through the states of Michoacán, Jalisco, Guanajuato, and Querétaro.

While the trip inevitably provided numerous adventures, Modotti and Weston felt the pressure of the immense job they had agreed to perform. They deviated from their course once in a while to see sites not on Brenner's itinerary and made a habit of heading for the markets of each town they visited in hope of discovering authentic folk art. Nevertheless, the burden of their project tempered their enjoyment, and the trips were taxing and arduous. To save money, the three travelers shared rooms; the weather was often uncooperative; and transportation was unreliable. Perhaps the greatest handicap they faced came as a result of President Plutarco Calles's anticlerical policies: the cessation of all church services provoked the Cristero revolt in the western states. The mood of unrest throughout the countryside made Weston especially nervous and created complications for the photographers. They were eyed mistrustfully at every church door they approached, suspected of being government spies; worse, they would find after arriving at a church filled with objects to be photographed that its sacristy had been sealed by the government.[179]

Between two hundred and four hundred photographs were taken during the course of the four-month trip; ultimately, there was room for only seventy to illustrate Brenner's book *Idols Behind Altars* (1929), in which she credited Modotti and Weston with "sharing the commission." When Modotti received a copy of the book from Brenner, she wrote back immediately to thank her and let her know what a "tumult of emotions and memories it brings to me looking over the several photographs done in so many corners of Mexico."[180]

Some of the photographs from the trip for Brenner Weston claimed as his own, and clear evidence—in the form of negatives, signed prints, and photographs published during his lifetime—corroborates his assertion. But the project was collaborative on all accounts, from gaining entrance to a collection, arranging the "still life" or choosing an angle in architectural sites, setting up the camera, and so forth, all tasks at which Modotti was proficient. None of the pictures from the trip that remain in Brenner's estate, however, are signed by Weston, but several dozen bear descriptive captions on the back in Modotti's hand.[181] The photographic expedition had provided Modotti with good training and enabled her to hone skills by which she earned a living. She was soon sought after

by artists, both muralists and easel painters, and commissioned to photograph their work.

Shortly after the trip, Frances Toor asked Modotti to be a contributing editor of *Mexican Folkways* and she began to photograph folk objects for the publication.[182] Most are straightforward recordings, but some are interesting in and of themselves. *Mask on Petate* (plate 60) and *Mask with Horns* (plate 61), for example, stand out among the over twenty-five images of masks Modotti photographed for the magazine a few years later. She set the masks on woven reed mats so that the combination of materials, textures, and tones animate the composition. Two of her most arresting images, *Head of Christ* (plate 59) and *Flagellation of Christ* (plate 58), are dramatic closeup photographs of a carved sculpture. Modotti also went out in the streets of Mexico City at Toor's behest and made at least four photographs of piñatas (plates 54 and 55).[183]

Modotti's stature as an artist was growing. In early October, she was included in "Exhibition of Modern Mexican Art," a massive group show mounted by the Gallery of Modern Mexican Art on the prestigious Paseo de la Reforma. Among the Modottis was *Baby Nursing* (plate 62), which is among her most admired images. The photograph, tender without being sentimental and descriptive without objectifying its subjects, is one of a series probably taken in 1926 (plates 64 and 65), and the woman pictured is Luz Jiménez, who also modeled professionally for Weston, Charlot, and Rivera.[184] The image is tightly cropped so that the geometric roundness of the breast and of the baby's head become significant compositional elements. The woven, plaid patterning of Jiménez's rebozo and the delicate polka-dotted sleeve of the infant flatten out the rest of the forms. Modotti's approach here recalls her still lifes, and presages future photographic series that use human elements.[185]

This photograph and one other by Modotti were featured in the October 14, 1926, issue of *El Universal Ilustrado*. One review acclaimed Modotti as "an exquisite artist of formative sensitivity. How many painters," the reviewer asks, "would wish to create, at least one solitary painting that records the emotion contained in the photographs of this modern . . . artist?" It must have given Modotti great pleasure to find that this review by Rafael Vera de Córdova (a painter who may well have met Modotti during her 1922 trip to Mexico) was translated into English and printed in the December 15, 1926, issue of *Art Digest*.[186]

By the time the review appeared in the United States Weston had already returned to California: in mid-November, he and Brett had boarded a train headed North. "The leaving of Mexico will be remembered for the leaving of Tina," he wrote.[187]

In the end, Modotti was philosophical about their conflicted relationship: "you were embittered and had lost faith in me—but I never did because I respect the manyfold possibilities of being found in all of us and because I accept the tragic conflict between life which continually changes and form which fixes it immutable."[188] Her reflections make an apt analogy for her art making; her photographs reflect a mediation between the vicissitudes of living and the permanence of art.

Their paths diverged irreconcilably. In the United States, Weston pursued his art for art's sake, while Modotti, in Mexico, turned her attention to making politically charged photographs and increasingly committed more of her time to radical activities. She chose not to mention such matters in her letters to him; rather, she focused on things of concern to Weston and on daily events that she hoped would amuse him, and thus they provide few clues to Modotti's larger concerns after the middle of 1926. The best primary sources for her intensifying political commitments are the photographs she produced during the next few years; they literally fill in her biography.

Modotti created her most politically powerful work from mid-1926 on. Shortly after her return from California in the spring of 1926 Modotti made *Workers Parade* (plate 65), which marks the beginning of a new phase in her photographic practice, the point at which she realizes her ambition to marry politics and art in her photography. *Workers Parade* was to be published at least five times (with five different titles) during her photographic career, first in the August-September 1926 issue of *Mexican Folkways*.[189] The image is notable for the elimination of the horizon (Modotti was shooting down from a high vantage point) and the overall scrim effect created by the sea of sombreros that unifies the surface of the picture. These formal effects are a visual metaphor for the idea of class unity and reinforce the image's social content. By

Figure 19 Tina Modotti. *Stanislas Pestkowski.* 1924–26. Collection Miguel Angel Velasco

depicting workers engaged in the struggle for political change, Modotti found a powerful tool to demonstrate her vision of socially relevant photography.

Modotti devoted her energy to a number of organizations, most of which were either directly or indirectly associated with the Comintern in Russia. She continued to work for *El Machete*, International Red Aid, and the Anti-Imperialist League, which spawned the Hands Off Nicaragua Committee in which she was also active. All of these organizations were controlled by the Mexican Communist Party, which she joined before the end of 1927.[190]

Within the party in the mid-to-late 1920s, dissatisfaction with the ruling government was growing. American journalist Joseph Freeman, who came to Mexico in 1929 as a correspondent for TASS, summarized its position succinctly: "The Party . . . attacked the government's compromises with the clerical and porfirist elements, as exemplified by the pact with the church; its cooperation with American imperialism, represented at the time by Dwight Morrow [American Ambassador to Mexico]; its reorganization and rationalization of industry in the interests of native and foreign capital; its agrarian policy which robbed the peasant of his land."[191] The new objective of the party was to agitate workers and peasants into a political bloc that could force the government to reverse these trends.

Modotti was enlisted by the party and its members to document events and take portraits. For her efforts she was, Charlot wryly observed, rarely paid, because being a photographer, she was expected to provide her comrades with family portraits free of charge.[192] All in all, most of these photographs are without distinction, although the intense portrait of Stanislas Pestkowski, Soviet ambassador to Mexico from 1924 until October 1926 when Alexandra Kollontai replaced him, is an exception (figure 19). Over the next few years, Modotti's camera bore witness to the existence of a number of "red" organizations, among them the Federation of Young Communists of Mexico and the Hands Off Nicaragua Committee, and documented their numerous demonstrations.[193]

One photograph that Modotti took for the party commemorates a reception at the Soviet Embassy in 1927 (figure 20). On the wall behind the three rows of comrades is her photograph of a hammer and sickle (plate 68). It is related to an exceptional series of photographs that Modotti made in 1927, in which she brought her still-life esthetic to bear on a few commonplace objects—an ear of dried corn, a guitar, a bandolier, and a sickle—and in the process, created a new kind of political picture (plates 70–72). The photographs' impact relies on the powerful associations of the objects depicted as well as on Modotti's effective formal composition. By uniting implements of agriculture, music, and war, Modotti evokes the Mexican Revolution, and the images function as "revolutionary icons." Here Modotti fulfills her goal of turning concrete things into abstractions, achieving an eloquent synthesis of the formal and the political.

The challenge of making "political art" has vexed artists throughout the twentieth century, when high art has catered largely to the needs and taste of the bourgeoisie. Modotti may have struggled to come to terms with certain contradictions inherent in her twinned

Figure 20 Tina Modotti. *Reception at the Soviet Embassy.* 1927. Centro de Estudios del Movimiento Obrero Socialista CEMOS, Mexico City

goals, but in her choice of medium and the politicized content of her work, she allied herself with the tradition of popular graphics that flourished in Latin America. It is the work of the turn-of-the-century printmaker José Guadalupe Posada that most clearly exemplifies the power of the medium. His satiric prints peopled with the popular *calavera* (skeleton) were "discovered" by the muralists in the 1920s and valued as a folk-art tradition undiluted by European taste. More than just content, it is the reproducibility of the print (and the photograph), and thus its accessibility, that has historically set it apart from so-called "high" art.[194] Mexican artists were finding innovative ways to fulfill the mandates of the post-revolutionary period—to make public art. Printmaking was one way, and virtually every muralist produced a powerful body of prints. The mural itself, appearing on walls that were accessible to the populace, was deemed a suitable form of public art since unlike an easel painting, the mural cannot be purchased and so resists becoming a commodity. Modotti took a place among her colleagues and transformed her medium into a tool for revolution.

The notion of mural painting as public art was forcefully expressed by the artist Xavier Guerrero in an article published in the May 1927 issue of *New Masses.* "The plastic

arts," he declares, "must be put to the service of world revolution." Guerrero sketches out an economic analysis of artmaking in relation to the class war, and predicts that the villages of Mexico—where artists of the people are nurtured—will be the site of the revolution: "with them we will paint in fresco the struggles of workmen and peasants . . . [and] tell stories to the country people . . . we will give them plain visual forms to read. Our function is to paint in union halls, in cooperatives, in workers' meeting places, always leaving the stamp of the class struggle on our work."[195] Guerrero concludes his anti-clerical, anti-capitalist invective with a prophecy that art can lead to "the classless culture of the future."

Modotti translated this article from Spanish into English for the *New Masses.* Whether or not she subscribed wholeheartedly to its principles is questionable, especially in light of her association with Weston, who remained unwavering in his dedication to art for art's sake. Modotti tried to strike a balance between these two poles: in the face of a purely formal art, Modotti became politicized; fanaticism like Guerrero's led her to reaffirm her commitment to "artistic" considerations.

By the time Guerrero's article appeared, he and Modotti were romantically involved. They had met in 1922, when he was in Los Angeles shepherding a massive exhibition of Mexican folk art through a bureaucratic maze.

Guerrero was among the first artists to paint on public walls under Vasconcelos's art program, although he was without formal, academic training. His father had been a house painter and had passed on to his son various formulas and techniques that played an important role in the early, experimental days of the mural movement. It was Guerrero who convinced Rivera to give up the wax-based encaustic he had been using and taught him the art of fresco painting as it had been developed in Mexico. By employing a medium that dated back to the pre-Columbian period, the muralists saw themselves as champions of a native Mexican art form and thus as fulfilling their mandate to create a contemporary art based on their own heritage.[196]

In the early years of the mural movement, Guerrero's role was primarily one of adviser and assistant, most notably to Rivera at the Preparatoria, the Ministry of Education, and at the School of Agriculture at Chapingo. In 1925, he painted murals on his own in Guadalajara and designed a door for the house of Governor Zuno.[197] (The carvings were, incidentally, among the objects Brenner had assigned Modotti and Weston to photograph.)

Not only did Guerrero, who was the same age as Modotti, inherit traditional fresco techniques from his father, but he was heir to his father's legacy of active union organizing and participation in street demonstrations in support of labor, a much more risky endeavor during the days of the Porfiriato. Now, in the post-revolutionary period, Guerrero and his fellow muralists donned coveralls and worked side by side on the scaffolds with masons and plasterers, and they began to appreciate the intrinsic affinity between the labor of artisans and that of artists. In the pages of *El Machete* and other leftist journals, Guerrero found an outlet for his politically charged woodcuts (figure 21).

While Modotti shared Guerrero's beliefs in the social value of art, she also pursued a more traditional path, following Weston's example by showing her work in art exhibitions both in Mexico and in the United States. She entered the Tenth International Salon of Photography at the Los Angeles Museum in January 1927, a juried show held under the auspices of the Camera Pictorialists of Los Angeles. That her platinum prints were submitted as "untitled" struck one reviewer as a "modernist" gesture.[198] Two years later her work was included in a group show at the Berkeley Art Museum alongside photographs by Cunningham, Edward and Brett Weston, Lange, Roger Sturtevandt, and Anton Bruehl. Modotti had encouraged her young colleague Manuel Álvarez Bravo to send Weston some prints, and these were included as well. A reviewer noted "some excellent qualities" in Modotti's work, but felt Álvarez Bravo had not "mastered the art of pictorial photography."[199]

Modotti also sought a wider audience for her photographs through the newly powerful picture press. Throughout the late twenties and early thirties, Modotti's photographs appeared internationally in the many journals, magazines, and periodicals that flourished during the period. The statistics are rather remarkable: in 1926, six of Modotti's (noncommercial) photographs appeared in two different journals; in 1927, ten appeared in three different journals; and during the three years 1928, 1929, and 1930 over fifty were published, in left-wing

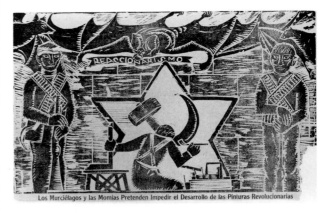

Los Murciélagos y las Momias Pretenden Impedir el Desarrollo de las Pinturas Revolucionarias

Figure 21 Xavier Guerrero. *Painters and Soldiers of the Revolution.* c. 1924. Woodcut. The Metropolitan Museum of Art, New York. Gift of Jean Charlot, 1929

journals such as *Arbeiter Illustrierte Zeitung* and *Der Arbeiter-Fotograf* (Berlin), *CROM* (Mexico City), and *New Masses* (New York); in literary periodicals such as *transition* (New York) and *BIFUR* (Paris); and in art magazines such as *Forma* and *Mexican Folkways* (Mexico City), *Creative Arts* (New York), and *L'Art Vivant* (Paris). Not surprisingly, her work was also represented in journals that mixed art and politics, such as *30–30* (Mexico City) and *International Literature* (Moscow); the latter printed half a dozen of her photographs in 1935 and 1936.

During the 1920s, photography (along with film) came to be seen as the medium that best reflected the new experiences of modern life, due in large measure to technological advances that made it possible to take better photographs with smaller cameras and reproduce them faster and more accurately, as well as to higher standards for professional and press photographers. Modotti recognized photography as the medium of modern literacy and grasped its potential role in shaping culture and politics. She exploited its graphic nature and its capacity for mass communication.

Modotti was certainly aware of photographic trends abroad from reading the international picture press, but she shaped her vision to suit her subject, Mexico, and her work expresses her commitment to a new social order there. Her strength was not as a documentary photographer or photo-journalist. Nevertheless, sometime before the spring of 1928 Modotti took a series of documentary photographs that were clearly influenced by the "Arbeiterfotograf" movement that emerged in Germany in the mid-1920s.[200]

The Arbeiterfotograf movement was the creation of the brilliant Communist propagandist Willi Münzenberg, who struck on the idea of a "worker photography association" and made it a part of the communications empire he built in Berlin during the 1920s.[201] In 1921 Münzenberg, at Lenin's behest, organized the Workers' International Relief (International Arbeiter-Hilfe or IAH), and from its original objective—to influence capitalist countries to contribute food and financial aid to mitigate the impending mass-starvation among Russian peasants—sprang a vast array of organizations: soup kitchens, pub-

lishing houses, newspapers, magazines, film companies and film distribution societies, and antifascist and anti-imperialist organizations, all headed by the protean Münzenberg.[202]

With earnestness and charisma, Münzenberg, who was known as "the patron saint of fellow travellers," enlisted some of the most prestigious writers, artists, and scientists of the day. His success was due in part to his remove from Moscow and his independent status. He distanced himself from the German Communist Party, functioning as a free-lance agitator, making sure nonaligned members of his various enterprises held prominent posts, while the Communists were less visible. Among the non-Communists who supported Münzenberg were Albert Einstein, Käthe Kollwitz, George Grosz, George Bernard Shaw, and Anatole France, as well as Henri Barbusse, who joined the French Communist Party in 1923. Even more effective were Münzenberg's innovative propaganda cum recruiting techniques devised on the principle that an emotional commitment stands the test of time. He asked workers to sacrifice to the cause something tangible connected with their daily lives, such as a day's wages or a product from their factory, and thus he recast charity as solidarity.[203]

The *Arbeiter Illustrierte Zeitung* (Workers Illustrated News, known as *AIZ*) was one of Münzenberg's most successful magazines—in Germany alone its circulation reached over two hundred and fifty thousand copies by 1924. As it evolved from its original purpose—an organ for IAH—into a popular journal, its focus shifted away from Russia and toward Germany and the working classes of all nations. *AIZ* was one of the many illustrated magazines that were important elements of the emerging mass media of industrial society, but it differed from other weeklies and monthlies in that its articles offered working men and women decidedly partisan opinions on current events, from sports to art. Significantly, its featured photographs were not the usual photo-journalist fare, but depictions of the conditions of the working and lower classes. Traditional (bourgeois) picture agencies failed to meet its demand for images of proletarian life—after all, the liberal press required photographs that represented the "joy of life"—and *AIZ* conceived of an ingenious way to create an inventory of appropriate imagery.[204] The March 1926 issue announced a photography competition, calling for the workers to send in "pictures of the proletariat." Münzenberg rightly understood photography's potential as a political tool. He went one step further, and with uncanny prescience, seized on the idea that a photograph might politicize both its viewer and the photographer.

Motivated by the potential venues provided by Münzenberg's emerging distribution system, a group of German photographers formed the Vereinigung der Arbeiterfotografen Deutschlands (VdAFD, Association of German Worker Photographers) and founded, in 1926, a monthly trade magazine, *Der Arbeiter-Fotograf,* (a Münzenberg concern, of course). Within its pages the worker-photographer was supplied with practical information, as well as instruction about theoretical propositions. For example, an article "The Working Man's Eye" explains how to become "the eye of the working class," contrasting the vision of a German industrialist, on the one hand, with

that of the working man on the other. Its author concludes, "you need the eye of a certain class in order to perceive the signs of prevailing social conditions in the internal and external life of our fellow-beings."[205] Illustrating the article "The Working Man's Eye" was Modotti's *Hands Resting on Tool* (plate 76), with the caption "We are building a new world."

Modotti was surely aware of the Arbeiterfotograf movement and its journal from its inception: her friendship with Alfons Goldschmidt, who had been a charter member of the IAH, virtually ensures it.[206] Goldschmidt founded Mexico's IAH section in 1924: Modotti (and Weston) were probably present at its genesis.[207] Trained in Germany as an economist, Goldschmidt was drawn to leftist causes and his interest in the arts led him to support the movement toward a mass and popular culture. In 1923 Goldschmidt traveled to Argentina to teach at the University of Córdova; there he met Vasconcelos, who offered him a professorship in economics at the University of Mexico. Goldschmidt and his family arrived in Mexico City in May 1923. His courses in Marxist economics were extremely popular, and he quickly became the center of an ardent following.[208]

Through Vasconcelos, with whom he shared an interest in ancient philosophy, Goldschmidt met the left-leaning artists who were also friends of Modotti and Weston. Weston was won over by Goldschmidt's warmth and infectious laugh and overcame his impatience with the writer's Communist inclinations, which he saw as slightly hypocritical in the light of the Goldschmidt's high standard of living and their enviable collection of popular Mexican art. Goldschmidt turned out to be a good friend to both Weston and Modotti, and an integral part of their social circle.[209]

Goldschmidt kept up a steady flow of communiqués back to Germany about his activities in Mexico, and probably showed Modotti Münzenberg's German publications. A handful of her photographs made in 1928 are comparable to the kind of work that the worker-photographers made abroad, and are radically different in sensibility from the rest of Modotti's work. For example, she made a series of images of the shocking living conditions and impoverished children in one of the poorest barrios of Mexico City, the Colonia de la Bolsa.[210] Its reputation as Mexico City's "Bad Lands" was notorious. Modotti and Weston had planned to visit there, not to see the poverty, but rather, to visit the school of Miguel Oropeza, who, in the midst of the ghetto, had built a school based on a democratic teach-yourself system. Modotti was exhilarated by his success and wrote to Weston about it in the summer of 1927.[211]

The school was a small shining light in the midst of hopeless destitution. The photographs Modotti produced depicted Mexico "from the inside," and they formulate a sharp indictment of the policies under Mexico's president Calles.[212] These photographs, which were destined for the pages of *El Machete,* reflect the unfulfilled promises of the Revolution. *Two Children* (plate 73), is the most impressive, in part because the image is severely cropped. Eliminating all distractions, Modotti's composition brings the children up to the surface of the photograph, intensifying our reaction to their poverty.

These photographs bear out the Arbeiterfotograf pre-

Figure 22 Abel Plenn. *Tina Modotti.* c. 1926–29.
The Museum of Modern Art, New York

cept that a camera can be "the eye of the working class."
Modotti understood photography's power and identified
herself as a worker-photographer. She developed her own
vision and trained herself to see with a "class eye": "I
look upon people now not in terms of race [or] types but
in terms of *classes.* I look upon social changes and phe-
nomena not in terms of human nature or of spiritual fac-
tors but in terms of *economics.*"[213]

Ironically, virtually none of Modotti's documentary
photographs were published in *AIZ* and *Die Arbeiter-
Fotograf.* Instead, it was her carefully composed, em-
blematic signature photographs that reached an interna-
tional audience through their pages. Modotti approached
these subjects in the same manner as she did her still
lifes and applied the same strategies she found so useful
in her botanical and revolutionary icons. Rather than fix
on inanimate objects, however, Modotti began to include
human elements. *Hands Resting on Tool* and *Labor 1*
(plate 75), both depicting workers' hands, are among the
strongest. Through close cropping and elegant composi-
tion, Modotti created icons that fairly explode. Literally,
these hands do the necessary work for Mexico, while figu-
ratively, they represent the potential political power
vested in the *campesinos* and *trabajadores.*

Modotti pictures workers in various relationships to
the work they perform. Some remind the viewer of the
chronic lot of the lower classes, with only their bodies as
a means to a bitter existence. Other workers, however,
are placed in a relationship to machinery but they are
presented neither as subservient laborers exploited
by capitalism nor as the glorified workers so prevalent

in Russian photography. Modotti envisions *obreros*—
workers—as the source of "the classless culture of the
future."

Modotti created some of her best-known photographs
of work and workers in 1927 for a book of poetry by List
Arzubide called *El Canto de los Hombres* (Song of
Mankind).[214] *Tank No. 1* (plate 77) is an especially elo-
quent example: the delicate light on the diagonal ladder
and the perpendicular pipe makes an arrow pointing dy-
namically to the sunlit laborer performing his job. Fur-
thermore, it incorporates its own caption, the "No. 1"
painted on the tank. In *Labor 2* (plate 78) another image
for this project, a construction worker is framed by a net-
work of girders, a ubiquitous symbol of modernism. In
both images, the sun is low in the sky so that strong
shadows are cast by the rivets that hold the structures
together, suggesting perhaps an analogous position of the
worker within economic reform. In her songs to men,
Modotti depicts workers in a symbiotic relationship with
the structures of modernization in post-revolutionary
Mexico.

In addition to the photographs Modotti made for *El
Canto de los Hombres,* she took numerous others that
could just as well have been included in the book. Some
depict workers caught in action while others appear
posed, or if you will, uncropped versions of the hands se-
ries (plates 5, 79–82, 84, 86). The power and originality
of these images arise from their portrayal of something

Figure 23 Tina Modotti. *Workers.* c. 1927. Reproduction
from *Horizonte,* April–May 1927, courtesy of the Centro
Nacional de Investigación, Documentación e Información
de Artes Plásticas (CENIDIAP), Mexico City

individual, even intimate, about their subjects, who also stand for all workers. Their very universality prevents them from being seen either as anthropological documents or as instantaneous recordings of reality. In contrast to Modotti's journalistic photographs for *El Machete,* these images move beyond "documentary" work.

Modotti's choice of subject matter for her art is in itself provocative, even in the post-revolutionary period. It is worth remembering the riot that broke out in the Preparatoria was in part a result of the subject matter of the murals on its walls. Vasconselos's mandate—to formulate a Mexican art—was premised on the notion of estheticizing indigenous art to create the impression of a national culture; to make the government policies of educational reforms designed for the lower and working classes, many of whom were of Indian descent, palatable to the middle classes. It is easy now to overlook the subversive power of Modotti's photographs and to miss the fact that images such as *Worker Reading "El Machete"* (plate 89) and *Campesinos Reading "El Machete"* (plate 88) were seen as potent manifestos of revolt. The young *obrero* reading *El Machete* is a reminder that the Revolution's promise of universal literacy would only be fulfilled by the activism of the people. In the crowded scene of the companion piece, all eyes, except two, are on the paper: one man looks up, staring intensely at the viewer. It is a disquieting image.

Modotti's photographs are among the most original solutions to the persistent challenges of making political art. Any uneasiness toward this marriage of art and politics is the result of a Eurocentric point of view, as literary theorist Fredric Jameson has argued. "What politics— what *a* politics—might be in the first place . . . [is] a perplexity no doubt meaningless in the rest of the world . . . , [in Latin America] . . . the political is destiny, where human beings are from the outset condemned to politics, as a result of material want."[215] Furthermore, although Modotti's photographs can be understood as part of the international phenomenon of "modernism," that is, as advanced cultural representations of industrial society, her setting, her metropolis, was vastly different from those working in other cosmopolitan centers. Industrialization had claimed for itself far more territory in Europe than in Latin America during the 1920s, and it had altered the material reality of the Mexican middle classes far less extensively. It was not until he left Mexico for a three-year stay in the United States that Rivera incorporated the machinery that was part of the industrial society north of the border in his work. Modotti too, in spite of her years in the United States, tailored her vision of modernism to suit the circumstances at hand: she was not working near the metropolises of Europe, but in an essentially agrarian Latin American country still reeling from changes wrought by revolution.

Modotti joined the Communist Party in late 1927, shortly before Guerrero, who had abandoned art making, was called to Moscow to take part in a three-year course at the Lenin School. It is possible that Modotti felt the need to express her long-term commitment to him on the eve of his departure by this symbolic act. Guerrero was an intense personality with a fierce and humorless dedication to the party. His letters to Modotti from Moscow are stern, even somewhat patronizing, and he admonishes her in one to refrain from befriending those outside her political circle for fear of scandal.[216]

At first Guerrero and Weston appear to have been opposites: the one quiet, dignified, and highly political; and the other gregarious and averse to organized groups, let alone political alliances. The only revolution Weston said he would take part in was an esthetic one.[217] Yet Guerrero and Weston resembled each other in their single-minded dedication to a radical stance with regard to the status quo, one in the social field, the other on an artistic plane. In both relationships, Modotti appears to have struggled between her role of helpmate and equal partner. Her attraction to men of ambition challenged her to forge a position for herself. Photography provided her with personal satisfaction and an individual identity. Soon after Guerrero's departure, she wrote to Weston reaffirming photography's significance in her life: "You don't know how often the thought comes to me of all I owe you for having been *the one important* being, at a certain time of my life, when I did not know which way to turn, the one and only vital guidance and influence that initiated me in this work that is not only a means of livehood [sic] but a work that I have come to love with real passion and that offers such possibilities of expression. . . . I find myself again and again speaking with friends about this precious work which you have made possible for me."[218]

Modotti was inundated with commissions at this point in her career.[219] She was especially preoccupied with making reproductions of murals by Rivera, Orozco, and Máximo Pacheco (a young painter whom she had come to know and admire), who were dependent upon her. She continued to provide photographs for *Mexican Folkways*: in mid-1929, she photographed more than twenty-five masks for the July/September issue.

Precisely when Modotti began the immense task of documenting the Mexican mural movement is unclear; it is certain that by the summer of 1927 she had committed an enormous amount of energy to photographing work by Rivera and Pacheco. In the April/May 1927 issue of *Mexican Folkways,* Toor announced the availability of Modotti's photographs of thirty-three of the latest frescoes by Rivera at the Ministry of Education (figures 24–26). In the next issue, Toor published a list of photographs by Modotti of Rivera's Chapingo murals, plus additional photos of the Ministry of Education murals; a separate advertisement in the same issue announced the availability of photographs of the frescoes of Pacheco.[220]

Beyond illustrating several monographs—for example, Ernestine Evans's *Frescoes of Diego Rivera* (1929) and Alma Reed's *José Clemente Orozco* (1932)[221]—Modotti's ongoing documentation of the Mexican mural movement had a significant impact on the art of the 1930s: her photographs were reproduced in art magazines and political journals throughout the world and thereby gave international visibility to the muralists whose work was inaccessible except to those who could travel to Mexico. Late in 1927, California philanthropist Albert Bender, who had begun investing in Mexican art, ordered an entire set of fifty prints of Rivera's murals directly from Modotti. Bender's collection formed the core of the San Francisco Museum of Modern Art's collection of Mexican art.

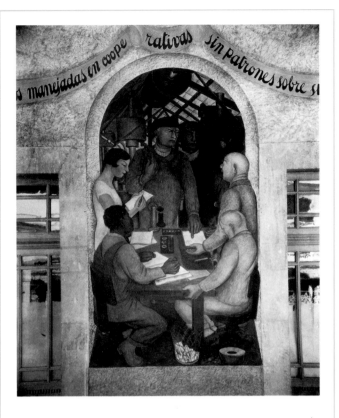

Figures 24–26 Tina Modotti. Details of Diego Rivera murals at the Ministry of Education, Mexico City. c. 1927. Hand-colored photographs. Courtesy Throckmorton Fine Art, Inc., New York

Meanwhile, that December in Moscow Alfred Barr, who was soon to become director of New York's Museum of Modern Art, noted Rivera's arrival in his diary. Barr eagerly anticipated seeing a complete series of Modotti's photographs of Rivera's Mexico City frescoes, and shortly thereafter had the opportunity to examine them. Throughout 1928, the first year of his eight-year stay in New York, Orozco wrote frequently to Charlot to be certain that Modotti was making reproductions of his mural work. Not only were they crucial to show prospective patrons, but he hoped to have them framed and placed in "offices, studios and shops of the best architects in New York."[222]

Modotti's formal affiliation with the party may account for the series of journalistic photographs she had made in the Colonia de la Bolsa for *El Machete* in the spring of 1928. They were published between mid-May and the beginning of September: six paired "contrasts of the regime" and seven single shots of poverty and destitution. The presentation of the photographs was anything but subtle: antithetic subjects were paired under sardonic headings. In one instance, a child sitting pretty in an elegant baby carriage on the Paseo de la Reforma is juxtaposed with an ill-dressed toddler playing in a wooden box on the street and the caption, in quotation marks, reads: "All Mexicans are equal before the law." Although most of the photographs—and possibly all—that were published were by Modotti, only one is credited to her, and it is at least possible that Modotti did not wish to acknowledge the others and may have felt somewhat apprehensive about this use of her art.

Elegance and Poverty (plate 95), the one image she acknowledged as her own, is a photomontage, a single image created out of pictures taken at different places and seamlessly united.[223] A billboard, lifted from one part of Mexico, appears conveniently above an image of a worker sitting dejectedly on a curb. The lower image is not a candid street photograph, but another example of Modotti's careful composing, similar to *Worker Reading "El Machete."* Posed with his face cast in deep shadow, this

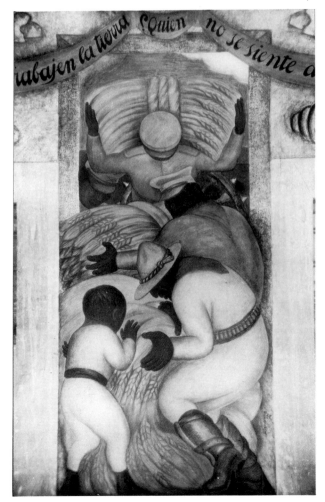

worker is transformed into "every worker," or rather, every unemployed working-class man. Modotti's placement of him in front of a stone wall literally isolates him and figuratively suggests the impossibility of his rising out of his situation. The billboard for Estrada Hnos (an abbreviation for *hermanos*, or brothers) promises, "from head to foot we have everything a gentleman needs to dress elegantly," expressing the "head to foot" division of the picture and, of course, society. In Germany in the late twenties and thirties, Dadaists Hannah Höch and John Heartfield used photomontage to reflect the disjointedness of modern life, often making stinging political commentary. Modotti's appropriation of the public billboard is analogous to their use of text and images cut from newspapers and magazines. Their work, however, is distinctive for its visual fragmentation and nonlinear narrative, while *Elegance and Poverty* looks like a photograph, thus ensuring a specific, rather than open-ended, meaning.

If Modotti's blatant propaganda photographs were appropriate for the overt political point the editors of *El Machete* hoped to make, her more original revolutionary still lifes resonated with the goals of the Treintatreintista group of artists, which formed in 1928. The Treintatreintistas came together to protest conservative trends in the National School of Fine Arts where many of them were employed. Their political aims were evident in the name they chose: the 30–30 was a rifle used by revolutionary forces during the uprising in 1910 and hence a popular icon of the Revolution (Modotti's *Bandolier, Corn, Sickle* had been published in 1927 opposite the lyrics of a *corrido*, or ballad, with the same title).[224] Appropriately, there were thirty members of the founding committee, most of whom were painters though the Cuban writer Martí Casanovas, who wrote a defense of Modotti's use of art on behalf of political change in the first issue of *¡30–30!*, the group's journal, in July, was among them.[225]

The Treintatreintistas were particularly enraged by the government-controlled school's reactionary position toward the Open Air Painting Schools that flourished throughout the 1920s on the outskirts of Mexico City, providing alternative educational instruction to the children of the workers and peasants who populated these semirural areas.[226] The Open Air Schools had become models for teaching art to the masses and therefore fulfilled one of the promises of the Revolution: to regenerate a Mexican culture. By 1928, however, they had also become associated with populist radicalism, and the officials in charge of the National School proposed drastic modifications in their curriculums. In response to what the more radical artist-instructors perceived as diminished artistic independence, combined with a growing reversion to academic, traditional art education, the Treintatreintistas published a series of statements, manifestos, and protests between July and December.[227]

There are uncanny similarities between the positions taken by the Treintatreintistas and another group of dissenters, the Soviet Oktyabr group, whose manifesto "October—Association of Artistic Labor" was published in March 1928 in Moscow.[228] Oktyabr included artists working in a variety of disciplines, especially the industrial and applied arts such as architecture, poster art, book design, film, and photography (the last two represented by Sergei Eisenstein and Alexander Rodchenko), who found themselves walking a fine line between avant-garde esthetics and the unpolished forms of expression characteristic of mass culture. They advocated an art that derived from popular Russian art, but that rejected both realism, which they associated with reactionary ideas, and Constructivism, condemned as art for art's sake. In part they were reacting against the drift toward social realism and the growing tendency for the Russian state to dictate the parameters of art making. Their fears were not unfounded: Stalin's 1932 decree "On the Reconstruction of Literary and Art Organizations" liquidated all existing arts organizations, institutionalized "social realism," and effectively eliminated innovative art for decades to come.[229]

Rivera, who spent six months in the Soviet Union beginning in September 1927, signed the Oktobyr manifesto. Back in Mexico by June 1928, he delivered a lecture at the National University on Russian art and culture at the same time that the Treintatreintistas were forming their group, and he is credited with having edited their "Protest" manifesto issued in November that adamantly rejected academic art, stating that no matter the subject, it can never fulfill revolutionary aims: "Even a good ex-combatant in the Revolution who paints pictures in the sterile colonial academic esthetic, is counterrevolutionary in artistic terms."[230]

It is inconceivable that Rivera did not share his experiences abroad with Modotti personally. Both artists were attempting to come to terms with the difficult questions raised by the Oktobyr and Treintatreintista groups. How was one to make revolutionary art uncontaminated by bourgeois culture, but produce work not alienating to the masses? What forms of art can be on the one hand innovative and on the other easily apprehended? It appears that Modotti found this question increasingly perplexing, and if she felt little pleasure in making the kind of pictures that *El Machete* could use to draw elementary political lessons, she was probably becoming equally uncomfortable making images that were not directly useful to the party.

In September 1928, Modotti wrote an anguished letter to Guerrero in Moscow, revealing her attachment to another man and making a definitive break with him. She had delayed for months, dreading the task which would hurt Guerrero, and yet her letter confirms the suspicion that Modotti may have confused allegiance to the party with loyalty to Guerrero. With the hope of mitigating the pain she was causing him, Modotti assured Guerrero that her new love would not interfere in any way with her work toward "revolutionary action"—"this has been my greatest concern, even more than my concern for you," hardly a comforting thought for Guerrero but perhaps indicative of Modotti's feeling toward him.[231]

Julio Antonio Mella, like the other men with whom Modotti became romantically involved, was passionately devoted and driven. A dynamic orator, persuasive writer, and charismatic figure, Mella threw himself into fighting for workers' rights as well as the rights of Latin American countries (especially Cuba, Mexico, Nicaragua, and Peru) to independence and freedom from imperialist and capitalist interests. Although not yet twenty-three when

he arrived in Mexico in early 1926, exiled from his native Cuba, Mella was already a legend in Communist lore.[232] He made a name for himself as the leader of the university reform movement and vigorously agitated against the intervention of the United States in Cuban affairs. Mella proved to be a far-sighted radical leader, working for concrete improvements for the disenfranchised, founding the short-lived "Popular University José Martí" devoted to educating workers, while at the same time orienting himself toward the establishment of an international proletarian state. When the Cuban Communist Party formed in August 1925, Mella was among the founding members and he was elected to its central committee. He was assigned two major tasks: to edit the party newspaper, *Lucha de Clases,* and to direct the education of new members. Mella also took it upon himself to organize the Communist Youth League, fomenting revolution among his university colleagues and recruiting for the party. The same year he founded the Cuban section of the Anti-Imperialist League and began an attack on Cuba's president-elect Gerardo Machado, whom he labeled "a tropical Mussolini." Hoping to quash Mella's influence, Machado jailed him in December 1925. The dictator's plan backfired, and instead, Mella brought worldwide attention to himself and his cause by going on a nineteen-day hunger strike: the press, both mainstream and leftist, covered his story. By the end of the year the government released Mella and shortly thereafter deported him.[233]

From birth, Mella was doubly stigmatized, born out of wedlock and of mixed national heritage. His mother, Cecilia MacPartland, was British—his given name was Nicanor MacPartland—and his father, Nicanor Mella, was a Dominican tailor who raised him when his mother moved to New Orleans. After an attempt to direct the young Mella toward a military career seemed doomed to failure, Mella studied law at university, where his activist career began. In Mexico, he took as his first name Julio Antonio and as his family name Mella, for its revolutionary connotations (his paternal grandfather had played a prominent role in the Dominican struggle for independence).[234] The symbolic import of names was not lost on Mella, and he used others as well. A number of articles that he published in *El Machete* were signed Cuauhtémoc Zapata, a shrewd fusion of two of Mexico's most revered heroes, both of whom had stood up to outside aggressors. (One cannot help but recall Modotti's first husband's metamorphosis from Ruby Richey, farm boy, to the bohemian Roubaix de l'Abrie Richey.)

Although Mella was clearly a man of action, his hyperactivity may have to some extent reflected a fervent search for a sense of identity. His forced exile from Cuba deprived him of his country; his mother had already abandoned him, and now he had left his father behind. Almost upon setting foot in Mexico, Mella became active in various party organizations, among them *El Machete* (which he helped edit and to which he contributed regularly), the Hands Off Nicaragua Committee, and the committee in support of Sacco and Vanzetti—all organizations in which Modotti was involved. He also became secretary of the Mexican Section of International Red Aid.[235] If the affair between Modotti and Mella had by necessity begun secretively, after her break with Guerrero

in September 1928 they became an acknowledged couple and began living together. Before the end of the year, Rivera memorialized their union in his mural in the Ministry of Education. The pair is seen handing out arms for the Revolution, Modotti holding the bandolier that had appeared in her revolutionary icons (figure 27).

Modotti made two very different "portraits" of Mella. One, dramatically lit and thoroughly heroic, reflects her devotion to and admiration of him (plate 93). Mella, presenting a classical profile and photographed from a low vantage point, is resolute. The image has all the earmarks of a publicity shot, and it was this photograph that appeared in newspapers and journals around the world after his death; it is the portrait by which he is still remembered.

The other photograph, *La Técnica* (plate 96), also known as *Mella's Typewriter,* can be seen as an abstract portrait, related in spirit to the drawings of machines that Francis Picabia made as symbolic portraits of his friends. (The most famous was his 1915 drawing of a camera called, *Ici, c'est ici Stieglitz.*) Modotti was almost certainly familiar with Ralph Steiner's 1921 photograph *Typewriter Keys,* which appeared in 1927 in the *New Masses.* She was, however, more likely inspired by the typewriters that were the indispensable tools of her intellectual and political friends and here pays tribute to a machine that was used explicitly in the service of her party. (Indeed, the typewriter was an apt emblem of Mella's historical contribution to Latin American radicalism: his written legacy had a crucial role in Cuba's history. Not only did his articulation of Marxist ideas lay the groundwork for the revolution in Cuba, but he was also recognized as the first to expose the exploitative nature of United States's imperialist policy in the Caribbean as a whole and to link the Cuban bourgeoisie with capitalist interests to the north.) Modotti's closely cropped, tightly composed image—it is made up of simple geometric shapes that balance and echo one another—is remarkably flat and reveals enough of the machine to make clear the process of communication: from the round white keys, awaiting the writer's touch; to the arching type bars poised for action; to the silvery ribbon, that thin membrane into which the type is struck, creating a positive image. The event has already occurred. In the top corner, a piece of paper held in place by the platen bears the words, "inspiración, artística, en una síntesis, existe entre la" ("inspiration, artistic, in a synthesis, exists between the"). Modotti has in effect montaged a text into her photograph, and in this case, one drawn not from advertising but from politics. The fragment is part of a statement by Leon Trotsky. The full citation, which Modotti used in the fall of 1929 on the brochure that accompanied her only major one-person show in her lifetime, reads, "Technique will transform itself in a more profound inspiration than that of artistic production: in time, it finds a sublime synthesis, the contrast that exists between technique and nature."[236]

The alternate title of this photograph, *Mella's Typewriter,* was supplied by Vittorio Vidali (nearly fifty years after the fact), who asserted that the text was part of an essay Mella was writing on Modotti's photography, that it remained unfinished, and that it was his last piece of writing before being assassinated in January 1929. He

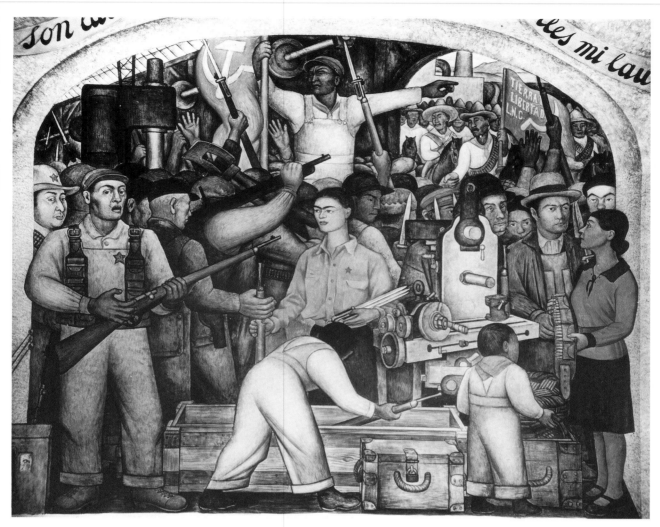

Figure 27 Tina Modotti. *Distributing Arms,* Diego Rivera mural at the Ministry of Education, Mexico City (with, from left, portraits of Siqueiros, Frida Kahlo, Mella, Modotti, and Vidali). c. 1928–29. Courtesy Throckmorton Fine Art, Inc., New York

thus imbued the image with a eulogistic aura.[237] In point of fact, Modotti had made *La Técnica* before September 1928, and Mella had admired the way it transformed an ordinary keyboard into something "socialized."[238]

Nevertheless, there is an emotional charge emanating from this photograph, which derives from our knowledge that Modotti's life was absolutely altered by Mella's murder. She was with him on the evening of January 10, 1929, when he was shot down in the street: he died in surgery a few hours later. Modotti was persecuted by the police in the aftermath of the assassination: she was interrogated repeatedly, her apartment was searched, and photographs (including nudes of her by Weston), love letters, and diaries that were found were seized. All was leaked to the press, to be made into fodder for lurid front-page stories. Modotti was damned for her unconventional romantic relationships, her foreign nationality, and her political activities and as a murderer when the police falsely charged her with the slaying and placed her under house arrest. "It is an infamy," she declared, "for the police to try to make out that this was a sentimental case. It is purely a case of political assassination."[239] To the left, Mella became an instant revolutionary martyr,

Figure 28 Fred Ellis. "Julio Mella," drawing for *Daily Worker.* 1929. Courtesy Tamiment Institute Library, New York University

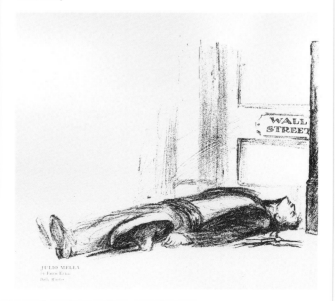

and throughout Mexico, *corridos* and poems were written in his honor (figure 28).[240]

Mella's assassin was, in all likelihood, one José Magriñat, sent from Cuba by Machado to put a stop to what the dictator began to see as a significant threat to his rule. In addition to publishing *Cuba Libre* (the organ of Cuban revolutionary refugees) from Mexico, Mella had been planning a coup, which he abandoned when word leaked out to Cuba. Although Magriñat was arrested, the Mexican government shortly set him free and no one was ever charged with the murder. Like many political assassinations, Mella's has given rise to various theories over the years, among them, the suggestion that the Comintern arranged for Mella's liquidation because of his unwillingness to yield to the will of the party and his Trotskyite leanings. If this was the case, Modotti's inclusion of Trotsky's words on the brochure accompanying the exhibition of her work that was shortly to take place was truly a defiant if not a reckless act. Trotsky's increasingly sharp criticism of Comintern—particularly of the Stalinist policy that elevated the defense of the Soviet Union above all other revolutionary goals—had led to his expulsion from the party in November 1927 (and eventually his exile from the Soviet Union in February 1929). Understandably, many Communists outside the Soviet Union had a tendency to reject "socialism in one country" in favor of Trotsky's commitment to a more internationally oriented ideal of "permanent revolution," and Comintern was increasingly alert to such deviations from the official line.

A week after the murder Modotti was acquitted, but the ordeal had been devastating. She was determined to carry on with her political work, but she understood the precarious nature of her safety in Mexico. With her obligations to party work increasing, Modotti found it more and more difficult to devote serious attention to her photography and rather than compromise her standards, she considered giving it up entirely. Ironically, at this time she was beginning to receive significant recognition as a photographic artist outside Mexico. In addition to the exhibition at the Berkeley Museum of Art in October 1929, *Creative Art* published an eight-page article (including seven reproductions) by Carleton Beals in the February 1929 issue. This was the first and, until 1966, only article on Modotti's photographs published in an English-language art magazine. A journalist not an art critic, Beals wrote sensitively about Modotti's work, drawing a connection between her Italian heritage and her imagery. In *Calla Lilies* (plate 2) he read the "delicacy and innocence reminiscent of the angel trumpets of Fra Angelico, but depicted in some gray dawn of which Fra Angelico never dreamed," while in other work he saw the structure of Piero della Francesca.[241]

The final months of 1929 were to be, for the most part, Modotti's last as an active photographer. In late summer, she traveled south to the Isthmus of Tehuantepec and photographed, perhaps for as long as a month, the women of Tehuantepec at work—carrying baskets, bathing children, and washing clothes—without a trace of sentimentality. Women's work in these images is neither idealized nor trivialized, but presented with sober matter-of-factness, as if to say, here is the proletariat of the proletariat.[242]

Most of the images from Tehuantepec are unposed, candid street photographs (plates 97, 98, and 100–104). On the back of one—a woman descending the steps of a covered, outdoor market—Modotti made a note to Weston: "Too bad the woman moved! Does the market place not look like a Greek temple?"[243]

Some of the photographs that resulted from her trip, however, are exemplary of her style. In particular, the heads of the women of Tehuantepec are notable for their careful composition and resultant symbolic content. In *Woman from Tehuantepec* (plate 101), the tightly cropped, intense closeup view makes the image function like a still life, in part because the Tehuana—or women from Tehuantepec—are a well-known Mexican "type." The Tehuana provided Modotti with an already-given meaning since Tehuantepec is a matriarchal society, where women have a significant voice in the running of the local economy and politics and are politically active on their own behalf.

By November, Modotti had plans to leave Mexico at the beginning of the year, though to where she seems not to have decided.[244] Since April, Modotti had felt acutely her status as a foreigner, subject to Article 33 of the Mexican constitution, which permitted the expulsion of "pernicious" aliens without a trial. "I am still in Mexico," she wrote to Weston in September 1929, "but it is so disagreeable to not know how much longer one is allowed to remain, it makes it almost impossible to make any plans for work, but of course the wisest attitude is to simply go on, do everything one intends to do as if nothing was ever going to happen to spoil one's plans."[245] Attacks on Communists were, indeed, escalating, growing more frequent and more violent; the offices of the Communist Party of Mexico and *El Machete* had been closed by the government in June 1929 (although the newspaper continued to be published and distributed in a haphazard manner).[246] Freeman's dispatches to the TASS office in New York recounted the aggressive drive by the Portes Gil government to paralyze groups on the left—a "White Terror" involving murders, kidnapping, illegal jailings, and deportations.[247] Modotti's status as a public figure in Mexico with a growing international reputation probably saved her life.[248]

To Modotti's consternation, Rivera was expelled from the Communist Party just before the end of September. He was a long-time friend and had come openly to her defense during the Mella trial: now she was required by party rules to renounce her friendship with him and she did. Rivera's position in the party had always been irregular; not that his deep-seated and intellectual commitment to Marxism was questioned but, as one observer astutely noted, "Most of those who knew him felt that communism was for Diego what theosophy was for Yeats—a source of metaphor."[249] Moreover, Rivera's disinclination to attend with any regularity the endless committee meetings that were required of members in good standing was a perpetual source of contention. While he was arguably the world's most visible and well-known Communist painter, Modotti felt that the Mexican government used Rivera cynically: "The reds say we are reactionaries, but look, we are letting Diego Rivera paint all the hammer and sickles he wants on public build-

ings!"[250] When he was offered—and accepted—the directorship of the San Carlos Academy, his integrity was utterly compromised in the eyes of his fellow Communists. Rivera was far too astute not to foresee the consequences of his action, and yet either felt himself to be above the fray or found this move a convenient means to free himself from the constraints of the party line. For Modotti, no such compromise was acceptable. Earlier in 1929, when offered the position of photographer of the National Museum she had turned down the honor, unwilling to work for the government that she believed to be complicit in Mella's murder.[251]

Living with the ever-present threat of deportation—her house was under surveillance by the police[252]—Modotti directed her anxiety into a powerful series of photographs of puppets. It is poetic justice that Modotti should end her photographic career in Mexico with the same subject she began it some seven years earlier. Yet how different the playfulness of that first photograph dubbed *My Latest Lover!* (figure 15) is from the photographs she made in response to the precarious situation in which she now found herself.[253] Now, the puppet manipulated from above had become a metaphor for the asymmetrical power relations between those governing and those governed, and, in many of the images, the puppeteer's hands and the strings from which the puppet dangles are all too clearly in evidence.

During 1929, Modotti had befriended a young artist from Chicago, Louis Bunin, who had written to Rivera asking if the master would accept him as an apprentice.[254] Rivera had responded favorably and Bunin went to work with Pablo O'Higgins on the National Palace murals. In addition to his duties for Rivera, Bunin began experimenting on his own, creating puppets and using them as a means of social commentary. Modotti and Bunin found that they shared an interest in the theater—Modotti had, after all, left a career of acting—and the art of political metaphor. In a country with widespread illiteracy and a tradition of handicrafts, the puppet theater appealed to them as an effective medium for conveying social and political messages. Throughout the fall, Modotti made photographs with Bunin, and their collaboration proved fruitful (plates 3 and 108–113).

Among Bunin's handmade marionettes were the cast of Eugene O'Neill's *The Hairy Ape* (1922), an acerbic, expressionistic play with a decidedly anti-bourgeois thrust. Elizabeth Morrow, wife of the American ambassador to Mexico, offered to fund Bunin's theater on the condition he abandon plans to produce *The Hairy Ape*. He refused and apparently found support for the production from writer and patron of the arts Antonieta Rivas Mercado. Some of the prints Modotti made relate directly to O'Neill's text and offer rather striking interpretations of the figure of Yank, the anti-hero of the play. In *Yank and Police Marionette* (plate 109), for example, the confines of a jail cell, one of the key metaphors of the play, is accomplished with a few rough charcoal lines drawn on the wall, and more innovatively, with dramatic shadows that suggest the bars of the prison. Modotti's high camera angle renders Yank more impotent, while the "empty" space above him contributes to the oppressiveness of his incarceration.

Bunin (and Modotti) were also capable of working on the lighter side. Although Morrow declined to support the O'Neill work, she did fund at least three performances of a less somber fare for diplomatic functions at the embassy. She arranged for spotlights and for the construction of an elaborate stage furnished with curtains and a backdrop. Bunin was less than enthusiastic about the "slap-stick vaudeville stuff" Morrow was willing to sponsor, but rose to the occasion (for a 300-peso fee) and created one of his most endearing puppets, a René d'Harnoncourt marionette, "monocle and all." D'Harnoncourt, who was to succeed Barr as director of the Museum of Modern Art in New York in 1949, arrived in Mexico from his native Austria in early 1926. There he supported himself as a free-lance artist, making tiny paintings for sale to tourists and decorating shop windows until he found a permanent job working for Frederick Davis at the Sonora News Company, a shop which was an important center for the exhibition and sale of Mexican folk art.[255] He had met Modotti during her travels with Weston in the summer of 1926, and they had remained on friendly terms. His graciousness endeared him to her and she in turn made two charming photographs of his "puppet," both of which appear to have been staged in Davis's shop. In one, d'Harnoncourt bows to the viewer, motioning to three *retablos* (plate 119). These small votive paintings would have been trophies of d'Harnoncourt's travels, like the toy bird crafted from a gourd in the pendent photograph.

The marionette photographs underline the enduring attraction to Modotti of an art that makes its point by metaphor and association rather than with dry facts or blunt propagandizing. As an artist, she hoped to awaken in the viewer a sense of class consciousness rather than deliver a lecture on dialectic materialism. This attitude is also evident in her assessment, rendered before Rivera's expulsion from the party, of Mexico's two greatest muralists: "Orozco's . . . things overflow with inner potentiality which one never feels in Diego's things. Diego comments too much, lately he paints detail with an irritating precision, he leaves nothing for one's imagination. With Orozco's things, you feel that you can begin where he leaves off, . . . he never says all he feels and knows . . . he just suggests."[256] Here, Modotti's art was fatally at odds with her politics, and she found herself recoiling from the narrow esthetics that the party line imposed at the very moment that her political allegiance to the party was becoming stronger.

Modotti knew that her departure from Mexico was inevitable and imminent, and she felt determined to present the work she had done there: "I am thinking strongly," she wrote in September, "to give an exhibit here in the near future, I feel that if I leave the country . . . [and] I feel pretty sure that ere long I will be going . . . I almost owe it to the country to show, not so much what I have done here, but especially *what can be done,* without recurring to colonial churches and charros and chinas poblanas."[257] (She was referring to the hackneyed objects, including men on horseback and Indian village girls, that were the conventional tourist souvenirs of a picturesque holiday in sunny Mexico.)

Modotti's first major one-person exhibition opened in Mexico City on December 3, 1929, in the vestibule of the

centrally located National Library to critical acclaim.[258] It was held under the auspices of the National University and arranged by her friends, painters Carlos Mérida and Carlos Orozco Romero. The opening reception included speeches, revolutionary songs sung by her friend Concha Michel, and a talk entitled "Photography and the New Sensibility." The daily hours were planned to accommodate those who would not otherwise be able to see the show because of work-related obligations. On the last day of the show, December 14, Siqueiros delivered a talk on "The First Revolutionary Photographic Exhibit in Mexico," which pleased Modotti by placing her work within the history of political art.[259]

In a flyer that accompanied the show, Modotti published her only statement on photography.[260] She conveys her self-image as a photographer and maps out what she hoped to achieve in the medium. She is quick to distinguish her work from photographs that use " 'artistic' effects," stating that she tries "to produce not art but honest photographs" that avoid "imitating other mediums of graphic expression." What she most values is the "photographic quality" of the medium, the camera's ability to record present reality, and she holds that photography is "the most eloquent, the most direct means for fixing, for registering the present epoch." Modotti does not engage in the argument of whether or not photography is a true art form; rather she sets out her criteria for what makes good photography: a practice which "accepts all the limitations inherent in the photographic technique and takes advantage of the possibilities and characteristics the medium offers." In this view, she was close to Weston.

Modotti's short essay ends, however, with a paragraph in which she alludes to the conflict between making art and making politics. The question she addresses is not posed from an esthetic point of view—can propaganda be art. Rather, she reverses the question—can art be revolutionary—and in this sense, she justifies her own art making by placing it in a Marxist framework: "Photography, precisely because it can only be produced in the present and because it is based on what exists objectively before the camera, takes its place as the most satisfactory medium for registering objective life in all its aspects, and from this comes its documental value. If to this is added sensibility and understanding and, above all, a clear orientation as to the place it should have in the field of historical development, I believe that the result is something worthy of a place in social production, to which we should all contribute."

Despite her notoriety and the political content of her work, the press treated the show with dignity and accorded Modotti a large measure of respect. Thus, it can only have been an utter shock to her that six weeks after the show closed, she was jailed and held incommunicado. The police used an attempt to assassinate the newly inaugurated president, Pascual Ortiz Rubio, as a convenient excuse to round up "enemies of the state" and Modotti was among them. She was frightened and had every reason to be. The physical discomforts of the notorious Lecumberri Penitenciaria, "an iron cot without mattress, an ill smelling toilet right in the cell, no electric light, and the food, well, the usual food of prisoners, I guess," (she wrote to a friend, hoping the letter might be smuggled out) were "nothing compared to my mental anguish in not knowing anything from the comrades." Modotti was concerned that her transfer from police headquarters to the prison had gone unnoticed and probably feared for her life. Though willing to endure this hardship, she hoped, at least, that her suffering could be used to help the cause: "I would like that it served something from the stand point of our propaganda."[261]

This letter and another, asking her American friend, Mary Doherty, to get in touch with a lawyer on her behalf, were intercepted. Their intended recipients never read them. Ironically, Modotti's desperate attempts to communicate reside in the collection of Mexico's National Archives, now housed in the very same jail from which they were written, a building renovated to hold the important papers of the state.

After two weeks in prison Modotti was released and given two days to pack her things and leave Mexico. She gave away what she could not take with her, which included some of her cameras. One made its way into the hands of Katherine Anne Porter, indirectly since Porter was not in Mexico when Modotti left.[262] Manuel Álvarez Bravo also is said to have been given a camera. When she had put her affairs in order as well as she could, the police escorted her to Veracruz and, on February 24, placed her on the cargo ship SS *Edam,* which was headed back to its home port in the Netherlands. A month and a half later she disembarked in Rotterdam only to find representatives from Italy eager to deliver her back to their fascist leaders. The Dutch branch of International Red Aid interceded on her behalf and Modotti was issued a visa to Berlin.

Germany may not have been her first choice of a place to relocate, but it presented certain advantages. Modotti had some command of the language (having lived seven youthful years in Austria), she had several friends and acquaintances who lived in Berlin (including Alfons Goldschmidt, who had since returned to Germany), and she had professional (and political) ties there, especially with Münzenberg and his publishing concerns. Modotti also arrived with some knowledge of the art scene: she was cognizant of the new vision photographers and the work of the Arbeiterfotograf movement; very likely she knew the work of leftist artists such as Käthe Kollwitz and George Grosz who had both been active in Münzenberg's Workers' International Relief since its founding. Although he was not a political artist, the still-life photographs of Albert Renger-Patzsch were also known to her.[263]

Once in Berlin, Modotti immediately set about finding a place to live and determining how best she could earn a living with photography.[264] Prospects were grim and she felt out of her element. She missed the bright sun of Mexico and bemoaned the cold, nasty weather, so unreliable for taking pictures. Modotti was also somewhat bewildered by the level of photographic sophistication in Germany and unsure of herself. She was keenly aware of the stiff competition from all sides, professionals and amateurs alike. "Here everybody uses a camera," she wrote, "and the workers themselves make those pictures and have indeed better opportunities than I could ever have, since it is their own life and problems they photograph."

Portraiture should have seemed a dependable source of income, yet Modotti hesitated because of the excellent quality of the work she saw, even in shop windows. She felt herself unfit for street photography and turned down the opportunity to do "reportage," believing she was not aggressive enough. Her methods of working were simply incompatible with the pace of Berlin.

By far the most serious impediment, however, was that European photographic supplies were manufactured to specifications that did not match her cameras. Modotti considered buying a Leica, the newly invented 35mm camera, and even tried one out, but found she could not get used to it. She does not seem to have used the one she eventually acquired.[265] Out on the street she felt conspicuous with her bulky Graflex, but the smaller camera did not suit the way she was "accustomed to work, slowly planning my composition, etc."

She did manage to produce a small body of work during her six months in Germany.[266] She made at least two photographs "on the street" but was forced to rethink her practice, both subject matter and strategy: with resourcefulness, she sought out sites where she could work unobtrusively. This is evident in *Couple at the Zoo, Berlin* (plate 116): the stout, bourgeois couple engrossed by a caged animal were completely unaware of her camera. Out on a public plaza, Modotti set her camera up as if her subject was a sculpture, and the passersby, in one case, a pair of nuns, paid no attention to her. The resulting images were ironic and humorous, but they lacked the incisiveness of Modotti's Mexican work.

Soon after she arrived, Modotti applied for and received membership in Unionfoto, a press agency, hoping to get some commissions. It is likely that Modotti made *Woman with Child* (plate 117), of a pregnant woman holding a child, for hire. Its forced reverence smacks of a formulaic approach that does not do her vision justice. Another commission, *Young Pioneers* (plate 118) appeared in the October 1930 issue of *AIZ* as the cover of an insert announcing a competition for children. Modotti's photograph had been cut into fourteen pieces: members of the Young Pioneers, a Communist youth group, were to piece the parts together like a jigsaw puzzle to win a prize. In the only known print, Modotti carefully touched up the badges so as to obscure the allegiance of the children, which explains why the children are often identified as Young Pioneers in Russia. No matter how good the cause, she can hardly have been pleased to see her photograph carved up in this manner.

Life in Germany was trying, and she wrote to Weston, "I often recall that wonderful line from Nietzsche you told me once: What does not kill me strengthens me. But I assure you this present period is very near killing me." With the rise of Hitler and the spread of fascism across Europe, Modotti's safety was still in question: she cautioned her correspondents not to put her name on the front of her letters, but to send them in care of another party member. Modotti was struggling to keep up her standards of photography, but even when she first arrived, she had resolved she would go where she could "be most useful to the movement" and now that appeared to be in Moscow. Before she left Berlin, Modotti hoped to have a small exhibit and the photographer Lotte

Jacobi offered her studio where she hung some of her work.[267]

Modotti arrived in Moscow in October 1930. Her experiences would have been similar to others who had come to "work for the Party." While the utopianism of the first five-year plan buoyed hope, the "rapid crystallization" of Stalinism cast a dark shadow over daily life in Moscow in the early part of the thirties. Modotti, used to a diverse cultural and intellectual life, found herself more and more restrained from uninhibited dealings with non-Communists. It was easier to restrict herself to a small circle of trusted friends. On the other hand, Moscow mirrored Mexico in some respects. Alfred Barr remarked that "only the superficials are modern, for the plumbing, heating, etc, are technically very crude and cheap, a comedy of the strong modern inclination without any technical tradition to satisfy it."[268]

When she arrived in Moscow Modotti still planned to continue with photography: an exhibition of her photographs of the November 7 celebrations marking the anniversary of the Bolshevik revolution was to have been held in New York in the winter of that year, but if they ever existed, the pictures are lost. Most artists were feeling the growing restrictions, however, and the obligation to propagandize grew more pressing. Modotti found this hard line impossible to reconcile with her ideals and decided to give up photography. The prospect of taking documentary photographs for the party must have been fearfully disheartening. Her cameras were virtually useless in Russia. Light, too, was a problem—Moscow, like Berlin, did not have enough sunlight.[269]

While Modotti pondered her future, she continued to receive international recognition for her Mexican work. In February 1930, examples of her work were scheduled to be included in the "All-American Photo Exhibit" held in New York and sponsored by the Workers Camera League. Later that year, in November, ten of her photographs appeared in the prestigious "Photography 1930," an exhibition of 170 works organized by Lincoln Kirstein and held at the Harvard Society for Contemporary Art in Cambridge. The brochure announced an upcoming Modotti exhibition at the Art Center in New York, which had been in the works since August, but it is not clear that this show took place. The astute, if left-leaning, film and photography critic Harry Alan Potamkin (who died prematurely at the age of thirty-three in 1933) understood her work to be an important aspect of modern photography. In his 1931 essay, "New Eyes, New Compositions, New Conscience," he placed Modotti in the context of the new photography. The momentum of her reputation made itself felt even two years after she ended her artistic career when her work was included in the exhibition "International Photographers" mounted by the Brooklyn Museum.[270]

In Moscow, Modotti gave up photography in order to devote herself completely to the party. She spent the next few years working in the headquarters of the MOPR, run then by Elena Stassova who had taken over from Clara Zetkin. Her facility with languages and her familiarity with the organization made Modotti invaluable. It is possible that during this time she was recruited as an agent

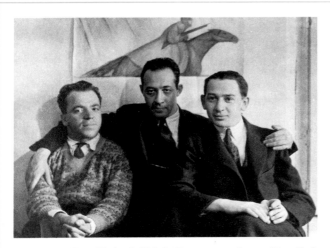

Figure 29 Tina Modotti. *Vidali, Freeman, and an unidentified man.* 1929. Joseph Freeman Collection/Hoover Institute Archives

for the GPU, Stalin's secret police, and that she was sent on missions out of the country.[271] This conjecture is strengthened by her close association with Vittorio Vidali, a fellow Italian, whom she first met in Mexico (figure 29). During her time in Russia, she and Vidali became an acknowledged couple and remained so until Modotti's death in 1942. Vidali had many of the same characteristics of her previous companions: although lacking classical good looks, he was extremely charismatic and was possessed early in life by a passion for political action and a talent for survival. He, like the other men Modotti was close to (except Weston), had several pseudonyms: in the United States, where he had lived before moving to Mexico, he was known as Enea Sormenti, and in Mexico he was known as Carlos and Jorge Contreras. Whether it was love that drew them together initially, or a shared past, or indeed, their ability to communicate in the dialect of northern Italy, their alliance was both a source of security and sometimes pain for both.

For the next ten years Modotti and Vidali carried out several missions together on behalf of International Red Aid. They administered the Parisian office of the Secours Rouge (as the IRA was called in France) in 1933 and 1934. Their activities in France included aid work, organizing, and publicizing the plight of political prisoners, as well as clandestine tasks that proved more risky. In 1935 they returned to Moscow and by early 1936 they were in Spain and ostensibly working for the IRA. Each took a nom de guerre: Vidali rose quickly in the Communist ranks and was known as Commandant Carlos, the fearless and ruthless head of the Fifth Regiment. Modotti became simply María. No last name, no specific country, and unavoidable allusions to biblical ancestors. She was remembered for her work in hospitals and shepherding orphans to safe houses.

After the fall of Madrid in 1939, Modotti escaped over the Pyrenées and obtained a ticket to New York aboard the *Queen Mary.* She traveled with a Spanish passport under the name Carmen Ruíz Sánchez. When she arrived on April 6, 1939, she was detained for six days by United States immigration officials who suspected that her documents were not quite in order. They refused her entry. On April 13, she was put on the ship *Siboney* bound for Mexico. Modotti became one of the forty thousand Republican refugees of the Spanish Civil War who flooded into Mexico, where they found asylum.[272] It was with people who had shared her experiences in Spain that Modotti associated during her last few years: few of the many friends she had made before her deportation even knew she was back. Known simply as María, she was *persona non grata* in the country where she had lived longer than anywhere else. In March 1941, she applied for and was granted political asylum in Mexico and reclaimed her name. Tina Modotti died less than a year after her pardon, late on the evening of January 5, 1942, while traveling in a taxi in Mexico City.

An homage organized by Spanish refugees was held at the end of February.[273] A pamphlet was published for the occasion and the speakers commemorated their comrade who had fought fascism and on behalf of the disenfranchised for her adult life.[274] Two months after Modotti's death, she was honored as an artist with an exhibition at the now flourishing Galería de Arte Mexicano (founded by Carolina Amor de Fournier, whose portrait Modotti had taken some dozen years before). Forty-nine of her photographs were displayed.[275] They had been borrowed from, among others, artists Manuel and Lola Álvarez Bravo, Adolfo Best Maugard, Miguel Covarrubias, Leopoldo Mendez, Carlos Orozco Romero, Manuel Rodríquez Lozano, and Salvador Novo. It was the last major exhibition of her work held in a metropolitan center until New York's Museum of Modern Art mounted an exhibition in 1977.

According to Modotti's death certificate, she died of congestive heart failure, a diagnosis some have questioned.[276] Indeed, almost every item on the *acto de defuncion* is incorrect. Her occupation at the time of her death is given as "housewife."[277]

Who was Tina Modotti? It is a question often asked; the answer is elusive. Modotti held to no one career, she remained only briefly in the many countries where she lived, and her facility for languages made her truly an international person. Modotti had come to represent many things, and in a curious way, her identity is often a projection of the viewer's wants and needs, just as artistic likenesses of her are. How did Modotti see herself? This question might be partially answered by her self-portrait: among the photographs included at her homage, one, now missing, was identified as a self-portrait. It is intriguing to wonder how Modotti may have conceived her self-image.

Modotti will be known through her photographs of Mexico. She depicted the face of a country whose crusade for progressive social change became her own, and she brought an international standard of art practice to bear on her subject—the unfulfilled promises made by the revolutionary government. Modotti's deportation is proof enough that her images had hit their intended mark. Her legacy is the synthesis of modernist photographic esthetic with Mexican culture, a synthesis that had become characteristic of photography in that country.

Plates

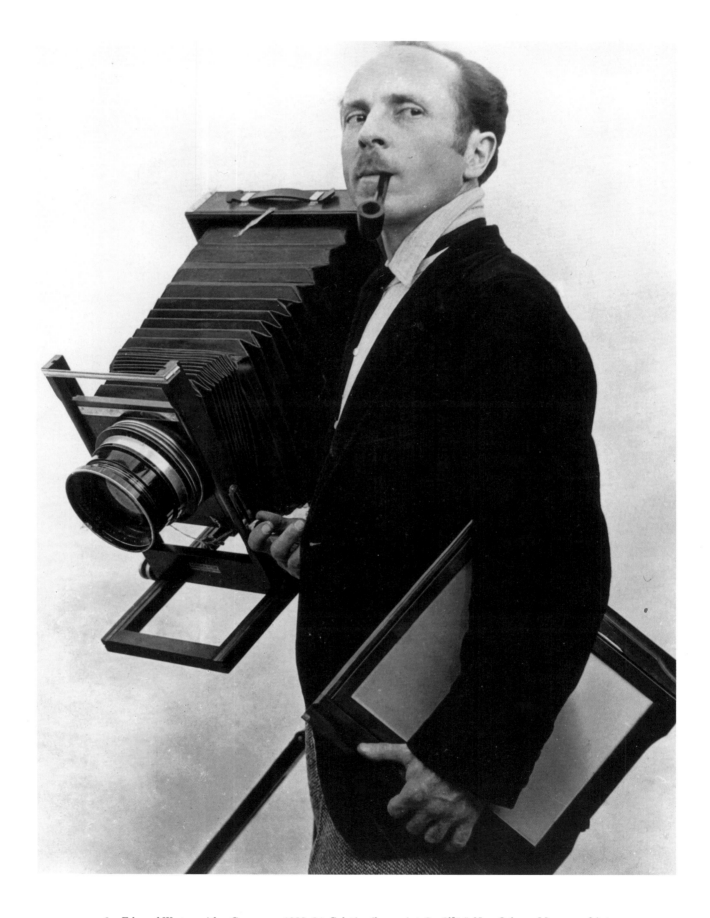

6 *Edward Weston with a Camera.* c. 1923–24. Gelatin silver print, 9 x 6¹³⁄₁₆". New Orleans Museum of Art: Museum Purchase: Women's Volunteer Committee Funds

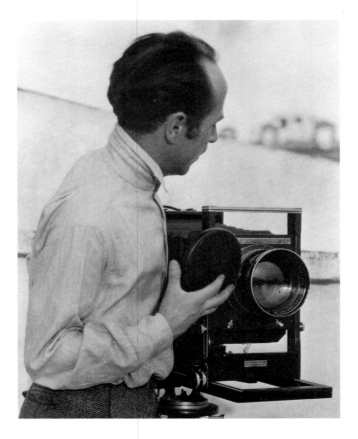

7 *Edward Weston.* 1924. Gelatin silver print, 4¼ x 3⅜″. The Keith Fishman Collection

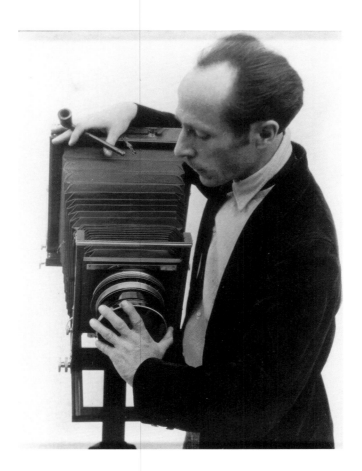

8 *Edward Weston.* 1924. Gelatin silver print, 5 x 4″. Collection Mr. and Mrs. Steven H. Hammer, Los Angeles

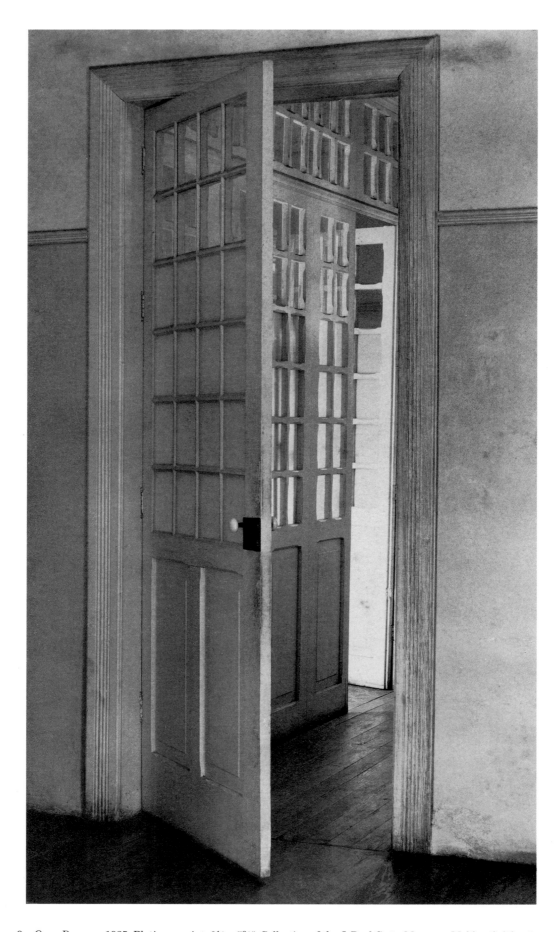

9 *Open Doors.* c. 1925. Platinum print, 9½ x 5⅜″. Collection of the J. Paul Getty Museum, Malibu, California

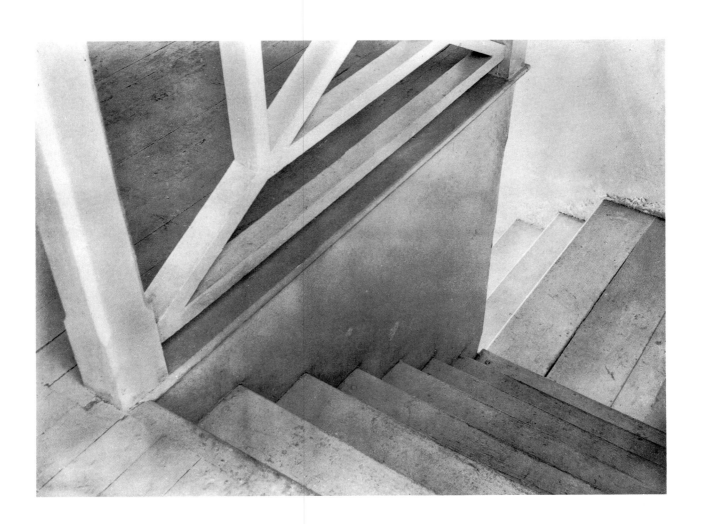

10 *Staircase.* c. 1924–26. Gelatin silver print, 7³⁄₁₆ x 9⁵⁄₁₆″. The Museum of Modern Art, New York. Anonymous gift

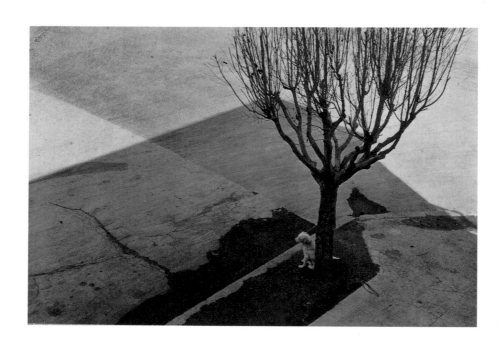

11 *Tree and Shadows* or *Tree with Dog*. 1924. Platinum print, 3¼ x 4¹¹⁄₁₆″. Collection of the J. Paul Getty Museum, Malibu, California

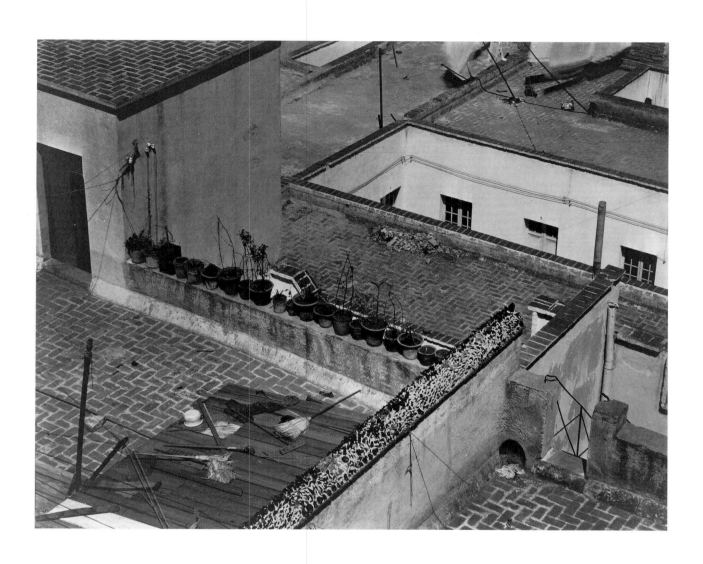

12 *View of Housetops.* n.d. Gelatin silver print, 7½ x 9⁷⁄₁₆″. The Museum of Modern Art, New York. Anonymous gift

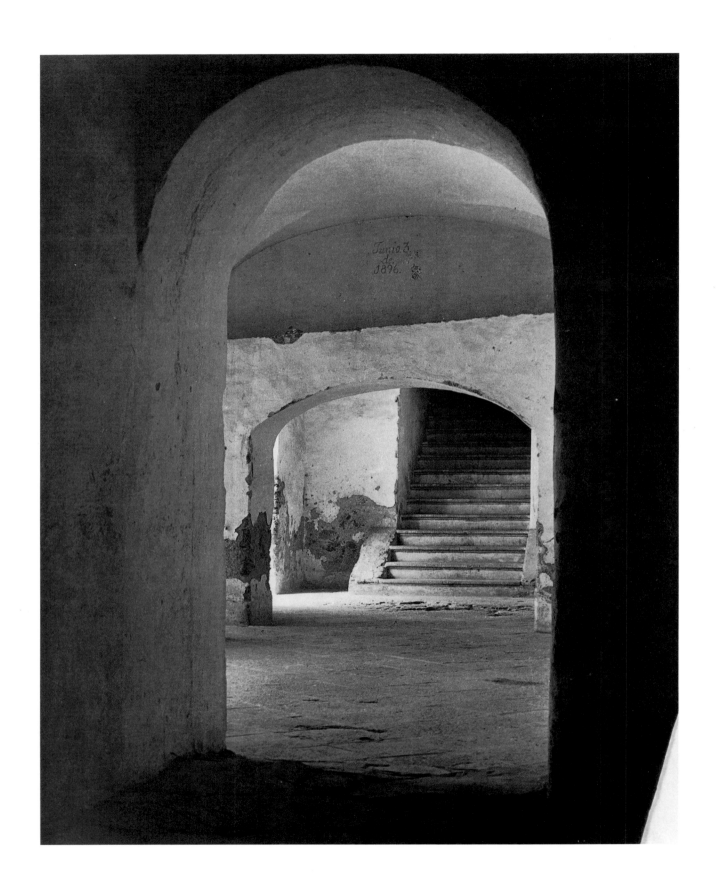

13　*Convent of Tepotzotlán (Stairs Through Arches)*. 1924. Gelatin silver print, 8¹³⁄₁₆ x 6¾″. The Museum of Modern Art, New York. Anonymous gift

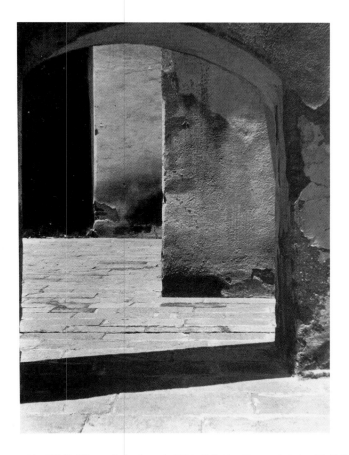

14 *Convent of Tepotzotlán (Walls Through Archway).* 1924. Gelatin silver print, 4 x 3″. Collection Sam Merrin

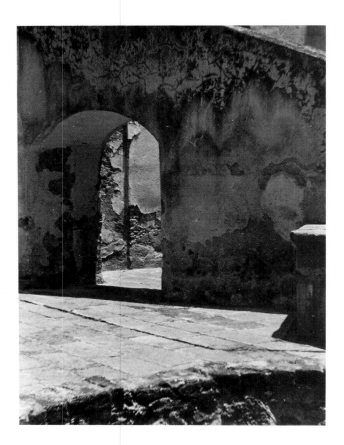

15 *Arch, Wall, and Fountain.* 1924. Gelatin silver print, 3½ x 3″. Collection Sam Merrin

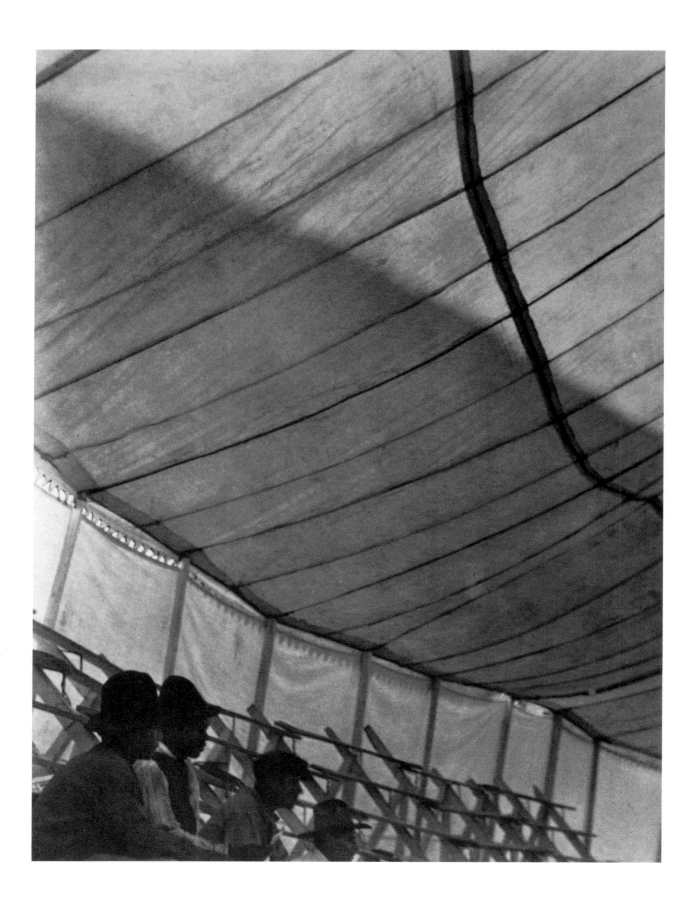

16 *Circus Tent, Mexico.* 1924. Platinum print, 9³⁄₁₆ x 6¹⁵⁄₁₆″. Collection of the Center for Creative Photography

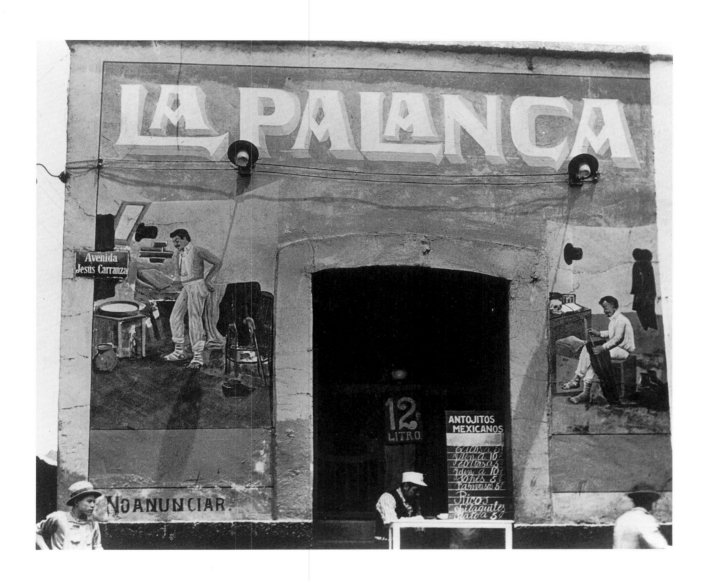

17 *Exterior of Pulquería.* c. 1926. Gelatin silver print, 7½ x 8½″. The Museum of Modern Art, New York. Anonymous gift

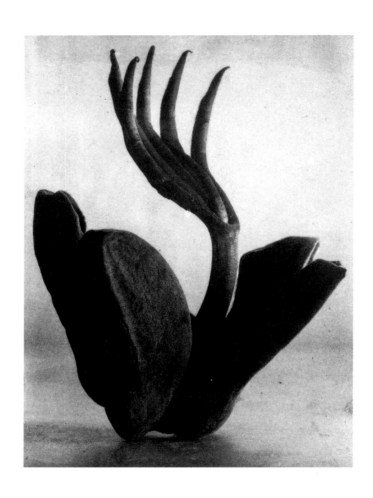

18 *Flor de manita* or *El Manito*. 1925. Platinum print, 4¹¹⁄₁₆ x 3½″. National Gallery of Canada, Ottawa.
Purchased from the Phyllis Lambert Fund, 1979

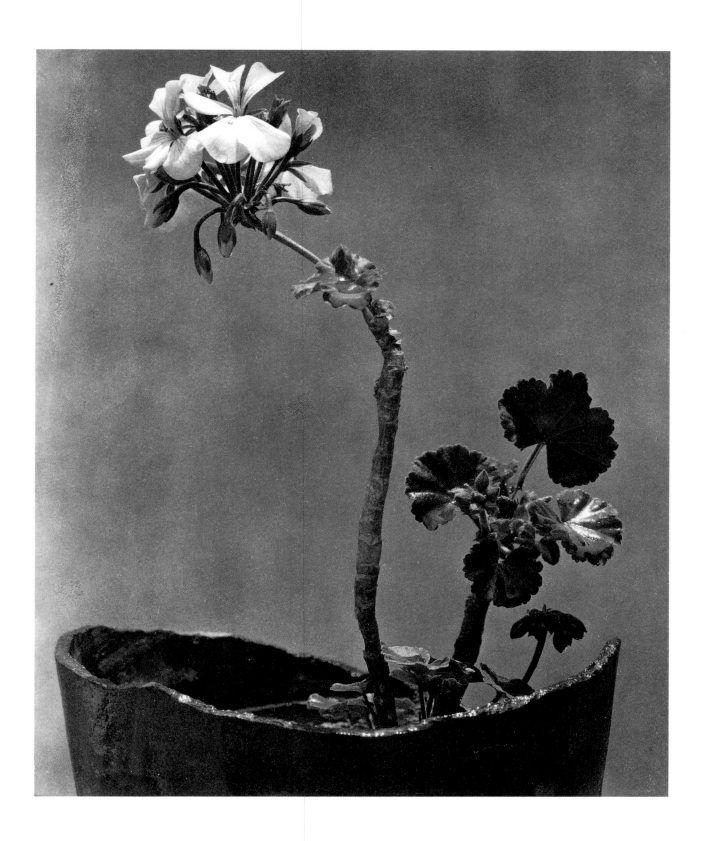

19 *Geranium*. c. 1924–25. Gelatin silver print, 9¼ x 7½″. Private collection

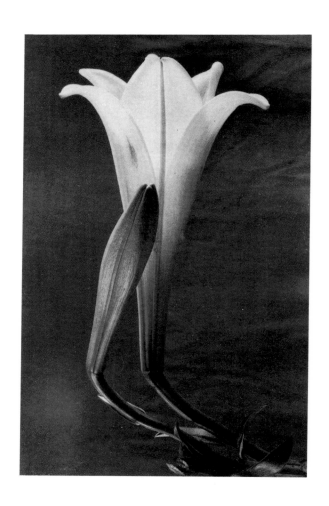

20 *Easter Lily and Bud.* c. 1925. Platinum print, 4⅝ x 3″. Private collection

21 *Nopal Cactus.* 1925. Gelatin silver print, 8⅞ x 6⅜″. The Museum of Modern Art, New York. Anonymous gift

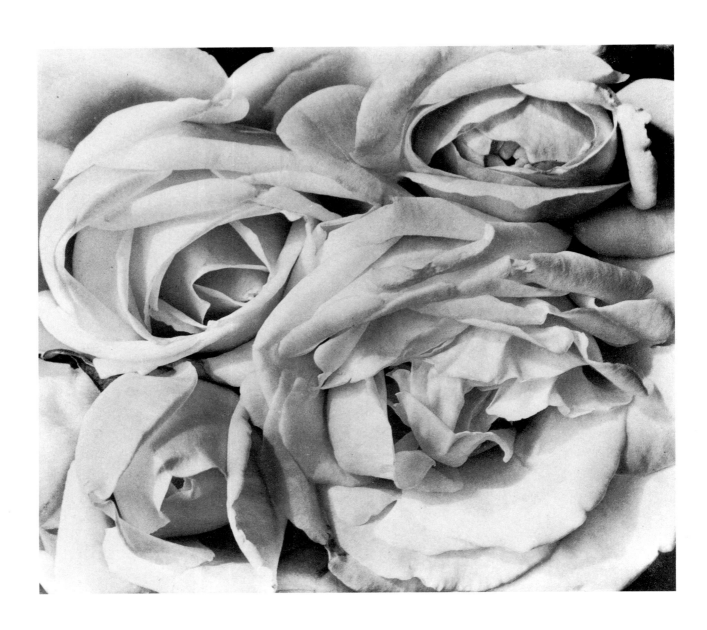

22 *Roses.* 1924. Platinum print, 7⅜ x 8⅜″. Private collection, San Francisco

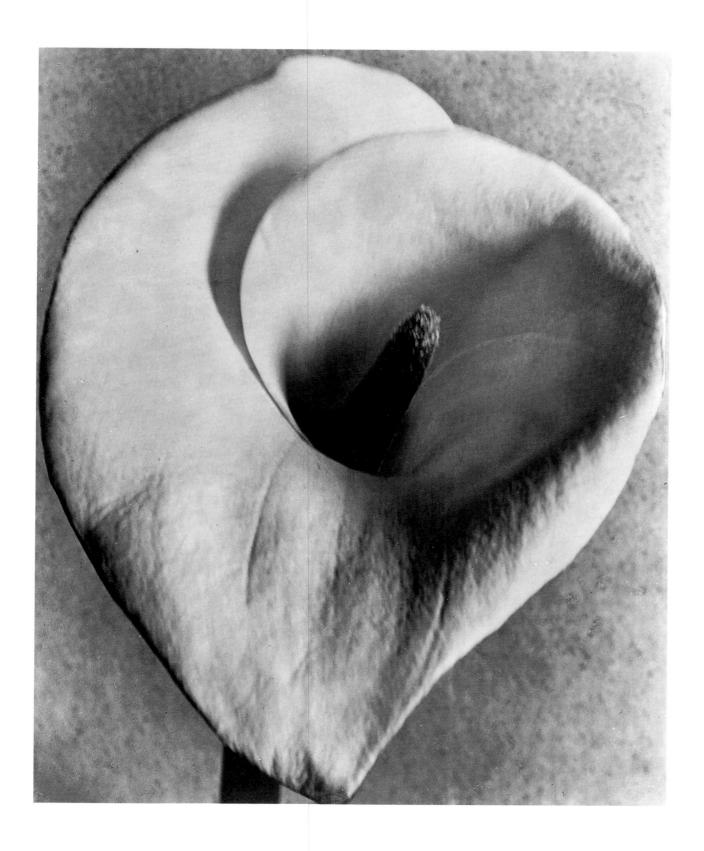

23 *Calla Lily.* 1924–26. Gelatin silver print, 8⅝ x 7¼″. The Museum of Modern Art, New York. Anonymous gift

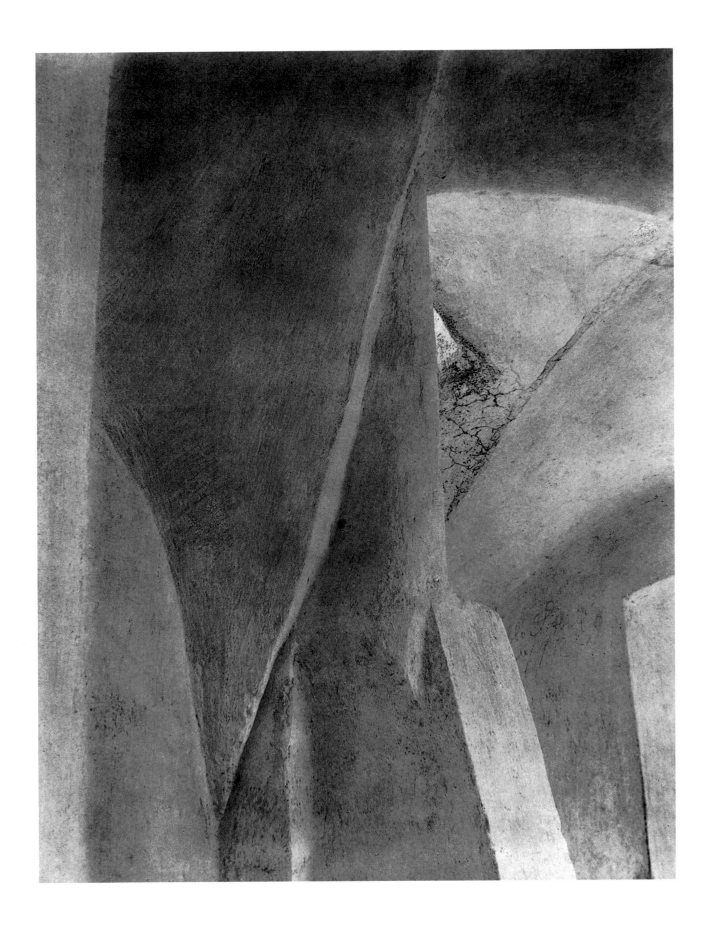

24 *Interior of Church*. 1924. Platinum print, 9 x 6⅝″. Page Imageworks: Tony and Merrily Page

25 *Experiment in Related Form* or *Glasses*. 1924. Platinum print, 7 x 9⅜". Mills College Art Gallery: Gift of the Artist

26 *Abstract: Crumpled Tinfoil*. c. 1926. Platinum print, 9¼ x 6¹⁵⁄₁₆″. Instituto Nacional de Bellas Artes/Museo de Arte Moderno, Mexico City

27 *Sugar Cane*. 1929. Gelatin silver print, 9½ x 7⁵⁄₁₆″. Instituto Nacional de Bellas Artes/Museo de Arte Moderno, Mexico City

28 *Telephone Wires, Mexico.* 1925. Platinum print, 9 x 6⅜″. The Baltimore Museum of Art: Purchase with exchange funds
from the Edward Joseph Gallagher III Memorial Collection; and partial gift of George H. Dalsheimer, Baltimore

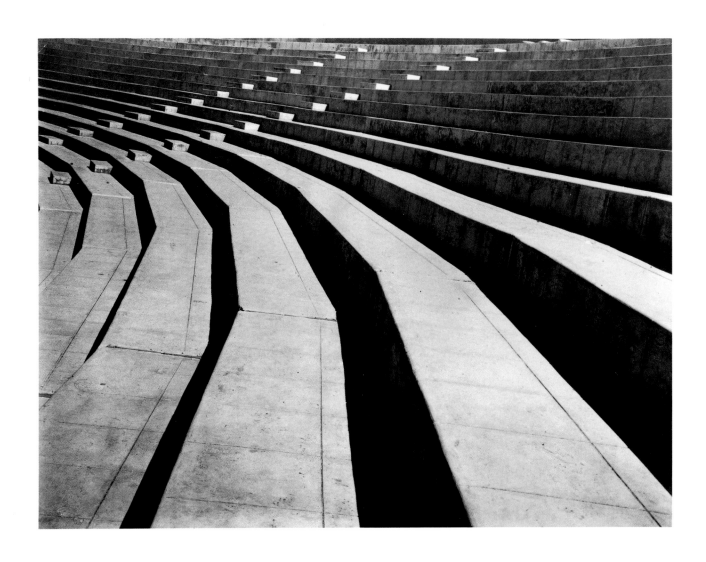

29 *Stadium, Mexico City.* c. 1927. Gelatin silver print, 7½ x 9½″. Collection Quillan Company. Courtesy of Jill Quasha

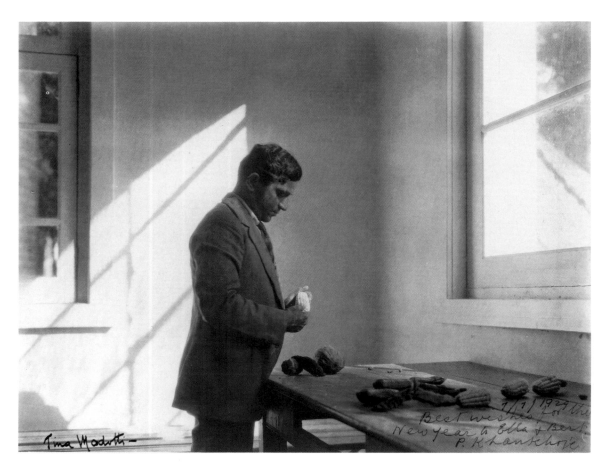

30　*P. Kahn Khoje.* c. 1923–24. Gelatin silver print, 7½ x 9½″. The Sandor Family Collection

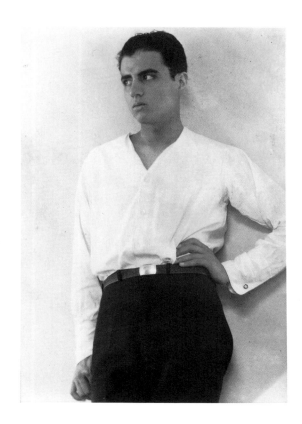

31　*Federico Marín.* 1924. Platinum print, 4⅝ x 3⅛″. Collection of the J. Paul Getty Museum, Malibu, California

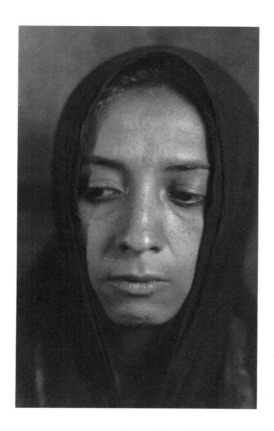

32 *Elisa.* c. 1926–28. Gelatin silver print, 4¹³⁄₁₆ x 2¹⁵⁄₁₆″. Collection of the George Eastman House

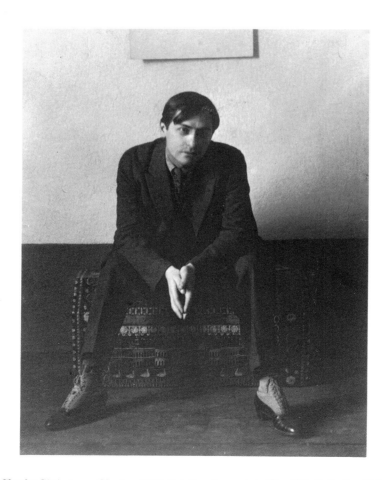

33 *Jean Charlot Sitting on a Chest.* c. 1923. Gelatin silver print, 4⅝ x 3⅝″. Collection Zohmah Charlot

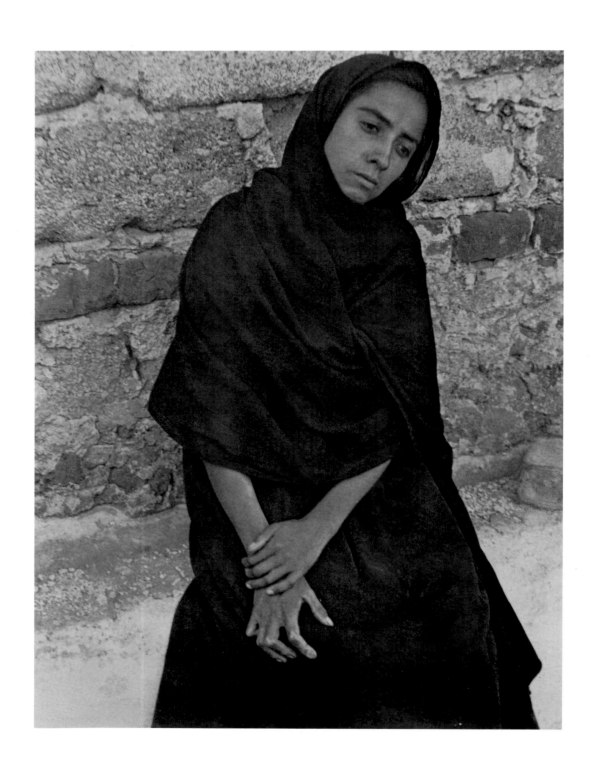

34 *Elisa Kneeling.* 1924. Platinum print, 8⅞ x 6¾". The Museum of Modern Art, New York. Gift of Edward Weston

35 *Pacheco Painting a Mural*. 1927. Gelatin silver print, 6⅝ x 9½″. Anita Brenner Estate

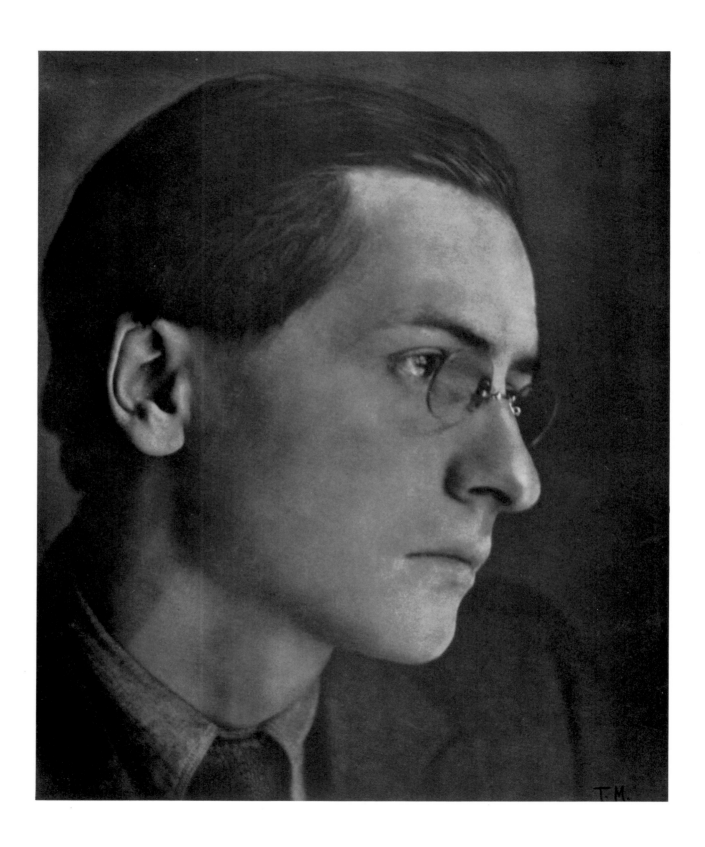

36　*Jean Charlot.* 1924. Platinum print, 9 x 7⅜″. Collection of the J. Paul Getty Museum, Malibu, California

37 *Carleton Beals.* 1924. Gelatin silver print, 9 x 7¼″. Carleton Beals Collection. Boston University Libraries

38 *Moises Saenz.* c. 1926–29. Gelatin silver print, 3¾ x 2⅝″. Private collection

39 *Portrait of a Woman.* c. 1926–29. Gelatin silver print, 9¹¹⁄₁₆ x 7⁵⁄₁₆″. Private collection, La Jolla, California

40 *Ramon de Negri*. c. 1926–29. Gelatin silver print, 9³⁄₁₆ x 7⅛″. Private collection, La Jolla, California

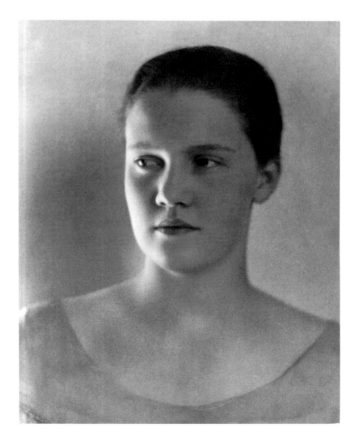

41 *María Orozco Romero*. c. 1925–26. Gelatin silver print, 9⁹⁄₁₆ x 7⁹⁄₁₆″. Private collection, La Jolla, California

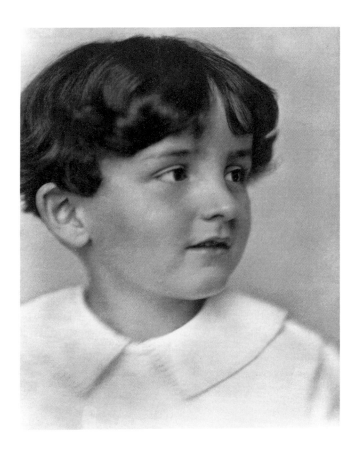

42 *Portrait of a Child.* c. 1926–29. Gelatin silver print, 9⁷⁄₁₆ x 7⅜″. Private collection, La Jolla, California

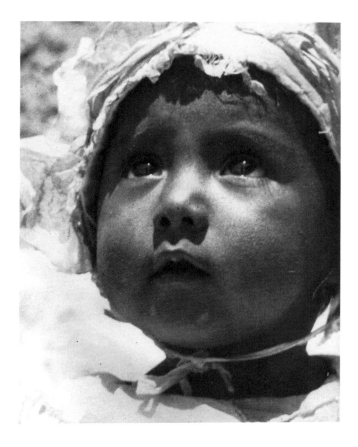

43 *Baby—Lupe Rivera Marín.* c. 1926. Gelatin silver print, 7⅝ x 6⅜″. Collection Mildred Constantine, New York

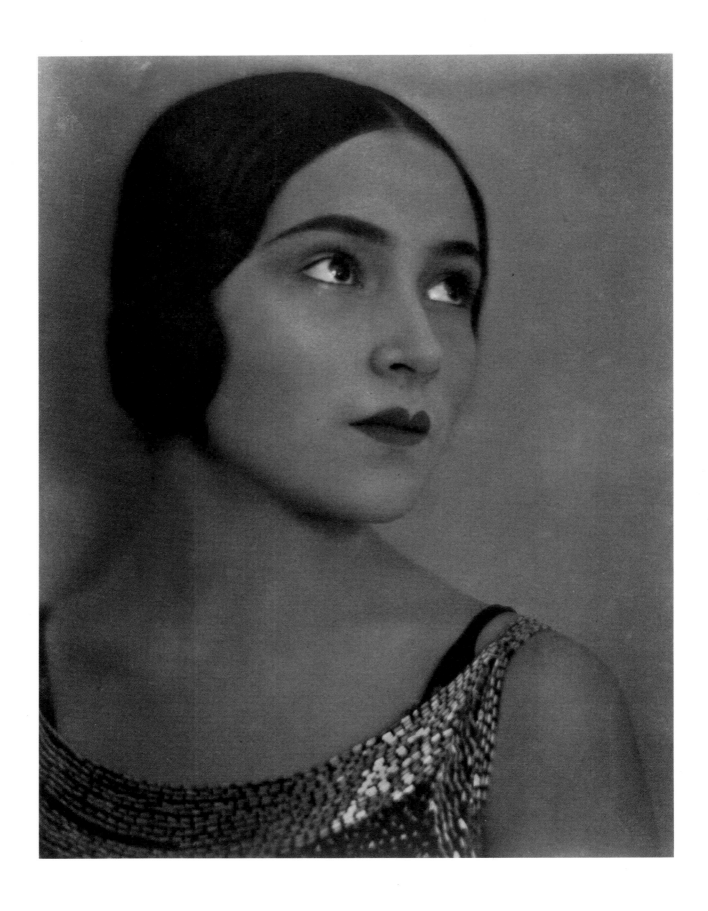

44 *Dolores del Rio.* 1925. Platinum print, 9¼ x 7⅛″. Private collection

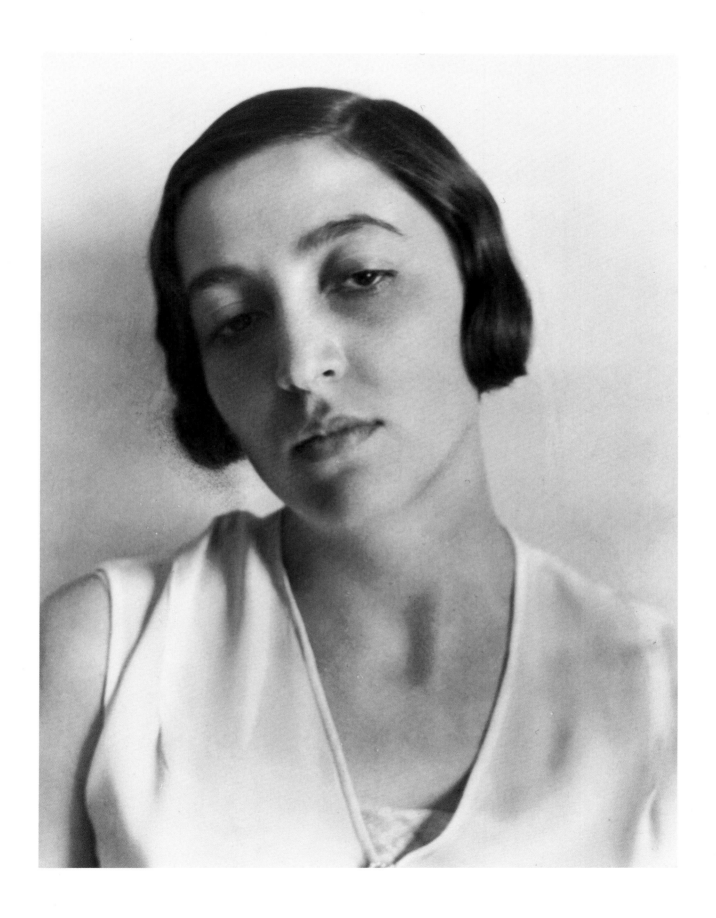

45 *Carolina Amor de Fournier.* c. 1929. Gelatin silver print, 9⁷⁄₁₆ x 7⁹⁄₁₆″. Collection Mariana Pérez Amor

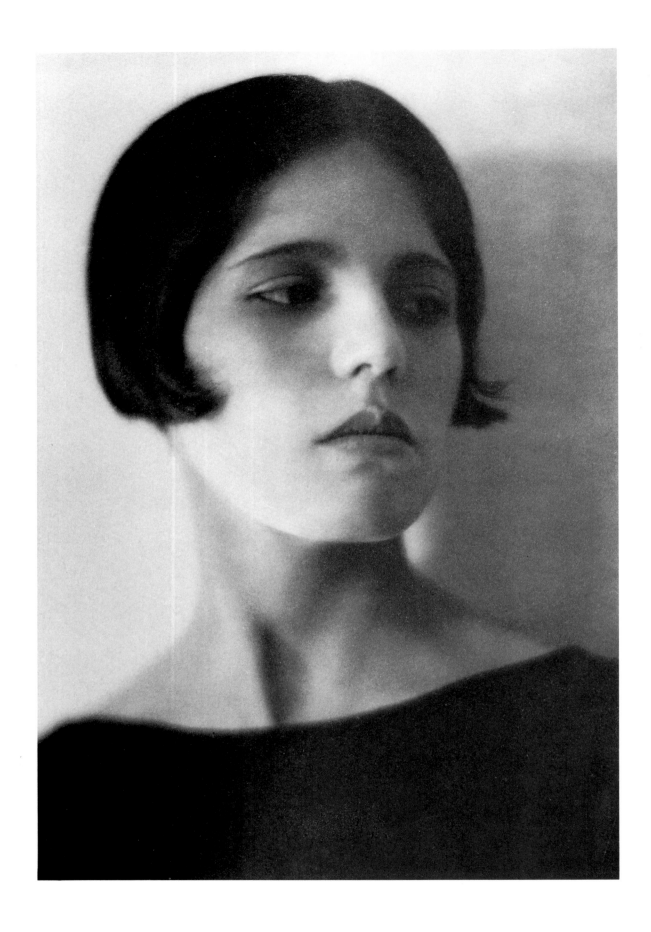

46 *María Marín de Orozco.* c. 1925. Platinum print, 9⅜ x 6½″. Ava Vargas Photographic Works

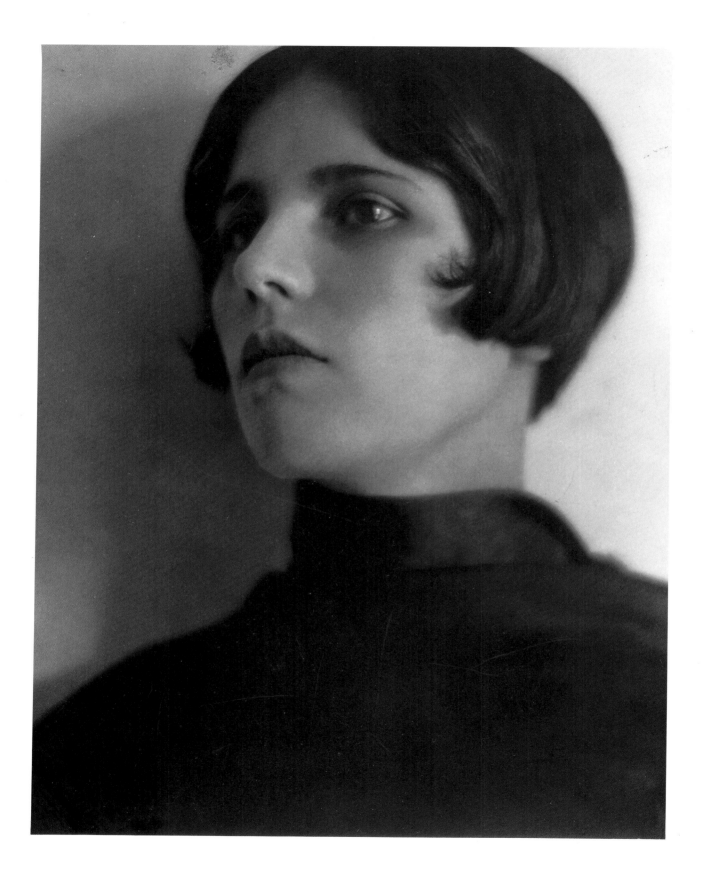

47 *María Marín de Orozco.* c. 1925. Platinum print, 8⁷⁄₁₆ x 7⅜″. Collection Thomas Walther, New York

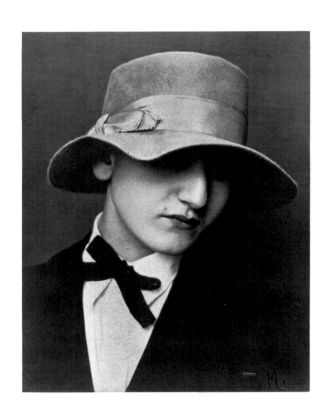

48 *Anita Brenner.* c. 1925–26. Gelatin silver print, 3¾ x 3″. Anita Brenner Estate

49 *Federico Marín.* 1926. Gelatin silver print, 9⁷⁄₁₆ x 7¹¹⁄₁₆″. Michael G. Wilson Collection, London

50 *Ione Robinson.* 1929. Gelatin silver print, 9 x 7¼″. Stephen Daiter Photography

51 *Portrait of Ione Robinson, Writer.* 1929. Gelatin silver print, 7⅝ x 6⁷⁄₁₆″. National Gallery of Australia, Canberra

52 *Portrait of a Woman, Looking Down.* c. 1927–29. Gelatin silver print, 3 x 2″. Private collection, La Jolla, California

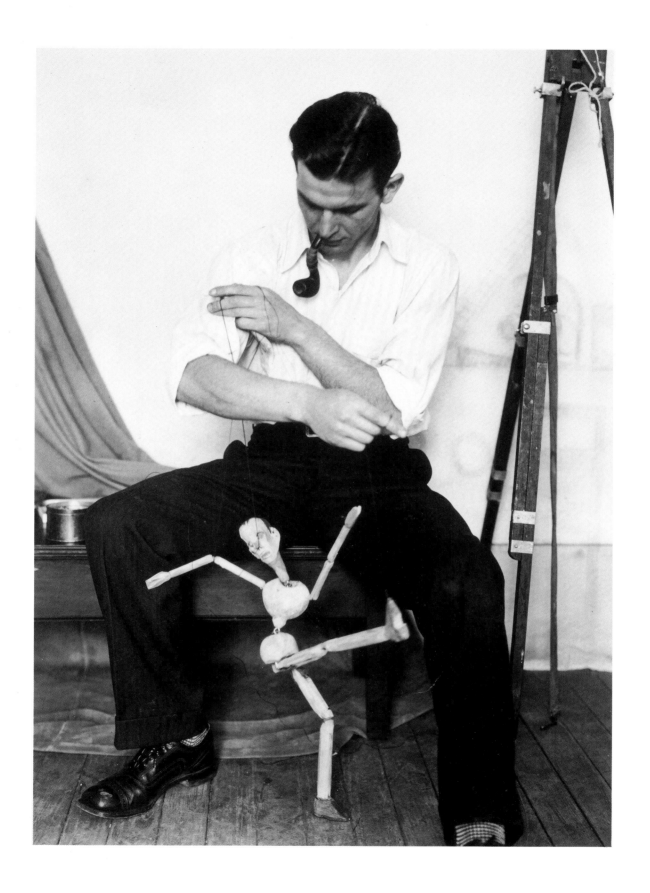

53 *Louis Bunin with Dancing Puppet.* 1929. Gelatin silver print, 9½ x 6½″. Throckmorton Fine Art, Inc., New York

54 *Piñatas.* c. 1926. Gelatin silver print, 3¹⁵⁄₁₆ x 3″. Collection of the George Eastman House

55 *Piñatas.* c. 1926. Gelatin silver print, 3⅞ x 2¹⁵⁄₁₆″. Collection of the George Eastman House

56 *Little Mule.* c. 1927. Gelatin silver print, 7½ x 8½". Ava Vargas Photographic Works

57 *Four Birds.* c. 1927. Gelatin silver print, 7½ x 9½". Museum of New Mexico Collections, Museum of International Folk Art, Santa Fe:
Gift of Mrs. René d'Harnoncourt

58 *Flagellation of Christ.* 1925–27. Gelatin silver print, 7½ x 9½″. The Museum of Modern Art, New York. Purchase

59 *Head of Christ.* c. 1925–27. Gelatin silver print, 9⅜ x 5⅜″. The Museum of Modern Art, New York. Purchase

60 *Mask on Petate.* c. 1929. Gelatin silver print, 9⅜ x 7⅜″. Throckmorton Fine Art, Inc., New York

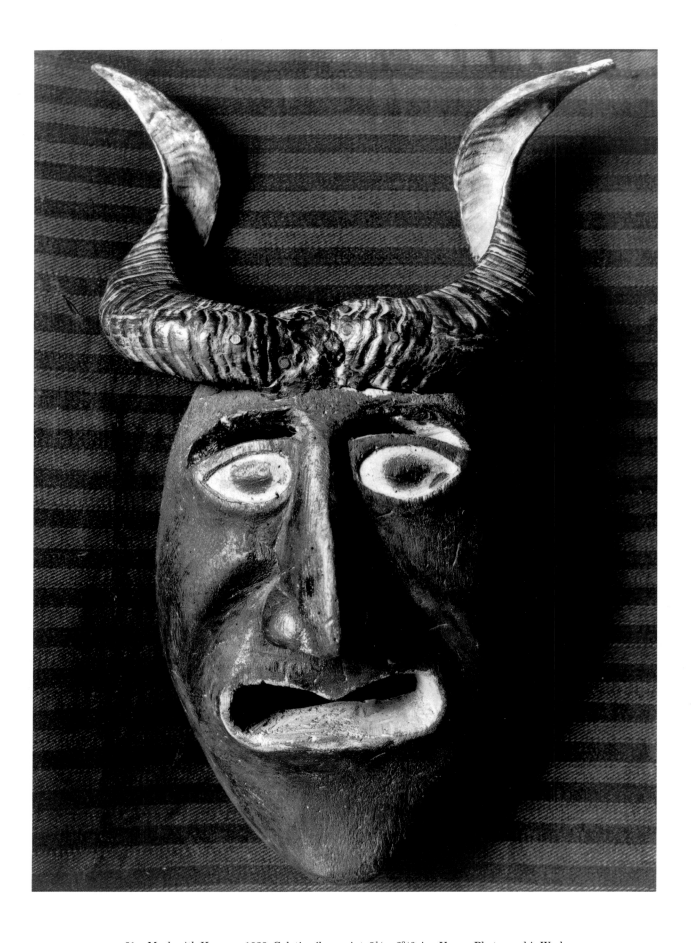

61 *Mask with Horns.* c. 1929. Gelatin silver print, 9¼ x 6¾″. Ava Vargas Photographic Works

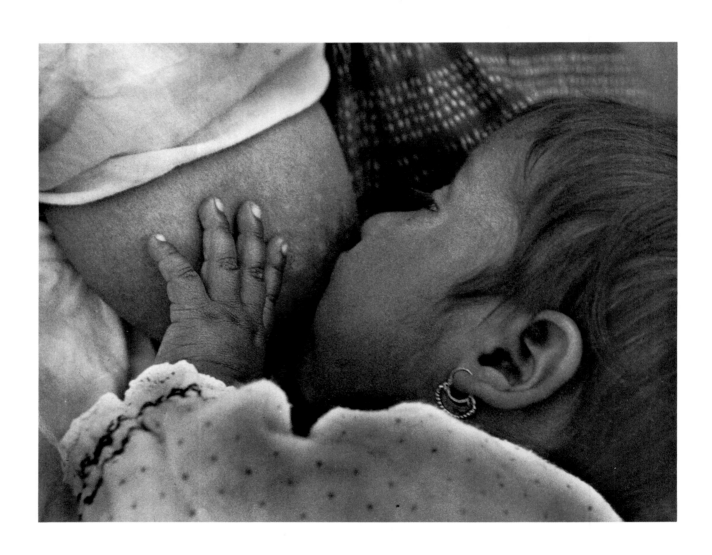

62 *Baby Nursing.* c. 1926–27. Gelatin silver print, 7¼ x 9⅛″. The Museum of Modern Art, New York. Anonymous Gift

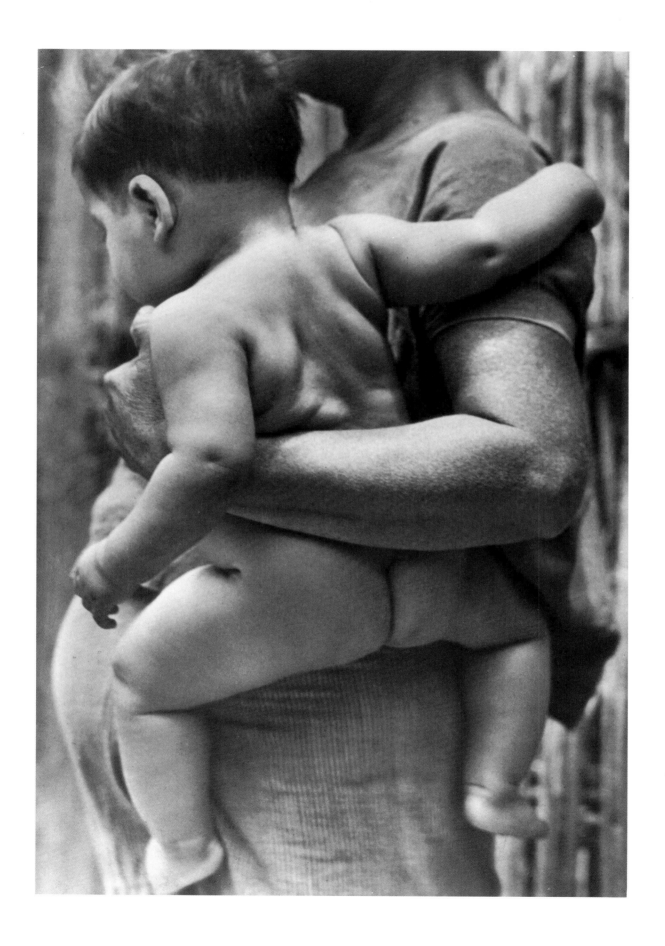

63 *Mother and Child, Tehuantepec.* c. 1929. Gelatin silver print, 8¹⁵⁄₁₆ x 6⅛″. Philadelphia Museum of Art: Gift of Mr. and Mrs. Carl Zigrosser

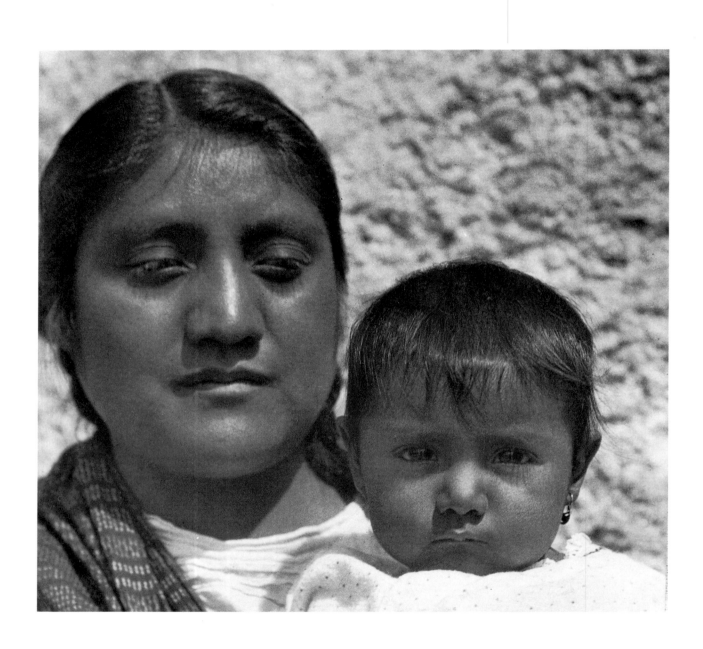

64　*An Aztec Mother.* c. 1926–27. Gelatin silver print, 7¼ x 7½". The Museum of Modern Art, New York. Anonymous gift

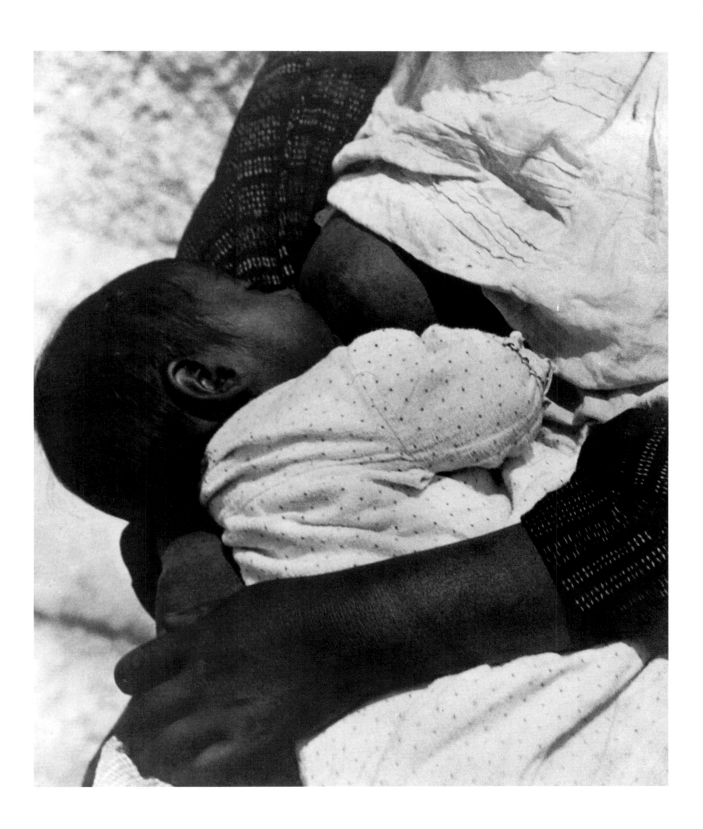

65 *An Aztec Baby.* c. 1926–27. Gelatin silver print, 8¼ x 7″. Private collection

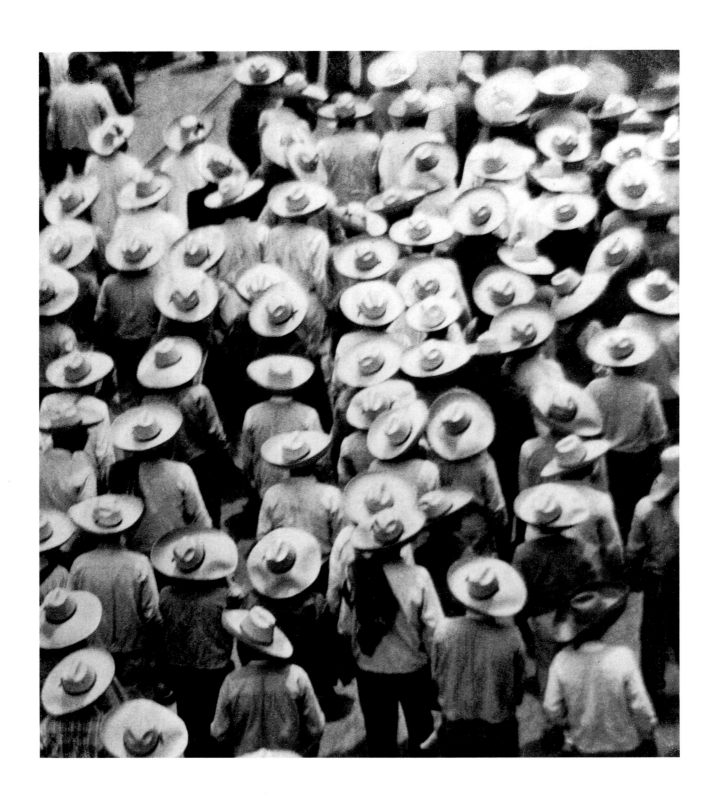

66　*Workers Parade.* 1926. Platinum print, 8⅜ x 7⅜″. Private collection, San Francisco

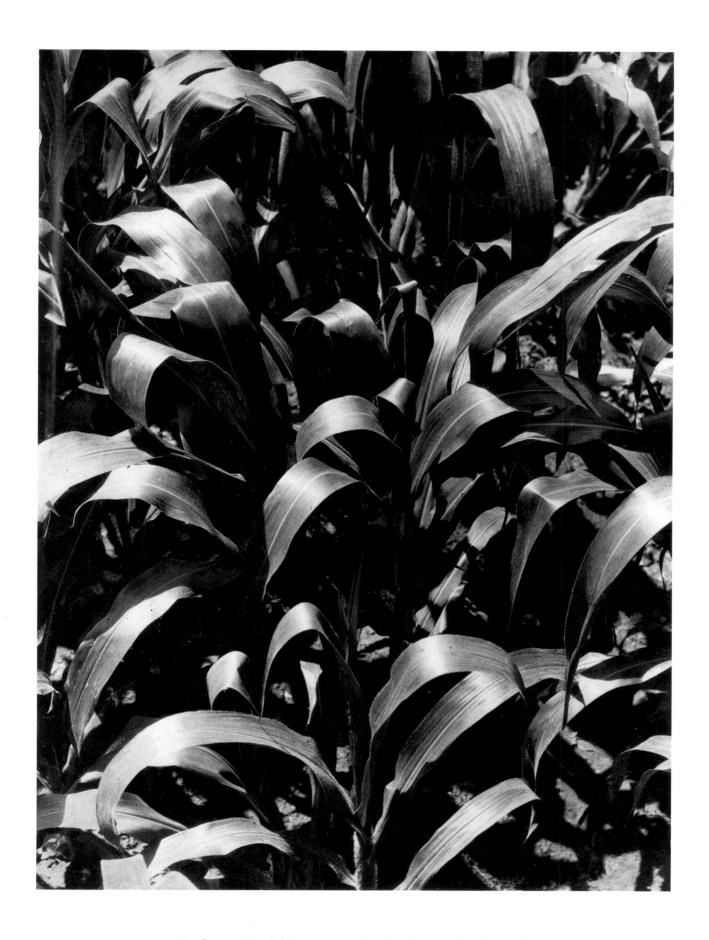

67 *Corn.* c. 1929. Gelatin silver print, 9 x 6⅝″. Collection Gary Wolkowitz

68 *Hammer and Sickle.* 1927. Gelatin silver print, 7³⁄₁₆ x 8⁹⁄₁₆″. Private collection, La Jolla, California

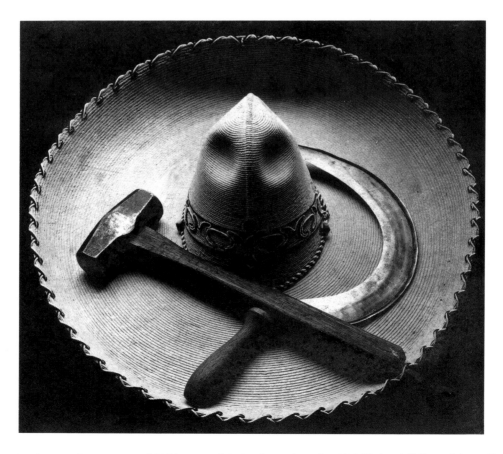

69 *Mexican Sombrero with Hammer and Sickle.* 1927. Gelatin silver print, 7⁵⁄₈ x 8½″. National Gallery of Australia, Canberra

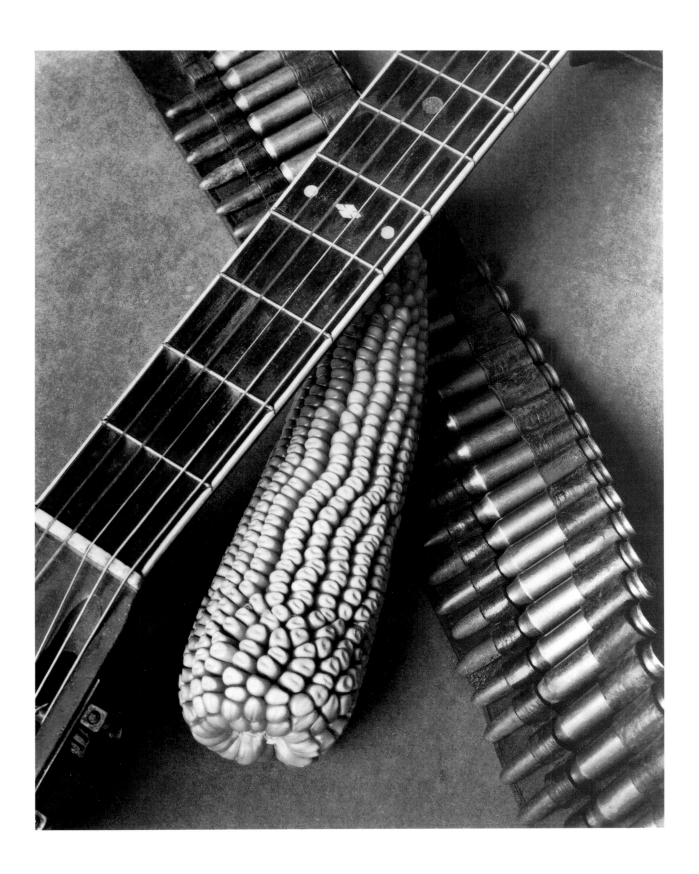

70 *Bandolier, Corn, Guitar.* 1927. Gelatin silver print, 9½ x 7½″. Collection Thomas Walther, New York

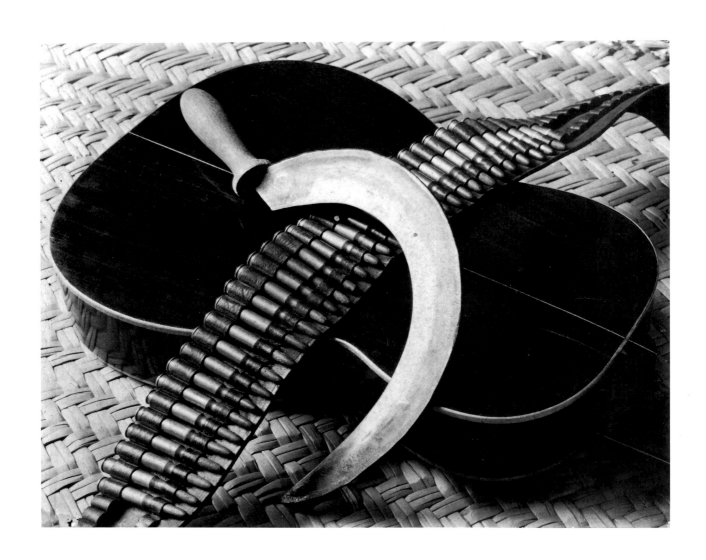

71 *Sickle, Bandolier, Guitar.* 1927. Gelatin silver print, 7⁹⁄₁₆ x 9½″. Bokelberg Collection

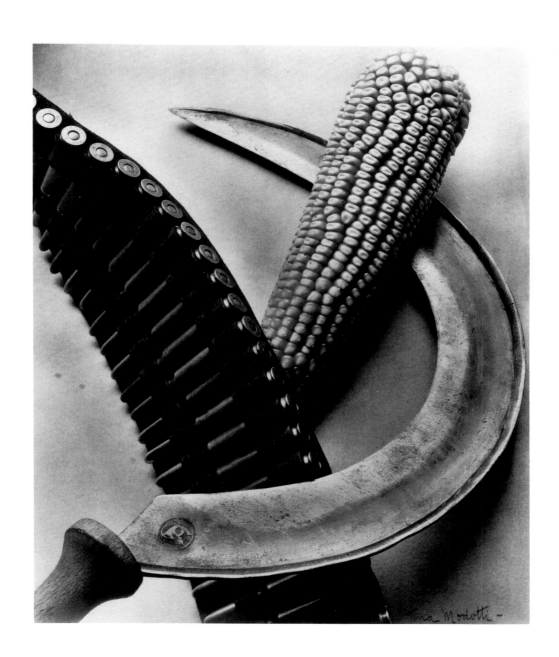

72 *Bandolier, Corn, Sickle.* 1927. Gelatin silver print, 8¾ x 7½″. The Manfred Heiting Collection, Amsterdam

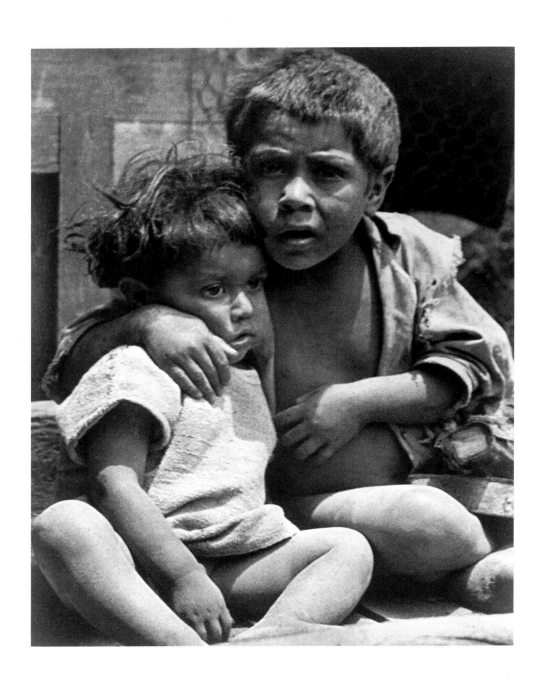

73 *Two Children* or *Boys from Colonia de la Bolsa*. c. 1927–28. Gelatin silver print, 8½ x 6½″. Private collection. Courtesy of William L. Schaeffer

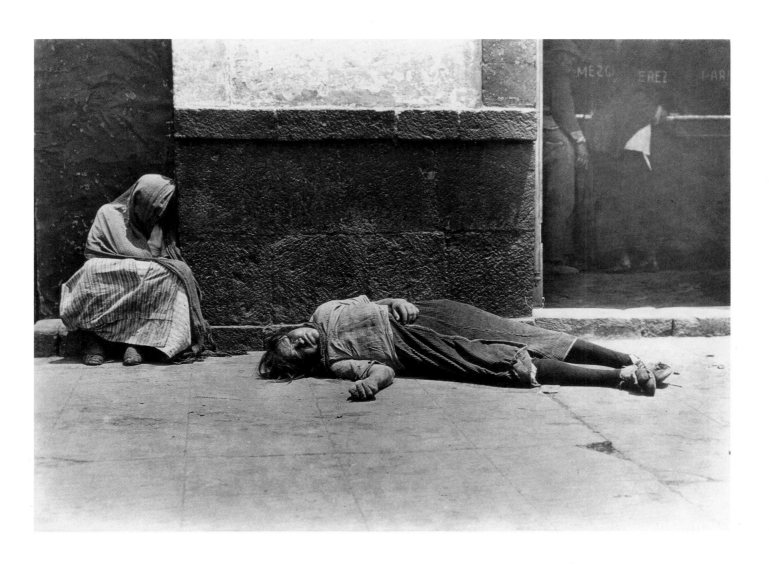

74 *Misery.* 1928. Gelatin silver print, 6⅞ x 9⅜″. Museum Folkwang, Essen, Germany

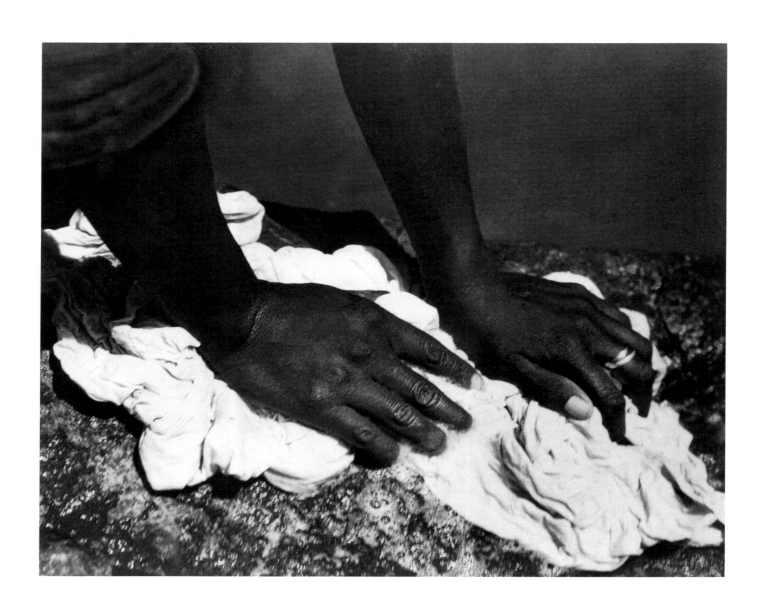

75 *Labor 1* or *Hands Washing.* c. 1927. Gelatin silver print, 7⁷⁄₁₆ x 9″. The Museum of Modern Art, New York. Anonymous gift

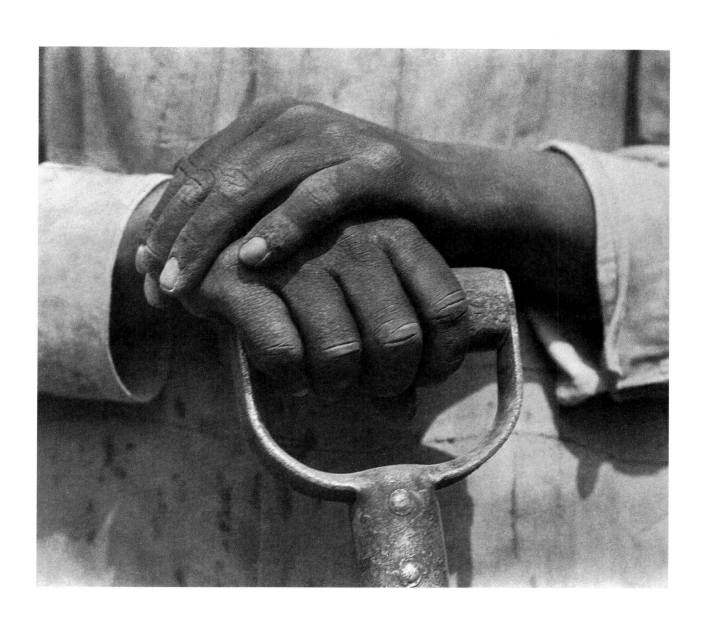

76 *Hands Resting on Tool.* 1927. Platinum print, 7½ x 8½″. Collection of the J. Paul Getty Museum, Malibu, California

77　*Tank No. 1.* 1927. Gelatin silver print, 9⁹⁄₁₆ x 7⁵⁄₈″. The Metropolitan Museum of Art, New York, Ford Motor Company Collection, Gift of the Ford Motor Company and John C. Waddell, 1987

78 *Labor 2.* 1927. Gelatin silver print, 7⅜ x 8⅝″. The Metropolitan Museum of Art, New York,
Purchase, Gift of Mr. and Mrs. Robert J. Massar, 1971

79 *Construction Worker, Stadium.* 1926–28. Gelatin silver print, 9⅜ x 6¾″. Collection Karen Arrigoni

80 *Workers, Mexico.* c. 1926–29. Gelatin silver print, 6¹¹⁄₁₆ x 8⅜″. Amon Carter Museum, Fort Worth, Texas

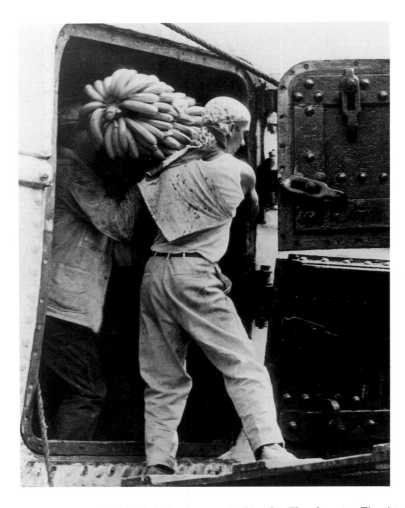

81 *Loading Bananas, Veracruz.* c. 1927–29. Gelatin silver print, 9¼ x 7¼″. Throckmorton Fine Art, Inc., New York

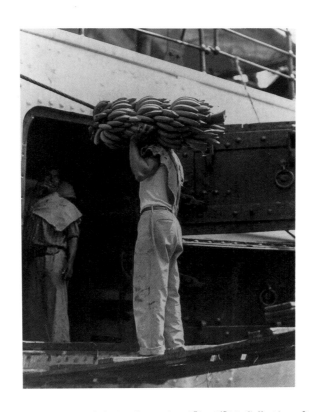

82 *Loading Bananas, Veracruz.* c. 1927–29. Gelatin silver print, 3⅞ x 2¹⁵⁄₁₆″. Collection of the George Eastman House

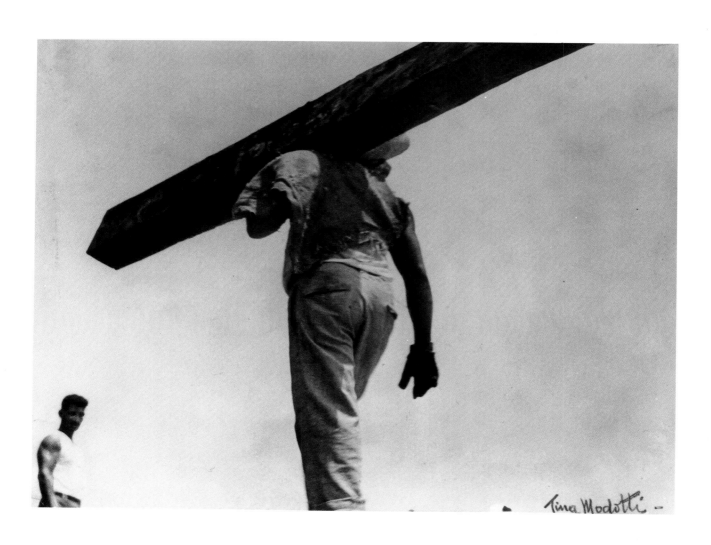

83 *Man with a Beam.* c. 1928. Gelatin silver print, 6⅞ x 8¾″. Centro Cultural/Arte Contemporáneo,
A. C./Fundación Cultural Televisa, A. C. Collection, Mexico

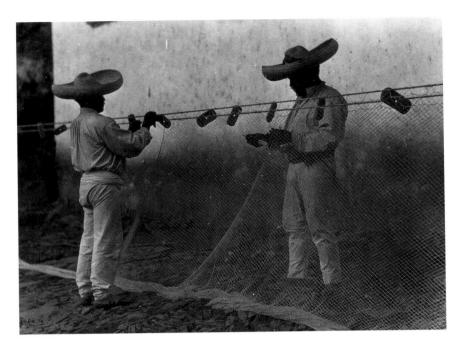

84 *Fishermen Mending Nets.* c. 1927–29. Gelatin silver print, 2⅞ x 3¾″. Collection of the George Eastman House

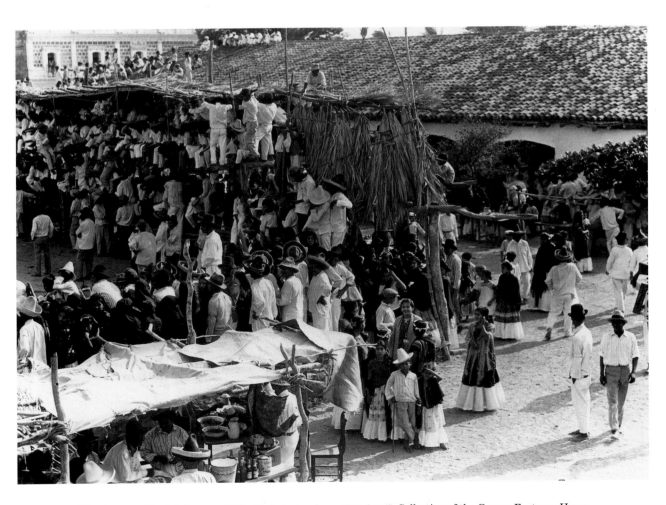

85 *Oaxacan Market Scene.* c. 1926–29. Gelatin silver print, 3 x 4″. Collection of the George Eastman House

86 *Campesino with Hay.* c. 1927–29. Gelatin silver print, 3¾ x 2⅞″. Collection of the George Eastman House

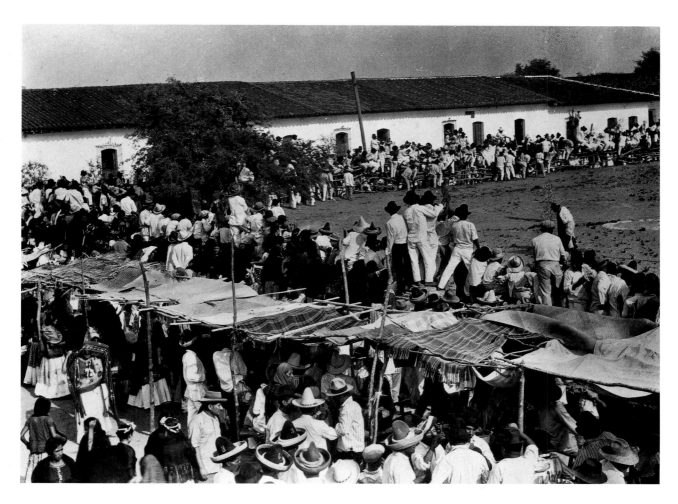

87 *Fiesta in Juchitán, Oaxaca, Mexico.* 1927–29. Gelatin silver print, 6¾ x 9½″. The Museum of Modern Art, New York. Anonymous gift

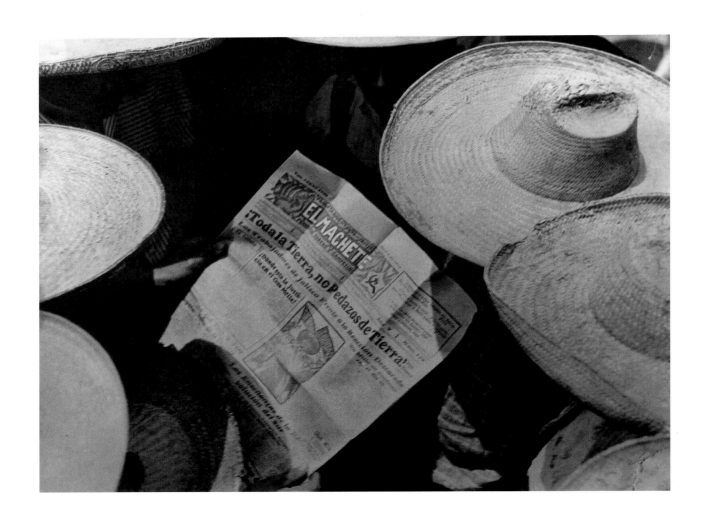

88 *Campesinos Reading "El Machete."* 1929. Gelatin silver print, 6¾ x 9¼″. Centro Cultural/Arte Contemporáneo,
A. C./Fundación Cultural Televisa, A. C. Collection, Mexico

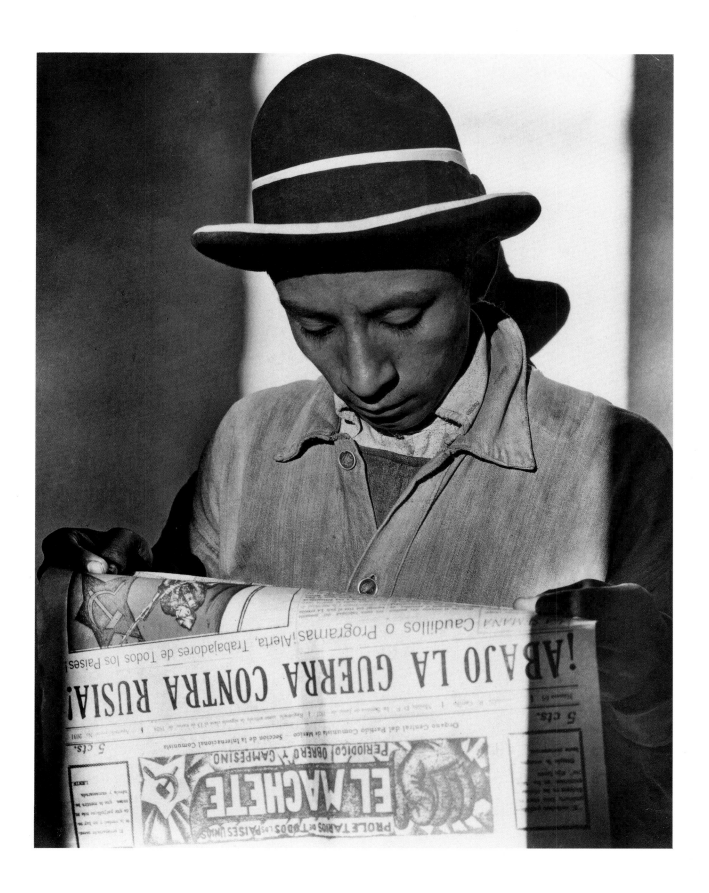

89 *Worker Reading "El Machete."* 1927. Platinum print, 9⁵⁄₁₆ x 7½". Private collection, La Jolla, California

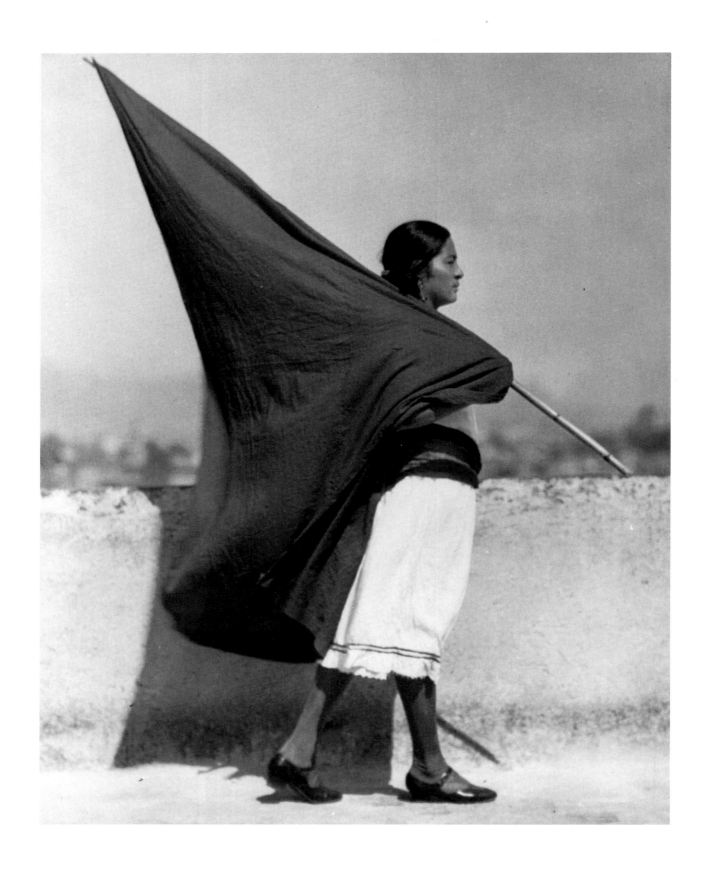

90 *Woman with Flag.* 1928. Palladium print by Richard Benson, 1976, 9¾ x 7¹¹⁄₁₆″. The Museum of Modern Art, New York.
Courtesy of Isabel Carbajal Bolandi

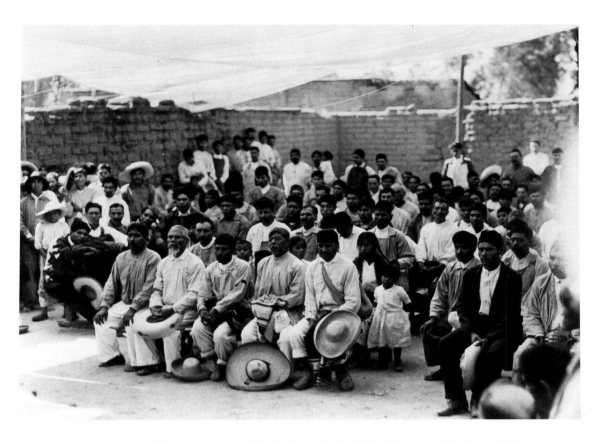

91 *Meeting of Campesinos.* 1927. Gelatin silver print by Richard Benson, 1976, 7½ x 10¹⁵⁄₁₆″.
The Museum of Modern Art, New York. Courtesy of Isabel Carbajal Bolandi

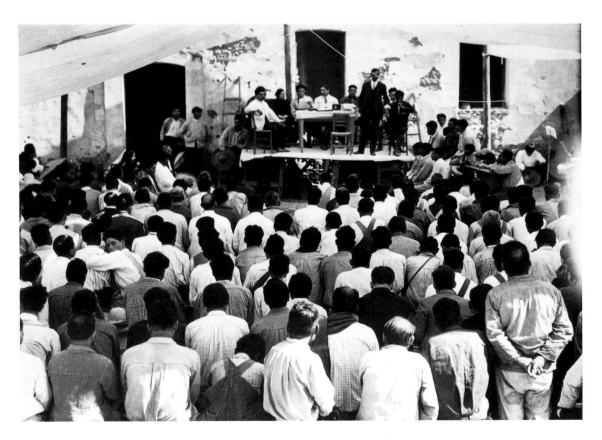

92 *Meeting of Campesinos (Stage).* 1927. Gelatin silver print by Richard Benson, 1976, 7⁹⁄₁₆ x 10¼″.
The Museum of Modern Art, New York. Courtesy of Isabel Carbajal Bolandi

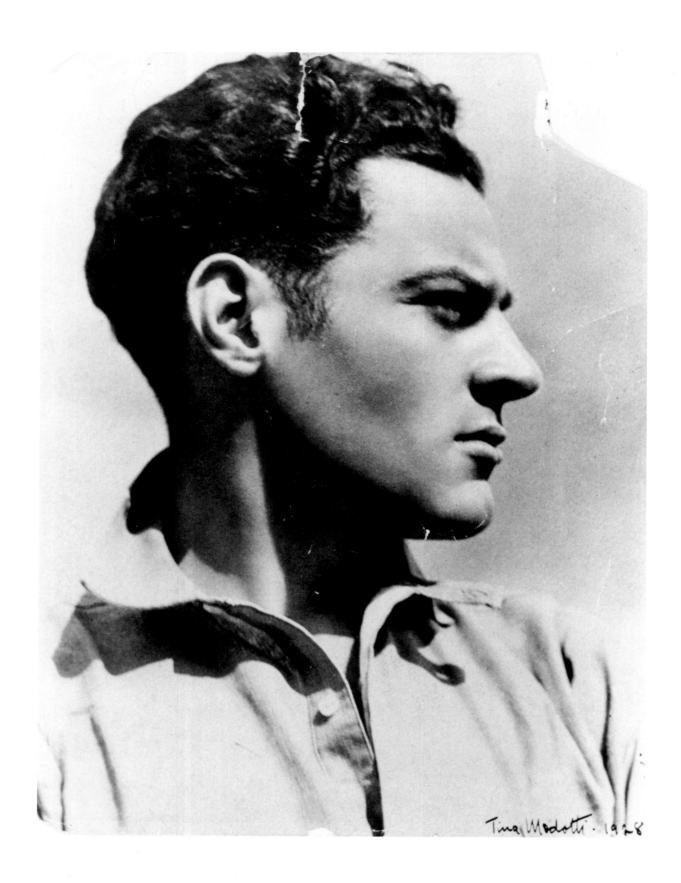

93 *Julio Antonio Mella.* c. 1928. Gelatin silver print, 9 x 6⅞″. Collection Miguel Angel Velasco

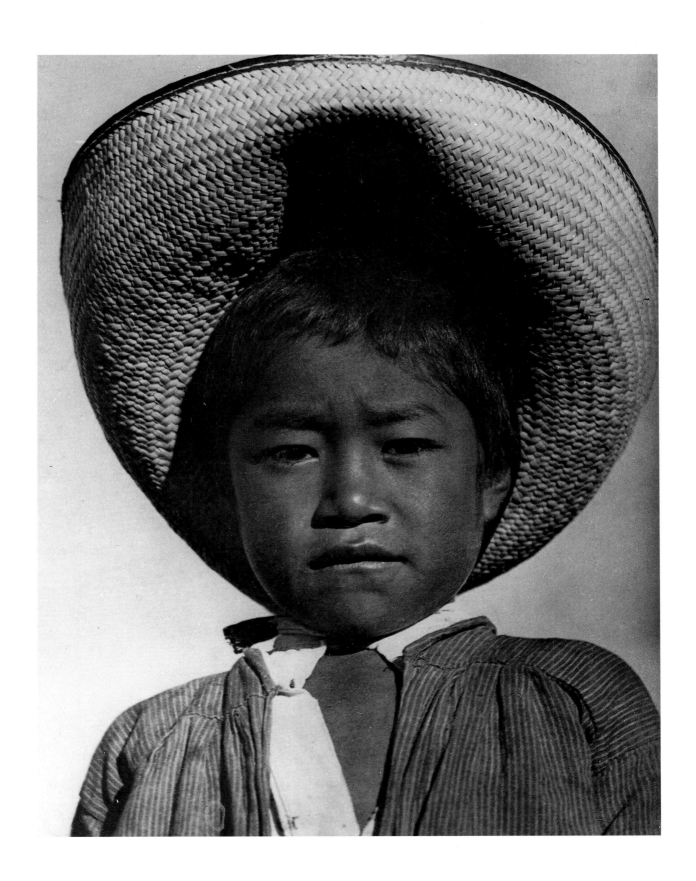

94 *Child in Sombrero* or *Son of Agrarista.* c. 1927. Gelatin silver print, 8½ x 6½". The Museum of Modern Art, New York. Anonymous gift

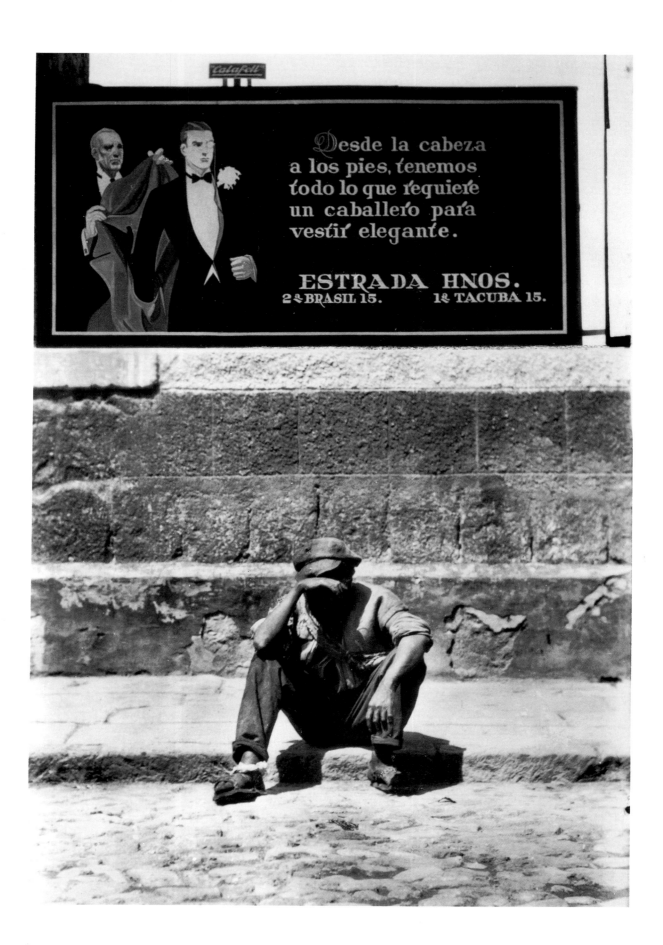

95 *Elegance and Poverty* (photomontage). c. 1928. Gelatin silver print by Richard Benson, 1976, 9¾ x 6½″.
The Museum of Modern Art, New York. Courtesy of Isabel Carbajal Bolandi

96 *Mella's Typewriter* or *La Técnica*. 1928. Gelatin silver print, 9⅜ x 7½″. The Museum of Modern Art, New York. Anonymous gift

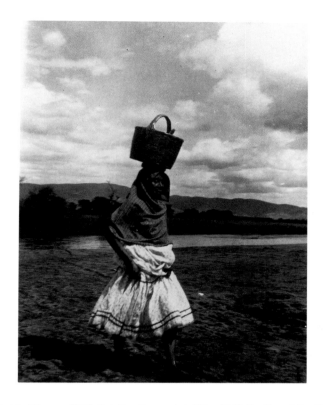

97 *Woman with Basket by River.* c. 1929. Gelatin silver print, 3⅞ x 3″. Collection of the George Eastman House

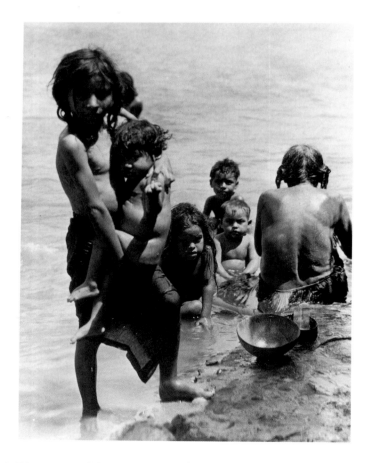

98 *Children in River.* c. 1929. Gelatin silver print, 3½ x 2¹¹⁄₁₆″. Collection of the George Eastman House

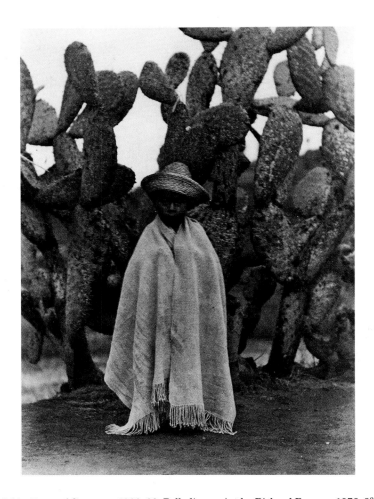

99 *Child in Front of Cactus.* c. 1926–28. Palladium print by Richard Benson, 1976, 9⅜ x 6⅞″.
The Museum of Modern Art, New York. Courtesy of Isabel Carbajal Bolandi

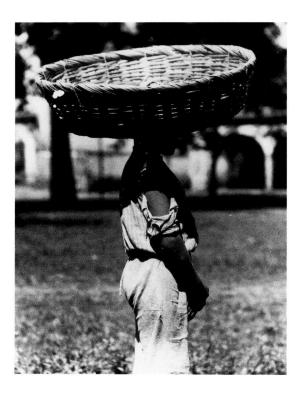

100 *Mexican with Basket.* c. 1929. Gelatin silver print, 3¾ x 2¹³⁄₁₆″. Collection of the George Eastman House

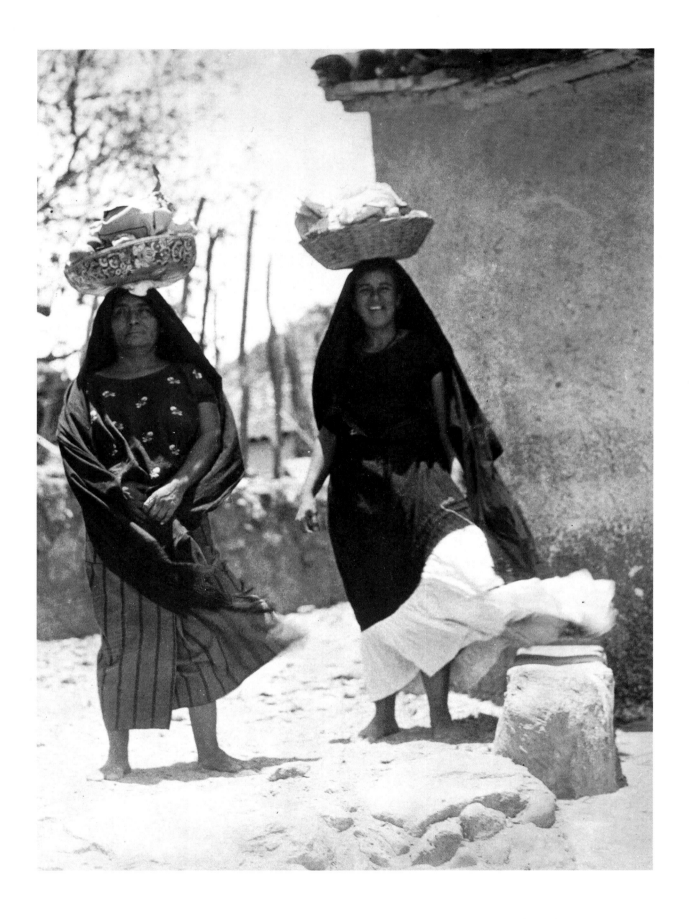

101 *Women from Tehuantepec.* c. 1929. Palladium print by Richard Benson, 1976, 9⁷⁄₁₆ x 6¾″.
The Museum of Modern Art, New York. Courtesy of Isabel Carbajal Bolandi

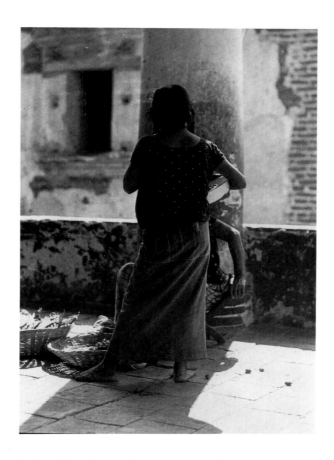

102 *Two Women on a Porch.* c. 1929. Gelatin silver print, 3¾ x 2¹¹⁄₁₆″. Collection of the George Eastman House

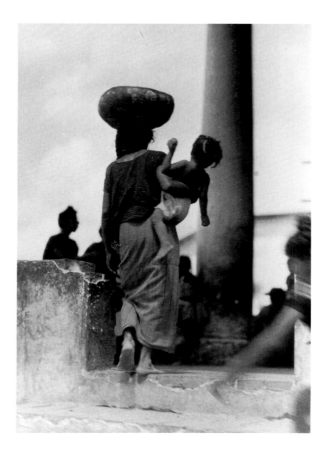

103 *Woman with Child at Market Carrying Basket.* c. 1929. Gelatin silver print, 3¾ x 2⅝″. Collection of the George Eastman House

104　*Two Women in Street with Jars.* c. 1929. Gelatin silver print, 3 x 2¹¹⁄₁₆″. Collection of the George Eastman House

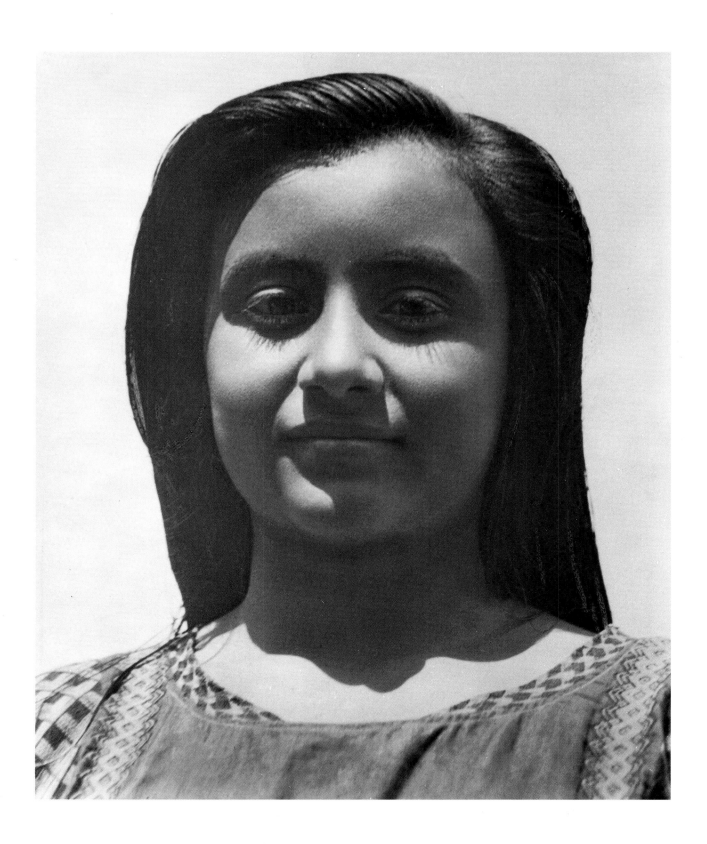

105 *Tehuantepec Type (Head of a Girl).* 1929. Platinum print, 9³⁄₁₆ x 7⅛″. The Museum of Modern Art, New York. Anonymous gift

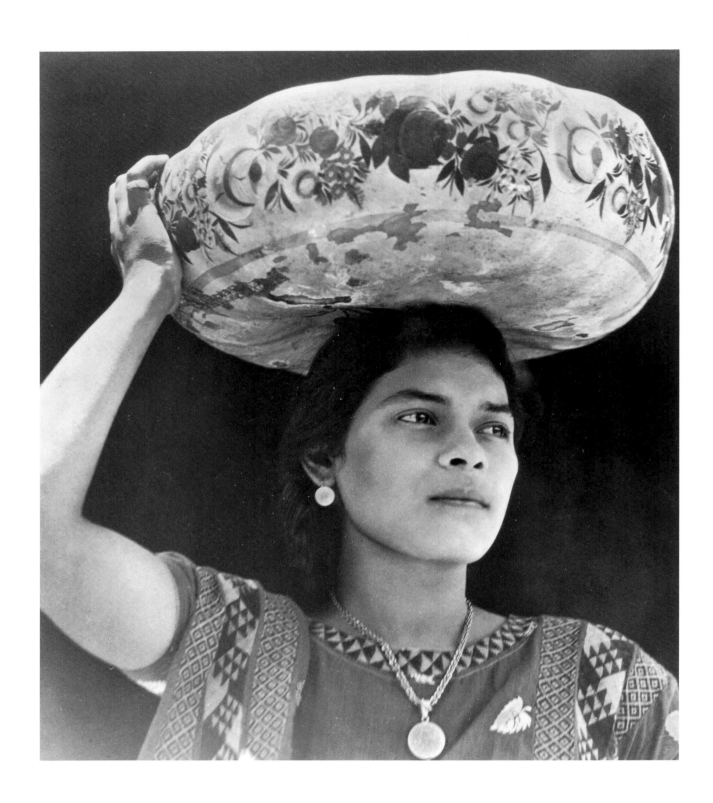

106 *Woman of Tehuantepec.* c. 1929. Gelatin silver print, 8⅜ x 7⅜″. Philadelphia Museum of Art: Gift of Mr. and Mrs. Carl Zigrosser

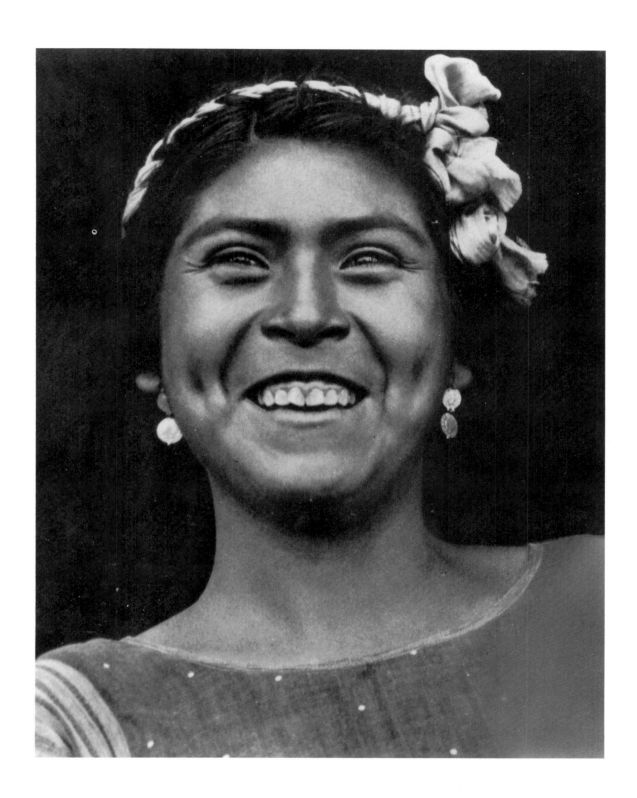

107 *Tehuantepec Type (Woman Smiling)*. c. 1929. Gelatin silver print, 9⅛ x 7¼″. The Museum of Modern Art, New York. Anonymous gift

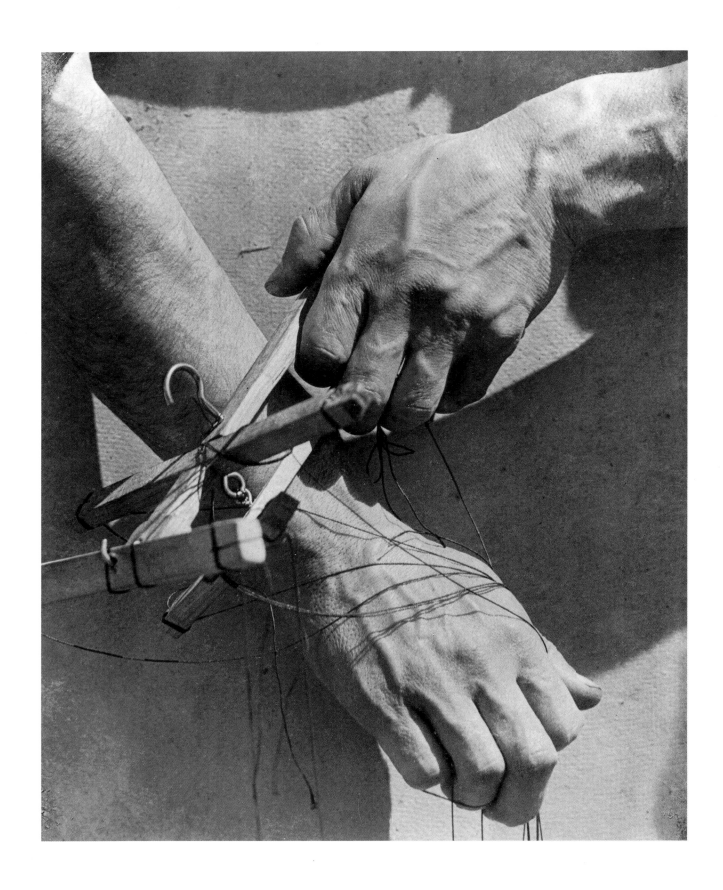

108 *Hands of the Puppeteer.* 1929. Gelatin silver print, 9½ x 7½". The Minneapolis Institute of Arts, The Mr. and Mrs. Patrick Butler Fund

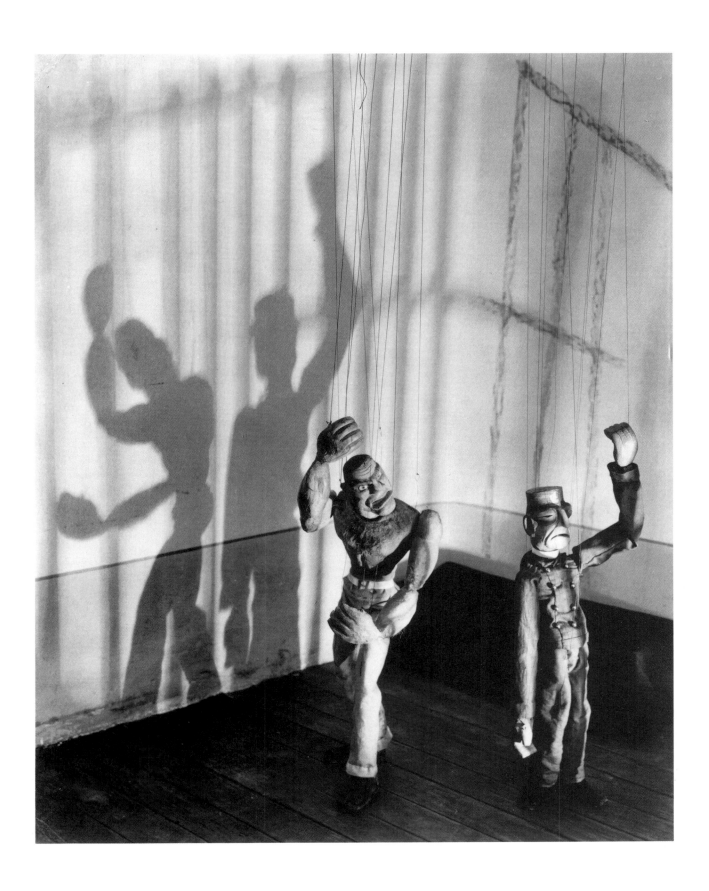

109 *Yank and Police Marionette*. 1929. Gelatin silver print, 9½ x 7½". Collection Helen Kornblum

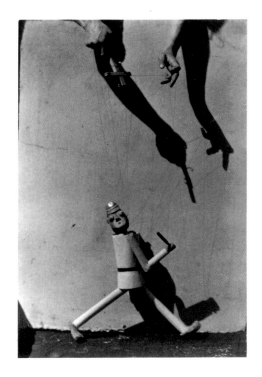

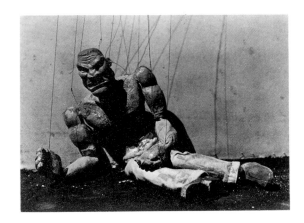

110 *Police Marionette.* 1929. Gelatin silver print,
3⅝ x 2⅜″. Collection Andrew Masullo

111 *Reclining Marionette.* 1929. Gelatin silver print, 2¹⁵⁄₁₆ x 3¾″.
Collection Andrew Masullo

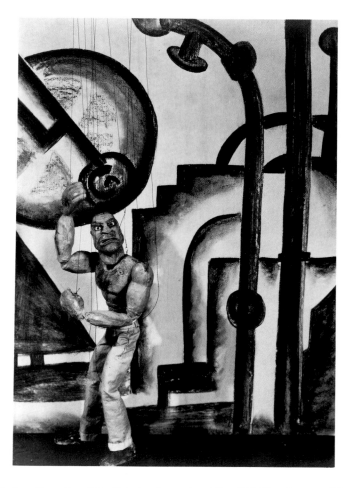

112 *Marionette and Modern Stage Set.* 1929. Gelatin silver print, 9⅜ x 6⅞″. Throckmorton Fine Art, Inc., New York

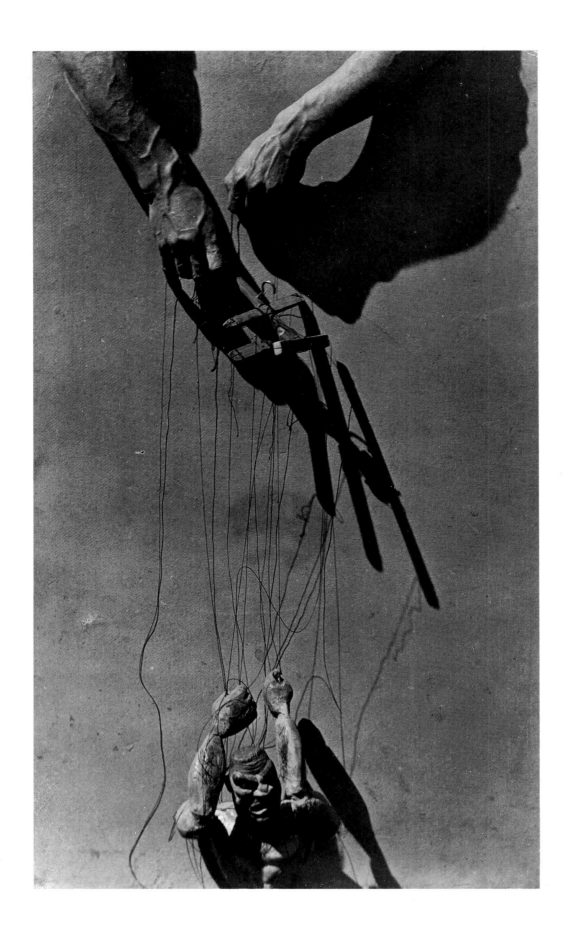

113 *Hands of the Puppeteer (Man's Hands with Yank).* 1929. Gelatin silver print, 8¹⁵⁄₁₆ x 5¼″. Collection Alexander Kaplen

114 *Street Scene, Berlin.* 1930. Gelatin silver print, 6⅝ x 8¼″. Collection of the J. Paul Getty Museum, Malibu, California

115 *Ventriloquist.* c. 1930. Gelatin silver print, 6¾ x 9⅛″. Collection W. Michael Sheehe

116 *Couple at the Zoo, Berlin.* 1930. Gelatin silver print, 8¹⁵⁄₁₆ x 6¾″. Collection of the J. Paul Getty Museum, Malibu, California

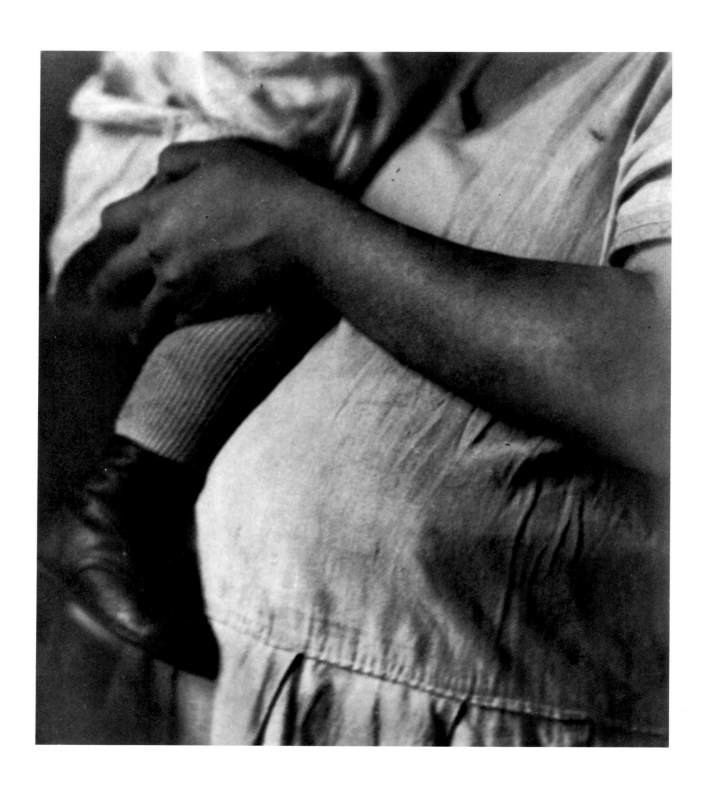

117 *Woman with Child.* 1930. Gelatin silver print, 7¹³⁄₁₆ x 6⅞″. The Saint Louis Art Museum. Purchase: Museum Shop Fund

118 *Young Pioneers.* 1930. Gelatin silver print, 6⅜ x 8¹³/₁₆″. Cincinnati Art Museum: Museum Purchase: Gift of the Estate of Clara J. Schawe, Mrs. Ralph Robertson, and Lane Seminary, by exchange

119 *René d'Harnoncourt Marionette.* 1929. Gelatin silver print, 9⅜ x 7¹⁄₁₆″. Collection Andrew Masullo

Notes

Abbreviations: DBI and DBII: Edward Weston, *The Daybooks of Edward Weston*, vol. I and vol. II, respectively

INTRODUCTION
[1]This account excludes Modotti's photographs of murals and paintings.

[2]In 1991, Modotti's *Roses* sold for $165,000, a record-breaking price paid at auction for a single photograph.

[3]Two examples of this treatment are: Constantine's *Tina Modotti: A Fragile Life* and Hooks's *Tina Modotti: Photographer and Revolutionary*. Barckhausen's biography *Auf den Spuren von Tina Modotti* (referred to in this text by its Spanish title, *Verdad y leyenda de Tina Modotti*) is, likewise, less interested in photography, but provides prodigious amount of new information on Modotti. Recent exceptions in English are: Conger's "Tina Modotti and Edward Weston" and Higgins's *Truth, Myth and Erasure*. Recent books in languages other than English are: Agostinis, ed. *Tina Modotti: gli anni luminosi*, a collection of new and previously printed articles includes 160 reproductions, of which 78 are of Modotti's photographs, many never before published; Saborit's *Una mujer sin país: Las cartas de Tina Modotti a Edward Weston, 1921–1931*, a translation of Stark [Rule], ed., "Letters," includes a new introduction, several unpublished letters from Modotti, and adds a few footnotes of his own; and Schultz's *Tina Modotti: Photographien & Dokumente* is also useful.

[4]Vidali's accounts of their shared life may have been colored by his desire to play down some of the less honorable episodes in his own life. Gallagher observes that Vidali's autobiographies might be called "revisionist" (Gallagher, *All the Right Enemies*, 287). D'Attilio is more explicit: "Concern over his historical reputation led Vidali, a Soviet agent, to begin a large-scale *apologia pro sua vita* based upon diaries that he had supposedly kept throughout his life (one should be skeptical that any Soviet agent would do this) so that as he put it, he could 'demythologize' his life" (D'Attilio, "Glittering Traces," 7).

[5]Caronia, *Tina Modotti: Fotografa e Rivoluzionaria*, English translation in *Tina Modotti: Photographs*, 6.

[6]Modotti wrote to a friend within months of arriving in Moscow that she was happy and in love (Frances Toor to Joseph Freeman, Joseph Freeman Papers, Hoover Institution); Vidali, meanwhile, had a daughter with Paulina Hafkina (Barckhausen, *Verdad*, 232, 248). By 1932, Modotti and Vidali were both working at MOPR headquarters and were an acknowledged couple (Castano, "Mosca 1932," 24).

[7][Vidali], *Tina Modotti*. This pamphlet has no acknowledged publisher.

[8]Two exceptions are: *Modernidad y Modernización en el Arte Mexicano: 1920–1960*, in which Modotti is tacitly connected with the Estridentistas through the reproduction of her photographs; and Blas Galindo, who includes Modotti as one of the artists who were "brought together" by the Estridentistas.

[9]In the late 1940s, Dee Knapp, working in the photography department of the Museum of Modern Art, New York, abandoned her research on Modotti after being warned that the political content of the work would draw attention in the current anti-communist climate. The fear induced by McCarthyism persisted. Of the thirty-four vintage photographs housed at MoMA, NY, twenty-eight were handed to the front desk anonymously in the late 1950s, and accessioned only six years later (Dee Knapp, interviews with author, September 23, 1988, and March 16, 1993; Tina Modotti artist file, Photography Department, MoMA, NY;

author's personal files; conversation with Grace Mayer, February 1990). A second attempt to recover Modotti's reputation was made by David Vestel in his 1966 article "Tina's Trajectory."

[10]Kahlo and Diego Rivera later denounced Trotsky, a fact made clear in Kahlo's diary. See *The Diary of Frida Kahlo: An Intimate Self-Portrait* (New York: Harry N. Abrams, Inc., 1995), passim.

[11]See Molderings, and D'Attilio's insightful articles ("Glittering Traces" and "Tina Modotti: La Militante. Tiníssima: La Militante," unpublished review of *Auf den Spuren von Tina Modotti* by Christiane Barckhausen and *I fuochi le ombre il silenzio* by Pino Cacucci) in which he skillfully delineates the complex and subtle issues around Vidali.

[12]Elena Poniatowska's best-selling novel, *Tiníssima* (Mexico City: Ediciones Era, 1992) and Margaret Gibson's book of poetry *Memories of the Future: The Daybooks of Tina Modotti* (Baton Rouge: Louisiana State University Press, 1986) are two examples.

[13]Carol Zemel, "Sorrowing Women, Rescuing Men: Van Gogh's Images of Women and Family," *Art History* 10 (September 1987): 351.

TINA MODOTTI: PHOTOGRAPHS
[1]August 17 on Modotti's birth certificate contradicts her baptismal record which gives August 16. Transcriptions of both documents in Tina Modotti Archive, Getty Center.

[2]Giuseppe Saltarini Modotti was born April 20, 1863, and died March 14, 1922 (Giuseppe Modotti, Death Certificate). Assunta Mondini (1863–1936) was born on November 29, 1863 (Barckhausen, *Verdad*, 19). For more comprehensive genealogical information on Tina Modotti's immediate and extended family, see Lowe, "Tina Modotti's Vision," Appendix I.

[3]Vidali's account that Giuseppe was a carpenter and mason has led many to assume the family was impoverished ([Vidali], *Tina Modotti*, 30). On the contrary, Tina Modotti's birth certificate identifies Giuseppe as a mechanic (see n. 1). The manifests of the ships Giuseppe and Francesco sailed on list them as engineer and mechanical engineer, respectively (Immigration Records, 1904, 1905).

[4]Barckhausen, *Verdad*, 29.

[5]Barckhausen, *Verdad*, 24; [Vidali], *Tina Modotti*, 3.

[6]Ivana Bonelli et al., "'Un cappello caduto nell'acqua' Tracce di Tina nella sua terra d'origine," paper delivered March 1993, Udine, Italy. Bonelli is a member of a collective that runs the Comitato Tina Modotti in Udine, which houses copies of municipal and ecclesiastic archives and repositories from Udine and from towns where the Modottis lived in Austria.

[7]Barckhausen, *Verdad*, 38.

[8]Barckhausen, *Verdad*, 41; Ellero, "The Childhood of Tina Modotti," 6.

[9]Foerster, *Italian Emigration*, 15.

[10]Barckhausen, *Verdad*, 29–30. The "Circolo Socialista" organized in Udine in 1897, directed by Luigi Pignat, Arturo Zambianchi, and Demitrio Canal, was disbanded by the authorities after a few months of existence. Ellero suggests that Giuseppe may have left Udine in 1897 for political reasons, then returned home the next year to take his family to nearby Austria (Ellero, "The Childhood of Tina Modotti," 10).

[11]Barckhausen, *Verdad*, 39–40.

[12]Foerster, *Italian Emigration*, 199.

[13]On the solidarity of Italian and Slavic immigrants in Austria, see Barckhausen, *Verdad*, 42. On Modotti's early experiences at political events, see Constantine, *Fragile Life*, 24, and Barckhausen, *Verdad*, 41.

[14]Benvenuto was the most active in radical politics of Modotti's siblings. See, for example, the seven letters in the appendix of Barckhausen's *Verdad*, which reside in an archive in Cuba. Yolanda and Joseph (called Beppo) were both active in the anti-fascist movement in the United States (Barckhausen, *Verdad*, 131).

[15]Giuseppe Pietro Maria (Beppo) was born August 30, 1905, two months after his father left for the United States (Ellero, "The Childhood of Tina Modotti," 6).

[16]See 1905 passenger manifest of SS *La Touraine*. Between 1902 and 1906, nearly a quarter of a million Italians immigrated to the United States. See compilation in Foerster, *Italian Emigration*, 15.

[17]Francesco Modotti first immigrated to the United States in 1892 and lived in Pittsburgh for several years, until returning to Italy sometime before the end of the decade. The 1904 passenger manifest of SS *La Gascogne* indicates that he was a mechanical engineer and that he was headed for Oyster Bay, Long Island. When his brother arrived the next year, he had already moved to Turtle Creek, PA.

[18]See photocopies of newspaper clippings dated January 25, 1932, and January 15, 1933, undated publication of the Welfare Planning Association. Originals in Carnegie Library of Pittsburgh, Pennsylvania Department, Pittsburgh, PA.

[19]Giuseppe Modotti's death certificate indicates that he lived in California for 15 years.

[20]*Crocker-Langley San Francisco Directory*, 1908 and 1908–1909.

[21]Ellero, "The Childhood of Tina Modotti," 6.

[22]Rosetta Porracin, letter to author, July 9, 1994. This information is published; see Tamburlini, "Tina promossa a pieni voti." Porracin is a member of the Comitato Tina Modotti collective in Udine.

[23]"Una Estrella de Cine que Ama y Conoce a México," 7; DBI, 69 (May 1, 1924).

[24]Rosetta Porracin, letter to author, July 9, 1994.

[25][Vidali], *Tina Modotti*, 15. This account of life in Italy, translated into English, mistakenly appears as evidence of the hardships endured by the family in San Francisco (Constantine, *Fragile Life*, 25).

[26]Constantine reproduced a portrait of a young boy, said to be Benvenuto, Modotti's younger brother (Constantine, *Fragile Life*, 21). A photograph of a photo-collage of the seven Modotti siblings is in the collection of the George Eastman House, Rochester, NY, but it is impossible now to determine the identity of the original photographer.

[27]The following discussion of Pietro Modotti's career is drawn from Zannier, *Fotografia in Friuli*, 17–19 and Ellero, *Pietro Modotti*, passim. Ellero has been a leading force in Udine in reviving interest in Pietro Modotti.

[28]Zannier, *Fotografia in Friuli*, 17, cites the following journals, *The International Annual of Anthony's Photographic Bulletin* and *The American Annual of Photography*, and provides the following specific citations: *La Gazzetta della Fotografia* [Milan] (March 1905); *Annuario Santoponte* [Rome] (1905); *Il Progresso Fotografico* [Milan] (September 1904 and April 1905); and *Annuario del Corriere Fotografico* [Turin] (1911).

[29]Barckhausen reached this conclusion after reading letters written to Pietro by his son Dino, who left Italy in 1926 for Bolivia (Barckhausen, *Verdad*, 27). The letters were intercepted by the Italian government, transcribed, and now reside as documents in the Italian State Archives. Copies of many may be found in the Tina Modotti Archive, Udine.

[30]See Ellero, "Nuove fotografie di Pietro Modotti," and "Gli allievi de Pietro Modotti."

[31]See 1913 passenger manifest of SS *Moltke*, which indicates she traveled as Tina Saltarini-Modotti, was sixteen years old, single, a student, was five feet, one inch tall, in good mental and physical health with no deformities or marks of identification.

[32]D'Attilio, "Notes for Future Biographers," 2. In anticipation of his wife, two sons, and one other daughter joining him, Giuseppe moved from 1952 Taylor Street around the corner to 901 Union

in 1919 *(Crocker-Langley San Francisco Directory*, 1919).

[33]Yolanda Modotti, interview with author, October 18, 1988, and Yolanda Modotti, interview with Margaret Hooks, February 23, 1990, cited in Hooks, *Tina Modotti*, 18, 258. The *Crocker-Langley San Francisco Directory* of 1922 indicates that Yolanda and Mercedes were employed at I. Magnin that year; Tina was already living in Los Angeles by then.

[34]"Tutti al Grande Comizio," broadside announcing meeting scheduled for July 20 [1912], Labor Archives and Research Center.

[35]Summary of the Lawrence strikes is drawn from Tirelli, "Formation of the Italian-American Working Class," 2–23.

[36]*L'Italia* (October 16, 1918); Yolanda Modotti, cited in Constantine, *Fragile Life*, 26.

[37]Richey's paternal grandfather was born in Kentucky and crossed the Rocky Mountains on the Oregon Trail, arriving sometime between 1848 and 1853. James Richey, Ruby's father, married the twenty-seven-year-old Rose Booth, a native Oregonian, in 1887; Ruby was born three years later and his sister, Mara An, was born in 1896. See 1900 Oregon census record.

[38]Modotti-Richey, *Book of Robo*, 9.

[39]An indication of how strongly Richey identified with and was identified as a Canadian is evident in the 1920 census data for San Francisco. Richey's place of birth is given as Canada and his mother tongue as French; his father's place of birth is France, with his native tongue as French, while his mother's place of birth is England. Richey was enumerated in both Los Angeles and San Francisco, which suggests he and Modotti were traveling between their parents' homes.

[40]Modotti-Richey, *Book of Robo*, 11.

[41]On cartoons: see 1920 census record, San Francisco, CA; *El Universal Ilustrado* [Mexico City] 5, no. 253 (May 9, 1922): 242; *Gale's* [Mexico] (May and September 1920): cover illustrations. On batiks: see Duell, "Textiles and Interior Decoration Department," 19; Borough, "Art, Love and Death," 22. On writing: see short stories "Webfoot," *Overland Monthly* 60 (September 1912): 240–43; "Dice of the Gods," *Overland Monthly* 60 (December 1912): 475–80; poem "Streetscape," *Lyric West* 1, no. 9 (January 1922). The last, a small poetry magazine based in California, included poetry by Sarah Bixby Smith, the wife of Edward Weston's friend Paul Jordan Smith.

[42]D'Attilio makes this point in "Glittering Traces," 9.

[43]Estavan, ed., *Italian Theatre*, 5. My thanks to Paul Hertzmann for calling my attention to this little-known WPA history.

[44]Gumina, *Italians of San Francisco*, 61.

[45]Gumina, *Italians of San Francisco*, 63–69; Edmond M. Gagey, *The San Francisco Stage: A History* (New York: Columbia University Press, 1950), 211; *L'Italia* (August 12, 1918).

[46]Estavan, *Italian Theatre*, 56–59, 122–23; Gumina, *Italians of San Francisco*, 69; advertisement in *L'Italia* (July 2, 1918).

[47]*L'Italia* (July 25, 1918). All translations from Italian to English are courtesy of Luisa Sartori unless otherwise noted.

[48]*L'Italia* (August 29, 1918); Estavan, *Italian Theatre*, 56–57.

[49]Estavan, *Italian Theatre*, 17.

[50]*L'Italia* (March 2, 1918) praises Modotti's excellent diction and acting in the role; Estavan, *Italian Theatre*, 56.

[51]See Marvin Carlson, *The Italian Stage: From Goldoni to D'Annunzio* (Jefferson, NC, and London: McFarland & Company, 1981). On "La Morte Civile," 145; on "Gli Spettri," 186; on "I Disonesti," 184.

[52]1920 census record, Los Angeles Township, CA.

[53]Richey was living at 568 Golden Gate Avenue (*Crocker-Langley San Francisco Directory*, 1913).

[54]Modotti writes that the two men corresponded and shared common interests (Modotti-Richey, *Book of Robo*, 10). The poet Andrew Dewing was also a close friend of Richey's. See letter from Roubaix de l'Abrie Richey, c. 1922, to Blanche D'Harcourt (Private collection, San Francisco, CA). Dewing's published poems are: "To George Sterling," *The Lantern* 3, no. 9 (December 1917):

276; "Cathedral Spires," *The Lantern* 3, no. 12 (March 1918): 381; "Kwannon," *Lyric West* 2, no. 2 (May 1922): 19.

55Harry Lawton, "The 'Last Bohemian'—A New Culture Hero?" *San Francisco Sunday Examiner and Chronicle, This World Sunday* (April 4, 1971), 38.

56*The Life and Times of Sadakichi Hartmann*, 5; Sadakichi Hartmann, "Art and Revolt," *Blast* 1, no. 22 (December 1, 1916): 3. *Blast* was a short-lived, but vital, radical magazine in San Francisco.

57On Schröder, see Valenti Angelo, *Valenti Angelo Arts and Books: A Glorious Variety* (Berkeley, CA: Regional Oral History Office, The Bancroft Library, University of California, 1980), 49, 52, 78. The two glamour photographs are reproduced in Constantine, *Fragile Life*, 34 and 35.

58See Jacob, "Tina Modotti a Hollywood," 211–22, for Modotti's youthful encounter with cinema in Udine.

59See compilation of personnel at various Bay Area independent film companies in Bell, *Golden Gate and the Silver Screen*, 166–67. The two most important were the Essanay Studio (active between 1907 and 1916) and the California Motion Pictures Corporation (active between 1914 and 1918), recruited from theaters, vaudeville houses, and cabarets in San Francisco, San Jose, Sacramento, and Oakland (Bell, 77–78, 172, n. 21).

60*L'Italia* (October 16, 1918).

61See 1920 census record, Los Angeles Township, CA. The Richey household lived at 1407 11th Street. By 1921, they had moved to 313 S. Lake Street (*Crocker-Langley Los Angeles Directory*, 1920–23).

62Duell, "Textiles and Interior Decoration Department," 19. Batik was popular enough to warrant an exhibition at the Los Angeles Museum's Fourth Annual Exhibition of Arts and Crafts of 1928 (see scrapbook for January 1928 through July 1929, archives of the Natural History Museum of Los Angeles County). In an undated letter from Modotti to Betty [Brandner], Modotti writes about her handmade dolls, which she calls "nuns of perpetual adoration" (Edward Weston Archive, Center for Creative Photography, hereafter, CCP).

63Estavan, *Italian Theatre*, 57.

64Modotti cited "actress" as her "trade, profession or particular type of work done," and La Moderna Dramatica Co. as her place of employment in the 1920 census record, Los Angeles Township, CA. This troupe was based in San Francisco (Hooks, *Tina Modotti*, 28–29).

65Reece exhibited at the Los Angeles Public Library (reviewed in *Alhambra* [November 18, 1919]) and was included in the *Camera Pictorialists Salon* and in a show at the Exposition Park Art Gallery (Chambers, "Jane Reece," 161–73).

66There are six known images from this series: five are at the Dayton Art Institute and one is in the Tina Modotti Archive, Getty Center. (See reproduction in the first edition of Constantine, *Fragile Life*, 34.) On *The Mission Play*, see Chambers, "Jane Reece," 142–46; Frederick Warde, *Fifty Years of Make Believe* (New York: The International Press Syndicate, 1920); *The Mission Play*, 1919 performance program notes, San Gabriel Historical Association Archives; and miscellaneous clippings in the Robinson Locke Collection, New York Public Library, Performing Arts Research Center at Lincoln Center, Theatre Division. Modotti's name is not mentioned in the 1919 program, but the play was presented as a pageant and included a group of ten to twenty "Spanish girls" who performed dances.

67Now in the Dayton Art Institute, acquisition number 52.12.131. Edward Fitzgerald's mid-nineteenth-century translations of Omar Khayyám's *Rubáiyát*, or quatrains, introduced the West to his one thousand epigrammatic stanzas that express his hedonistic philosophy. Reece did not consider this picture part of a series, although fifteen years earlier, Bay Area photographer Adelaide Hanscom established her reputation as an innovative pictorialist with her illustrations for a 1905 version of the *Rubáiyát* (Dimitri Shipoundoff, "From Kitsch to Culture," *Berke-*

ley Monthly* [October 1979]: 17). Stanza 93: "Indeed the Idols I have loved so long/Have done my credit in the World much Wrong:/Have drown'd my Glory in a shallow Cup,/And sold my Reputation for a Song."

68"'The Tiger's Coat' is Well Under Way," *Motion Picture News* (July 3, 1920): 264. The movie was being filmed at the Brunton Studios in Los Angeles and was mentioned regularly in trade magazines during the next few months. *Motion Picture News* (August 14, 1920, October 16, 1920, November 13, 1920, December 18, 1920); *Moving Picture World* (July 3, 1920, October 30, 1920); *Variety* (December 30, 1920). Two other articles, dated November 12, 1920, and December 25, 1920 (source unidentified), are in files at the Academy of Motion Picture Arts & Sciences, Beverly Hills, CA.

69For information on the cast and directors, citations in the trade magazines, as well as a summary of the plot, see *The American Film Institute Catalog of Motion Pictures in the United States* (Berkeley and London: University of California Press, 1971): vol. 1, 933; vol. 2, 654, 372. To date, only *The Tiger's Coat* has been found in film form; *Riding with Death* exists as a script with the title *Pony Tracks*, and *I Can Explain* has vanished. A print of *The Tiger's Coat* is available through the Motion Picture, Broadcasting and Recorded Sound Division, Library of Congress, Washington, D.C. The script for *Riding with Death* is contained in the Twentieth Century Fox Archive, Collection 010, folder #148.1, Theatre Arts Library, UCLA.

70Conger, *Edward Weston: Photographs*, 117/1924, n. 1.

71Gómez Robelo, *Satiros y Amores*.

72Modotti-Richey, *Book of Robo*, 12.

73Richey produced sixteen drawings, plus a portrait of Gómez Robelo, an end drawing, and the cover illustration.

74*Gale's* (October 1918–January-February 1921); Schmitt, *Communism in Mexico*, 4.

75See Schmitt, *Communism in Mexico*, 3–7.

76The following discussion of the oil controversy is drawn from Turchen, "The Oil Expropriation Controversy," chs. 1–3, passim, which provide a concise history of subsoil rights in Mexico and a detailed but lucid account of the diplomatic history between Mexico and the United States.

77Many of the contributors to *Gale's* also lent their names to *The New Justice*, a short-lived venture based in Los Angeles which was edited by self-named "unrevolutionary humanitarians." They voiced more even-handed reports on the Soviet Union than the conservative press. See Joseph R. Conlin's unpaginated introduction to *The New Justice* (Westport, CT: Greenwood Reprint Corp., 1970).

78Letter from Ricardo Gómez Robelo to Edward Weston, Edward Weston Archive, CCP. This correspondence opens the possibility that Gómez Robelo may have introduced the Richeys and Weston.

79Peter and Rose Krasnow, interview by Harry Lawton.

80Naef, "Edward Weston: The Home Spirit and Beyond," 12.

81DBII, 209 (March 17, 1931); Conger, *Edward Weston: Photographs*, 2; Maddow, *Edward Weston*, 38.

82Modotti and Weston met each other sometime during the early spring of 1921 (Stark [Rule], "Letters," 14 [Letter 22.1, January 27, 1922]). When precisely they began their affair is uncertain, although the suggestion that it was as early as April 1921, is based on inconclusive evidence: a twice-transcribed and undated fragment (the original is now lost) of a passionate letter from Modotti to Weston, which was assigned the date April 21, 1921, by Nancy Newhall (Edward Weston Archive, CCP; author's correspondence with Amy Rule).

83Peter Krasnow, interview by Harry Lawton. Krasnow met Weston in 1922 (Peter Krasnow Papers).

84Weston gives Mather credit for being "the first important person in my life...perhaps...the most important" (DBI, 145, December 29, 1925). Among artists and photographers who concurred with this opinion were Imogen Cunningham (Justema, "Margaret: A Memoir," 9); Roy Rosen (Roy Rosen, interview by

Harry Lawton); Peter Krasnow (Peter Krasnow, interview by Harry Lawton); and Nancy Newhall who writes that Weston "…fell in love with art and Margrethe Mather at the same time, and for some eight years could not separate them" (Newhall's introduction to *The Daybooks of Edward Weston*, xvii). Information about Mather is scarce because little has been done to discover more about her, in spite of the influence she had on Weston. One notable exception is an issue of the CCP's *Archive* from 1979 devoted to Mather.

[85] Roy Rosen, interview by Harry Lawton.

[86] Letter from Edward Weston to Flora Weston, September 1, 1923, cited in Stark [Rule], "Letters," 17.

[87] In a note dated 1944, Nancy Newhall wrote: "Tina's first husband was Roubaiz [sic] de Richéy, (she was never actually married to him but that is confidential)" and in another dated 1965 "[Tina]…married Roubaix de Richez [sic]. (Weston said they were never actually married)" (Museum of Modern Art, NY, Tina Modotti Artist File).

[88] Letter from Edward Weston to Johan Hagemeyer, n.d., Edward Weston Archive, CCP; *Film Daily* (November 13, 1921), 13; *Variety* (December 16, 1921); letter from Edward Weston to Flora Weston, February 22, 1924, Edward Weston Archive, CCP, cited in Stark [Rule], "Letters," 17.

[89] Roubaix de l'Abrie Richey to Edward Weston, Edward Weston Archive, CCP.

[90] Precisely what Richey died of is also unknown. His contemporaries report the cause of death was smallpox (Borough, "Art, Love and Death," 22); letter from Edward Weston to Johan Hagemeyer, February 13, 1922, Edward Weston Archive, CCP. Three later writers, without giving sources, maintain he died of tuberculosis (Robinson, *A Wall to Paint On*, 85; Vestel, "Tina's Trajectory," 6; Wolfe, *Fabulous Life*, 194), while another states that he died of cholera (Maddow, *Edward Weston*, 47).

[91] Letter from Roubaix de l'Abrie Richey to Edward Weston, 1921, Edward Weston Archive, CCP; and [Pacheco], "Ricardo Gómez Robelo," 52.

[92] Vera de Córdova, "Photographs as True Art"; letter from Edward Weston to Johan Hagemeyer, April 6, 1922, in Weston-Hagemeyer Collection, CCP, cited in Stark [Rule], "Letters," 12.

[93] Letter from Modotti, Mexico City, to Roy Rosen, [Los Angeles] California, Sunday, March [19?], 1922. Photocopy courtesy of Lawrence Jasud, Memphis, TN. My thanks to Paul Hertzmann for alerting me to the existence of this letter.

[94] This image is reproduced in Constantine, *Fragile Life*, 18.

[95] Stark [Rule], "Letters," 55 (c. January 8, 1928); letter from Edward Weston to Johan Hagemeyer, April 9, 1923, Edward Weston Archive, CCP, cited in Stark [Rule], "Letters," 12, 13, n. 18; Maddow, *Edward Weston*, 48.

[96] Shortly before she left for Mexico, Modotti's eerily portentous poem (the only one so far found) was published in the prestigious literary journal *Dial* 74 (May 1923): 474.

> PLENIPOTENTIARY
> by Tina Modotti de Richey
>
> *I like to swing from the sky*
> *And drop down on Europe,*
> *Bounce up again like a rubber ball,*
> *Reach a hand down on the roof of the Kremlin,*
> *Steal a tile*
> *And throw it to the kaiser.*
> *Be good;*
> *I will divide the moon in three parts,*
> *The biggest will be yours.*
> *Don't eat it too fast.*

[97] "Una Estrella de Cine que Ama y Conoce a México," 7.

[98] Modotti met Ricardo Gómez Robelo and the painter Xavier Guerrero. According to scholar Ruth Moore Alvarez, cinematographer Roberto Turnbull and painters Adolfo Best Maugard, Emilio Amero, and Julio Castellanos joined Guerrero in Los Angeles to accompany an exhibit of Mexican art for which Guerrero

was the art director. Katherine Anne Porter wrote a catalogue to accompany the show: *Outline of Mexican Popular Arts and Crafts* (Los Angeles: Young & McCallister, Inc., 1922). The show opened in Los Angeles in November 1922 (letter from Ruth Moore Alvarez to author, February 5, 1990; Lopez, "A Country and Some People I Love," 58–68).

[99] Their first residence, a leased house in Tacubaya, was a 40-minute trolley ride from the city (DBI, 15, August 20, 1923). When they realized the commute and lack of a telephone were hindering their commercial prospects, they moved to a place in town on Lucerna (DBI, 21, September 15, 1923).

[100] DBI, 22 (September 23, 1923); letter from Edward Weston to Flora Weston, October 2, 1923, Edward Weston Archive, CCP.

[101] Conger, *Edward Weston in Mexico*, 74. Conger writes, "The portrait work he was doing [in 1923] to support his family was not aesthetically enriching for him; it did not satisfy his desire or need to express himself…" (Conger, *Edward Weston in Mexico*, 3). Weston reflected upon his time in Mexico from a distance of six years. On March 2, 1932, he wrote: "I can blame three things, conditions for my failure in Mexico: immaturity, psychic distress, and economic pressure. The latter condition kept me waiting in the studio for work [i.e. sitters] which seldom came" (DBII, 247). While there, he lamented this pressure and the need to take portraits: "Of the future, I hardly dare think, for all I can see ahead is day after day of professional portraiture, trying to please someone other than myself" (DBI, 25, October 30, 1923).

[102] Letter from Edward Weston to his family, September 1, 1923, Edward Weston Archive, CCP. Higgins is one of the few people to acknowledge Modotti's importance to Weston's career: "In Tina Modotti [Weston] would find a friend, lover, peer, nurse, model, muse, apprentice, translator, agent, studio manager, and occasional porter, cook and maid" (Higgins, *Truth, Myth and Erasure*, unpaginated).

[103] See correspondence between Llewellyn Bixby Smith and his mother, Sarah Bixby Smith, AG6: Box 5, CCP. Llewellyn Bixby Smith left Mexico on November 24, 1923 (DBI, 32). A year later one of his photographs was included in the Camera Pictorialists of Los Angeles annual exhibition (*The Pictorialist*, no. 2 [December 1924]: 16).

[104] Weston specifically mentions Modotti's help in landing this exhibition (letter from Edward Weston to his family, September 1, 1923, Edward Weston Archive, CCP; DBI, 99, October 22, 1923).

[105] Referring to their passage by ship to Mexico, Weston writes: "Thanks to Tina—her beauty—though I might have wished it otherwise!—el Capitán has favored us in many ways: the use of his deck, refreshing drinks in his cabin, his launch to carry us ashore" (DBI, 13, August 4, 1923).

[106] Letter from Edward Weston to his family, February 22, 1924, Edward Weston Archive, CCP.

[107] Letter from Edward Weston to Neil Weston, September 6, 1923, Edward Weston Archive, CCP. Nancy Newhall acknowledges their contractual relationship (DBI, 212).

[108] Weston kept a diary, which he called his "daybooks" for twenty-two years, from January 1922 until the end of 1934. Although the original no longer exists, a "transcription" was made, edited down twice, and then published in 1961. The two volumes, Mexico I and California II, offer an extraordinary chronicle of an artist's life.

[109] Letter from Edward Weston to Johan Hagemeyer, October 21, 1924, Edward Weston Archive, CCP; Stark [Rule], "Letters," 41 (Letter 26.1, January 23, 1926); Charlot, foreword to Orozco, *Artist in New York*, 18; Conger, "Tina Modotti and Edward Weston," 68.

[110] Stark [Rule] "Letters," 73 (Letter 30.4, May 23, 1930).

[111] Weston writes on October 7, 1924: "I am utterly exhausted tonight after a whole day in the darkroom, making eight contact negatives from the enlarged positives" (DBI, 96). Also see Newhall's "Edward Weston's Technique," DBI, 204–6.

[112] DBI, 24 (October 6, 1923); 27 (November 4, 1923); 32 (November 19, 1923).

[113]DBI, 63, 210.

[114]Charlot, foreword to Orozco, *Artist in New York*, 18.

[115]DBI, 81 (June 27, 1924).

[116]DBI, 52 (March 2, 1924); 53 (March 3, 1924).

[117]The following ideas have been discussed in Lowe, "Immutable Still Lifes."

[118]DBI, 55 (March 10, 1924).

[119]DBI, 109 (December 12, 1924).

[120]Robert Rosenblum borrows this term from John Ruskin to describe the attribution of human emotions to inanimate objects, especially in landscape painting (Robert Rosenblum, *Modern Painting and the Northern Romantic Tradition* [New York: Harper & Row, Icon Editions, 1975], 36).

[121]Coleman, "The Photographic Still Life," 5.

[122]"[Modotti's] photographs resembled Weston's in subject but were less assured and perfect..." (Hancock de Sandoval, "One Hundred Years," xii). "*Maize Plants* is a study in natural forms that might have been done by Weston" (Linda Andre, "Body Language: Frida Kahlo and Tina Modotti," *Exposure* 22 [Summer 1984]: 19–28).

[123]Conger, *Edward Weston: Photographs*, 11.

[124]Stark [Rule], "Letters," 51 (Letter 27.4, June 25, 1927).

[125]DBI, 69 (May 2, 1924).

[126]A single negative for this image is housed in Fototeca de I.N.A.H., Pachuca, Mexico. It appears that Modotti made this print by first making a negative of the five glasses and then making two interpositives, each different sizes. She then sandwiched them and contact printed the final negative.

[127]In February, Modotti and Weston visited a Dr. García who had an X-ray machine. Weston reported: "Dr. G. offered to turn the x-ray on us—Tina was first. We watched the weird revealment—saw her heart beat—noted that her lungs were in fine shape..." (letter from Edward Weston to Flora Weston, February 2, 1924, in Edward Weston Archive, CCP).

[128]See *The New Vision* exhibition catalogue for a thorough discussion of the issues surrounding "the new vision" and Christopher Phillips's insightful commentary in *Photography in the Modern Era*.

[129]The Movimiento Estridentista was a loose alliance of artists and writers who drifted in and out of the fold, thus making it difficult to draw up a definitive list of its "members." To the original Estridentista group—painter Fermín Revueltas, his musician brother Silvestre, and engraver Leopoldo Méndez—came Jean Charlot and painter Ramón Alva de la Canal, as well as poets Salvador Gallardo and Germán List Arzubide, Guatemalan novelist Arqueles Vela, and sculptor Germán Cueto. Later writers Salvador Novo and Luis Quintanilla joined. On the Estridentistas, see Fauchereau's excellent overview, "The Stridentists," 84–89; List Arzubide, *Movimiento Estridentista*, passim; Schneider, *El Estridentismo*, passim.

[130]Maple Arce's manifesto is translated and printed in Ades, *Art in Latin America*, 306–9. All quotations are drawn from this source.

[131]The Estridentistas produced a number of short-lived, but vital small magazines, including: *Actual* (1921–22); *Ser* (1922–23); *Irradiador* (1924); *Horizonte* (1926–27). Titles and dates are given by Fauchereau, "The Stridentists," 88.

[132]Arqueles Vela, *El café de nadie* (Jalapa: Ediciones de Horizonte, 1926), 11, cited in John S. Brushwood, *Mexico in Its Novel: A Nation's Search for Identity* (Austin and London: University of Texas Press, The Texas Pan-American Series [1966], 1970), 193. See also Schneider, *El Estridentismo*, 72.

[133]DBI, 63 (April 12, 1924).

[134]Modotti met Jean Charlot in mid-November 1923 (DBI, 34) and Germán and Lola Cueto in January 1924 (DBI, 43).

[135]According to Fauchereau, Cueto went on to experiment with stone, wood, bronze, iron wire, sheet metal, cement, cardboard, and mosaic (Fauchereau, "The Stridentists," 89).

[136]Parmenter, *Lawrence in Oaxaca*, 8; Ruth Stallsmith Quin-

tanilla, interview by Ross Parmenter, February 11, 1974. My thanks to Ross Parmenter for sending transcriptions of his interviews and sharing his thoughts with me.

[137]List Arzubide, *Movimiento Estridentista*, 54.

[138]*transition* no. 15 (February 1929), after 272. This issue also published *Workers Parade* as "Strike Scene," after 272. *transition* no. 18 (November 1929), after 278, reproduced *Bandolier, Corn, Sickle* with the caption, "Crisis."

[139]Schneider, *El Estridentismo*, 163.

[140]Letter from Edward Weston to Flora Weston, March 29, 1924, cited in Stark [Rule], "Letters," 31–32. The manifesto is translated and printed in Ades, *Art in Latin America*, 323–24. All the quotations from the manifesto are drawn from this source. See also Charlot's account of the syndicate in his *Mexican Mural Renaissance*, 241–51.

[141]Of the eight who signed the manifesto, four had been to Europe and two had traveled to the United States before 1923. Siqueiros went to Paris in 1919 and to Barcelona in 1921; Rivera went to Spain in 1907, to Paris in 1909, to Italy in 1920, and returned to Mexico in 1921; Guerrero traveled with an exhibition of folk art to Los Angeles in 1921 (where he met Modotti and Weston), and in 1929 he went to Moscow, via Europe for political purposes; Orozco traveled to New York and San Francisco in 1917 and again to New York in 1927 where he remained for several years; Mérida, born in Guatemala, studied in Paris in 1910, traveled to Belgium, Holland, and Spain, and settled in Mexico in 1919; Germán Cueto traveled abroad in 1916.

[142]See Cordero Reiman, "Constructing a Modern Mexican Art," 10–47 (in English and Spanish).

[143]Charlot, foreword to Orozco, *Artist in New York*, 19.

[144]Rivera's overt reference to Giotto's Arena Chapel in his panel *Meeting at the Golden Gate* at the Ministry of Education and Charlot's Uccelloesque *The Combat of the Great Temple* in the National Preparatory School are two examples. Marion Greenwood, an American painter who went to Mexico to paint murals under the direction of Rivera, recalls analyzing reproductions of the Italian masters using the golden mean (Marion Greenwood, interview by Dorothy Seckler, January 21, 1964).

[145]Cited in Charlot, *Mexican Mural Renaissance*, 235.

[146]Tina Modotti, "La Contrarrevolución Mexicana," *Amauta* [Lima] no. 29 (February 1930): 94. As Frances Toor noted in 1929, Modotti "has caught and expressed the social unrest of the Mexico of today" (Toor, "Exposición," 194).

[147]DBI, 101 (November 1, 1924).

[148]Inscription by Modotti to Weston, October 1924, Mexico scrapbook, 36, Edward Weston Archive, CCP; reproduced in Stark [Rule], "Letters," 18.

[149]DBI, 101 (November 2, 1924).

[150]*El Universal*, English News Section (December 18, 1924): 6.

[151]Emily Edwards, interview with Mildred Constantine, cited in Constantine, *Fragile Life*, 81.

[152]Modotti met P. Kahn Khoje sometime in 1924 (DBI, 84, July 19, 1924). He is one of the few people from this period in Modotti's life whom she saw again in the early 1940s upon her return to Mexico. Letter from Mary Doherty to Katherine Anne Porter, December 13, 1963, Katherine Anne Porter Collection.

[153]Letter from Edward Weston to his family, Edward Weston Archive, CCP, cited in Maddow, *Edward Weston*, 69.

[154]In her engaging memoir, *A Wall to Paint On*, Ione Robinson recounts her time in Mexico, including the fact that Rivera arranged for her to stay with Modotti when she first arrived.

[155]Carolina Amor de Fournier recalls, for example, that it was her boyfriend who insisted she have her portrait taken by Modotti (Carolina Amor de Fournier, interview with author, February 22, 1989).

[156]Stark [Rule], "Letters," 39–40 (Letter 25.4, July 7, 1925).

[157]Weston commented once: "I would probably be a first-class Fascist, *if* I would let my (contempt) for the Masses get the upper hand; but instead I have pity (a very dangerous virtue) just as one

feels deeply over a lost dog, cat, child" (Maddow, *Edward Weston*, 21).

[158]This discussion of Modotti's activities with the Communist Party and its fronts draws on Barckhausen, *Verdad*, 103–8. Hooks restates Barckhausen's account (Hooks, *Tina Modotti*, 104, 110–11).

[159]Tibol, ed., *Julio Antonio Mella*, 9. Charlot dates the conversion to November 1924 (Charlot, *Mexican Mural Renaissance*, 248).

[160]My understanding of the history, scope, and operation of MOPR derives from Ryle, "International Red Aid."

[161]Letter from Ella Wolfe to Carleton Beals, March 25, 1925, Carleton Beals Collection.

[162]Among some of the other members of the executive committee, all of whom in some way were to touch Modotti's life, were: Salvador de la Plaza, a journalist who regularly contributed to the *Labor Defender*, the organ for the International Labor Defense; Ursulo Galván, founder of the Liga Nacional Campesino (National League of Peasant/Farmers); Jacobo Hurwitz, a Peruvian left-wing journalist; Herman Laborde; Tristan Marof (the pseudonym of Gustavo A. Navarro), a Bolivian writer (1898–1979); Fritz Bach; Dr. Ignacio Millan. These names were published as part of a list of organizing committees in sixteen countries (*Der Rote Aufbau* [Berlin] 3 [July 1929]: 105).

[163]For an informative essay on Ella Wolfe, see Daniela Spenser Gollová, "Cabos Sueltos: El tiempo de Ella Wolfe," *Nexos* [Mexico City] (April 1991): 5–11.

[164]Stark [Rule], "Letters," 39 (Letter 25.4, July 7, 1925). One photograph a month suggests that as of July she had made five or six photographs which pleased her. We can guess that among the prints she was satisfied with were *Flor de Manita*, *Open Doors*, and *Staircase*. In her annotation of this letter, Stark [Rule] proposes a list of photos that Modotti made in 1925, a roster that can now be updated. *Head of Christ* dates from 1925; *Crucifix* is not by Modotti; *Wine Glasses*, also known as *Experiment in Related Form*, dates from 1924.

[165]Stark [Rule], "Letters," 37 (Letter 25.2, April 2, 1925); 44, n. 4.

[166]David Alfaro Siqueiros, "Una Transcendental Labor Fotográfica: La Exposición de Weston-Modotti," *El Informador* [Guadalajara] (September 4, 1926): 6. Translated and reprinted in Newhall and Conger, *Edward Weston Omnibus*, 19–20.

[167]DBI, 183.

[168]DBI, 129 (September 22, 1925).

[169]For the record and to date, only circumstantial evidence has been proffered to substantiate Modotti's probable lovers, other than Guerrero and Mella. Nancy Newhall, in her introduction to the *Daybooks*, confirms that by the time she came to edit it, Weston "had already cut from what the various typists received nearly all references to the agony he suffered over Tina Modotti's other lovers" (xiv). It is often assumed that Modotti and Rivera had a sexual relationship: the evidence in favor lies in the fact that Modotti and he were good friends (until he was excommunicated from the Party in 1929); that he had a penchant for having numerous brief affairs; and that his then wife, Lupe Marín, accused him of betraying her with Modotti (see Constantine, *Fragile Life*, 64). It is said, however, that the affair began after Weston left (see Hooks, *Tina Modotti*, 131–32). American-born artist Pablo O'Higgins "knew her intimately for many years (they were very much in love...)," according to Martha Dodd Stern, who also knew O'Higgins "intimately" (see letter from Stern to Mildred Constantine, December 23, 1974, Martha Dodd Stern Papers, Library of Congress, Washington, D.C.). Lou Bunin, who was in Mexico in 1929, thought he remembered Modotti and O'Higgins being married (Louis Bunin, interview with author, March 9, 1990). This would suggest that their intimacy occurred sometime after Mella's death in January 1929 and before Modotti's deportation in February 1930. O'Higgins went to Moscow in November 1931.

[170]Letter from Edward Weston to Miriam Lerner, October 15, [1925], states, "Tina's sister Mercedes arrives here tonight,"

Miriam Lerner [Fisher] Collection; Mercedes Modotti's diary, Private collection.

[171]Letter from Edward Weston to Miriam Lerner, December 14, [1925], Miriam Lerner [Fisher] Collection.

[172]Stark [Rule], "Letters," 41 (Letter 26.1, January 23, 1926).

[173]Letter from Consuelo Kanaga to Lee Witkin, August 9, 1973, Lee Witkin Archive, CCP. See also Barbara H. Millstein and Sarah M. Lowe, *Consuelo Kanaga: An American Photographer* (Seattle: University of Washington Press, 1992).

[174]Stark [Rule], "Letters," 43 (Letter 26.4, February 9, 1926).

[175]Rivera, "Edward Weston and Tina Modotti," 17. Translation by author.

[176]*Mexican Folkways* 1, no. 5 (February-March 1926): 10; Karen Thompson, "Jean Charlot: Artist and Scholar," in *Jean Charlot: A Retrospective* (Honolulu: University of Hawaii Gallery, 1990), 16. For Charlot's summary of his activities, see his foreword in Orozco, *Artist in New York*, 19–20.

[177]DBI, 175. Weston's account of their trip provides a entertaining travelogue (DBI, 162–90). See also Conger, *Edward Weston in Mexico*, 60.

[178]Letter from Edward Weston to Anita Brenner, June 28, 1926, Brenner estate, cited in Conger, *Edward Weston in Mexico*, 52.

[179]DBI, 175.

[180]Letter from Modotti to Anita Brenner, October 9, [1929], Anita Brenner Archives, unclassified. Courtesy of Dr. Peter Glusker and Susannah Glusker.

[181]Conger claims that all but one photograph was made by Weston (Conger, *Edward Weston in Mexico*, 50). Although Weston was the member of the Party who signed the contract with Brenner, Modotti's deference to Weston's mastery of photography (evident in her letters to him), her lack of a proprietary disposition, even her sensitivity to his vanity, may have prevented her from claiming credit for her photographs.

[182]Over the course of the next few years, Modotti contributed some forty-five photographs to this journal, some credited, others not. Some images were published as examples of her art work and others appear to be commissioned as illustrations for articles. Not included in this number are the dozens of reproductions of the murals of Rivera, Orozco, Siqueiros, and Máximo Pacheco by which Modotti supported herself.

[183]Three of Modotti's photographs of piñatas were reproduced in the following issues of *Mexican Folkways*: April-May 1926; December 1926-January 1927; April-June 1929. Modotti, however, was extremely critical of the work she did "on the street." She wrote a note to Weston on the back of one: "This I rather like—I went back one day intending to work more carefully but most of the piñatas were gone" (photograph, Collection of the George Eastman House, Rochester, NY, accession number 74:061:172). But when Toor published another from this series, she was dismayed, believing it unworthy to sign her name to (Stark [Rule], "Letters," 49 [Letter 27.1, March 19, 1927]).

[184]Weston remarks in his *Daybooks* that Charlot showed him thirty sketches of "Luziana" (DBI, 109, December 12, 1924).

[185]This photograph is one of a series of five that Modotti took of Luz Jiménez and her daughter, Concha, probably in 1926. While *Baby Nursing* was published in 1926, another from the series, *Aztec Baby*, is signed and dated 1927.

[186]Vera de Córdova, "El Arte Moderno en México," 42, 66, and in translation as "Art in Mexico," *Art Digest*, 10; Cuesta, "En la Exposición de Arte Moderno," 43, 63. The two photographs by Modotti were reproduced in *El Universal Ilustrado*: *Judus's (with church)*, 10, and *Baby Nursing*, 42. Vera de Córdova reviewed the exhibition, which included Robo's work, that Modotti attended in 1921 (see n. 92).

[187]DBI, 202 (November 9, 1926).

[188]Stark [Rule], "Letters," 43–44 (Letter 26.5, November 14, 1926).

[189]The five magazines were: *Mexican Folkways* (1926): *Workers Parade*; *New Masses* (1928): *May Day in Mexico*; *Creative Art*

(1929): *A Peasants' Manifestation*; *transition* (1929): *Strike Scene*; and *BIFUR* (1930): *Mexique*. Many of Modotti's works are untitled; she submitted works to exhibitions without titles and perhaps sent them to publications without indicating a preferred caption.

[190]Vidali has supplied the date for Modotti's joining the Communist Party. See his comments on her decision in Barckhausen, *Verdad*, 131–32, in part translated in Hooks, *Tina Modotti*, 139.

[191]Freeman, "Painting and Politics," 23.

[192]Charlot, foreword to Orozco, *Artist in New York*, 18.

[193]Some original and many copy prints of Modotti's political photographs may be found in the archives of the Centro de Estudios del Movimiento Obrero Socialista (CEMOS), Mexico City.

[194]Walter Benjamin articulated the significance of technical aspects of the photograph and its mechanical origins, and thus mechanical reproduction, in his decisive essay, "The Work of Art in the Age of Mechanical Reproduction," reprinted in Walter Benjamin, *Illuminations*, ed. and introduction by Hannah Arendt (New York: Schocken Books, 1969), 217–52.

[195]Guerrero, "A Mexican Painter," 18.

[196]A similar kind of nationalism was behind the exhibition of Mexican folk art that Guerrero organized on behalf of the government, a massive assemblage of 80,000 objects that was to travel throughout the United States on a tour arranged by Katherine Anne Porter (see nn. 98, 141). At the time, the United States was refusing to recognize the Obregón regime and thus declined to see the show as art, but labeled it "political propaganda." It languished in a railroad siding for two months until duty was paid on it as a commercial enterprise and it was sold to a private dealer in Los Angeles.

[197]In the 1940s, after he returned from Russia, Guerrero traveled to Chile, where he received several commissions. For additional information about Guerrero's art, see biographical entries in Ades, *Art in Latin America* and *Images of Mexico: The Contributions of Mexico to 20th Century Art*, exhibition catalogue, ed., Erika Billeter (Dallas, TX: Dallas Museum of Art, 1988). For Guerrero's role in the Syndicate, see Charlot, *Mexican Mural Renaissance*, 241–51. For Guerrero's contribution to fresco technique, see Rochfort, *Mexican Muralists*, 36.

[198][Bingham], "Camera Pictorialists at Museum," 9.

[199]"Art in Photography," 16. See also articles: "Creative Photography on Exhibition at Berkeley Art Museum" and "Exhibition of Photography."

[200]See Ollman, *Camera as Weapon*, passim.

[201]On Münzenberg, see Hunt, "Willi Münzenberg," 72–87; Gruber, "Willi Münzenberg's German Communist," 278–97; Schleimann, "The Organisation Man," 64–91.

[202]Lazitch, *Biographical Dictionary*, xxix. For an excellent history of the organization, see the Department of State's "Memorandum on the Workers' International Relief (based exclusively on Communist and Soviet Sources)," compiled in 1932 (R59, General Records of the Department of State, 1930–1939 Central Decimal File, Box 4516A 800.00B Worker International Relief, Civil Branch, National Archives, Washington, D.C.).

[203]This analysis is Arthur Koestler's, cited in Schleimann, "The Organisation Man," 90.

[204]On the lack of suitable imagery, see Eskildsen, "Photography," 93. For a lucid discussion of one of the most successful liberal publishing houses and how their politics affected their policies, see Lavin, *Cut with a Kitchen Knife*, 54–61.

[205]Edwin Hoernle, "Das Auge des Arbeiters" (The Working Man's Eye), *Der Arbeiter-Fotograf* 5, no. 7 (1930). Reprinted in translation in Mellor, ed., *Germany: The New Photography*, 47–48.

[206]Münzenberg's IAH functioned much like the International Red Aid, with which it is often confused—Hooks makes this mistake (Hooks, *Tina Modotti*, 208–9). Their differences lie with the respective aims of their aid: the former assisted in economic struggles, while the latter provided relief for political prisoners.

[207]DBI, 82 (June 27, 1924). *El Machete* reported the formation of a Mexican section of the Workers' International Relief or International Workers Aid (Hooks, *Tina Modotti*, 104).

[208]Before he arrived in Mexico, Goldschmidt had been to Russia and had founded the Berlin League for Proletarian Culture in 1919 and, later, the Proletarian Theatre (Willett, *Art and Politics*, 56). See also Kiessling's biographical essay in *Mexico/Auf den Spuren der Azteken*, 5–37. My thanks to Leni Kroul for her gift of this book and to Susan Felleman for her translation of this essay.

[209]DBI, 60 (April 2, 1924); 82 (June 27, 1924).

[210]Modotti visited the Colonia de la Bolsa in the summer of 1927 and some have dated the series she made from that year (Stark [Rule], "Letters," 53 [Letter 27.5, July 4, 1927]); Moyssén, "Una colección de fotografías," 139. However, a number of the images were published in the pages of *El Machete* between May and September 1928. See further discussion below.

[211]Stark [Rule], "Letters," 53 (Letter 27.5, July 4, 1927); Anita Brenner, *Your Mexican Holiday: A Modern Guide*, 4th ed., rev., (New York: G. P. Putnam's Sons, 1941), 337–38.

[212]Moyssén, "Una colección de fotografías," 139.

[213]Letter from Modotti to Anita Brenner, October 9, [1929], Anita Brenner Archive, unclassified. Courtesy of Dr. Peter Glusker and Susannah Glusker.

[214]It is unlikely that the project was ever completed. List Arzubide published *Cantos del Hombre Errante—Poemas estridentistas* (Mexico City: Edición Rosilbert, 1971), which lacks photographs by Modotti.

[215]Jameson, foreword to Retamar, *Caliban and Other Essays*, vii.

[216]Cited in Barckhausen, *Verdad*, 139.

[217]DBI, 187 (July 4, 1926).

[218]Stark [Rule], "Letters," 55 (Letter 28.1, January 8, 1928).

[219]Modotti remarks in a letter to Weston that "as far as work is concerned I have plenty of it, in fact more than I can do…" (Stark [Rule], "Letters," 68 [Letter 29.3, September 17, 1929]). In addition to photographing the murals of Rivera, Orozco, Siqueiros, and Pacheco, Modotti photographed the paintings of a number of artists. As Toor noted in her article, "No artist will have his paintings copied by anyone else…" (Toor, "Exposición," 192). Modotti's professional stamp has been found on the back of photographs of work by Abraham Ángel, Rosa Rolando Covarrubias, Xavier Guerrero, Manuel Rodríguez Lozano, Carlos Mérida, Ione Robinson, as well as sculpture by Juan Gonzalez. Rivera also sent out her photographs of his work to potential patrons.

[220]The earliest reference that firmly establishes Modotti's involvement in making mural photographs dates from 1927 (*Mexican Folkways* 3, no. 2 [April-May 1927], and 3, no. 3 [June-July 1927]). Nothing supports the suggestion that the mural published in the February-March 1926 issue of *Mexican Folkways* is by Modotti, or that the list of photographs of the murals Toor published in the December-January 1926-27 issue of *Mexican Folkways* are Modotti's (Hooks, *Tina Modotti*, 119–20). Most likely, the painter and photographer José María Lupercio produced these images. He is credited with a mural reproduction in the August-September 1926 issue of *Mexican Folkways*, and at least ninety-five photographs of his exist today in the collection of the Instituto de Investigaciónes Estéticas, UNAM (Moyssén, "Una colección de fotografías," 139–40). Also, Modotti mentions her decision not to repeat Lupercio's copies of Rivera's murals (Stark [Rule], "Letters," 49 [Letter 27.1, March 22, 1927]).

[221]Precisely how many books and monographs reproduced Modotti's mural photographs is unknown: she was rarely given credit. William Spratling's review of Evans's book in *Mexican Folkways* 5, no. 4 (October-December 1929): 205, attests that Modotti's photographs were used, "credit for which was not published." Charlot asserts in his foreword to Orozco, *Artist in New York*, 19, that he personally sent or carried Modotti's photographs to Reed, who reproduced most of them in her book. Although she is not credited, there is every reason to believe that Modotti's photographs of Rivera's work were reproduced in *Das Werk des*

Malers Diego Rivera, which was published in Germany. During his trip abroad in 1927, Rivera stopped in Berlin to see Münzenberg, whose Neuer Duetscher Verlag published the volume a year later (Gruber, "Willi Münzenberg's German Communist," 287).

[222]Letter from Modotti to Albert Bender, November 17, [1927], Albert Bender Collection; Barr, "Russian Diary," 15, 34; and Orozco, *Artist in New York*, 75.

[223]Another example of a photomontage by Modotti is *Código Federal del Trabajo* (1929). This photograph of a worker's hand holding a hammer in the air, surrounded by text clipped from a broadside, or possibly from an issue of *El Machete*, is a visual call for workers to unite against the government's changes in the Federal Work Code. A print exists in the Joseph Freeman Papers, Hoover. Reproduced in Hooks, *Tina Modotti*, 185.

[224]*Mexican Folkways* 3, no. 4 (August-September 1927): 189.

[225]Casanovas, "Las Fotos de Tina Modotti," 4–5.

[226]Cordero Reiman, "Constructing a Modern Mexican Art," 39; Reyes Palma, "Arte Funcional y Vangardia," 86–88.

[227]See González Matute, *¡30–30!*, passim.

[228]For summary of various Oktyabr publications, see John E. Bowlt, ed. and trans., *Russian Art of the Avant-Garde, Theory and Criticism, 1902–1934* (New York: Viking Press, 1976): 273–79. For a summary of Rivera's period in Russia, see Messenger, "Art and Political Intrigue," passim; Wolfe, *Diego Rivera*, 235–47; and Diego Rivera, *My Life, My Art: An Autobiography with Gladys March* (New York: The Citadel Press, 1960): 146–66.

[229]See John E. Bowlt, "Russian Art in the Nineteen Twenties," *Soviet Studies* 22, no. 4 (April 1971): 575–94, especially 583–91.

[230]Wolfe, *Diego Rivera*, 245. The November 7, 1928, "Protest of Independent Artists '30-30' " manifesto is translated and printed in Ades, *Art in Latin America*, 325–26. All the quotations from the manifesto are drawn from this source. See also González Matute, *¡30–30!*, 51.

[231]The original letter does not exist. Constantine dates the letter September 15, 1928, and transcribes it from the testimony given at Modotti's hearings after Mella's assassination (Constantine, *Fragile Life*, 123–24).

[232]Biographical information on Mella is drawn from Suchlicki, *University Students*, 20–23.

[233]An AP dispatch was released noting that "requests for the release of Mella had been sent to President Machado from throughout Latin-America, the United States and Europe." Cited in Manuel Gomez, "Rescuing a Prisoner of Imperialism," *Labor Defender* 1, no. 2 (February 1926): 25.

[234]When Mella applied to the Universidad Nacional de México in February 1926, he used Nicanor MacPartland. Raquel Tibol, "Julio Antonio Mella: símbolo del antimperialismo," in *Mexico y Cuba: Dos pueblos unidos en la historia* (Mexico City: Centro de investigación científica, Jorge C. Tamayo, A.C., 1982): 549.

[235]Although the IRA professed nonaffiliation, it was their practice to have high-ranking Communists placed as secretaries in the various sections (Ryle, "International Red Aid," 79, cites an article in *Inprecor* [February 1, 1929]: 95).

[236]The Spanish reads: "La técnica se convertiera en una inspiración mucho más poderosa de la producción artística: más tarde encontraba su solución en una síntesis más elevada el contraste que existe entre la técnica y la naturaleza."

[237]Vittorio Vidali, *Garibaldi e artista* (Exhibition catalogue, Udine, Italy: Circulo Culturale Elio Mauro, 1973), 27.

[238]Letter transcribed (in Spanish) in Barckhausen, *Verdad*, 141. Excerpts printed in English in Constantine, *Fragile Life*, 123, and Hooks, *Tina Modotti*, 156, 159. The letter was probably found among Modotti's personal papers when her home was searched.

[239]Modotti is cited in an article from *Daily Worker* (January 14, 1929). Clipping from National Archives, MID files.

[240]See obituary in *Labor Unity* 3, no. 1 (February 1929): 15. A *corrido* was published in *El Machete*; a poem by Helen Colodny, "To Julio Mella," appeared in the *Labor Defender* 4, no. 4 (April 1929): 80; and a rather grisly (purely imaginary) painting by Jakob

Burck of Mella's murder appeared in the *Labor Defender* 4, no. 3 (March 1929): 49.

[241]Beals, "Tina Modotti," xlviii.

[242]My contention that Modotti went to the Isthmus of Tehuantepec in late summer is based on the fact that her brother Benvenuto was issued a visa on January 16, less than a week after Mella's murder. He came to Mexico and remained there until August 4 when he sailed for New York (Immigration Records, 1929), and it is unlikely that Modotti would have traveled during Benvenuto's visit. Robinson notes that Benvenuto worked in a cement factory while in Mexico (Robinson, *A Wall to Paint On*, 86). Modotti wrote to Weston in mid-September sending him "snapshots done in T," adding that "all the exposures had to be done in such a hurry, as soon as they saw me with the camera the women would automatically increase their speed of walking; and they walk swiftly by nature" (Stark [Rule], "Letters," 67 [Letter 29.3, September 17, 1929]).

[243]Modotti sent contact prints of many of the photographs she took in Tehuantepec to Weston with notes to him on the back of several photographs. Most reside at the George Eastman House, Rochester, NY.

[244]Letter from Modotti to Anita Brenner, October 9, [1929], Anita Brenner Archive, unclassified, courtesy of Dr. Peter Glusker and Susannah Glusker; letter from Louis Bunin to Joseph Freeman, November 4, 1929, Joseph Freeman Papers, Hoover. Barckhausen cites an interview with Modotti that appeared in *Deutsches Magazin von Mexiko*, a German-language magazine published in Mexico, in which Modotti said she wanted to go to Germany (Barckhausen, *Verdad*, 199).

[245]Stark [Rule], "Letters," 67 (Letter 29.3, September 17, 1929). This letter is dated in Stark [Rule] as September 17 but internal evidence suggests it is either a typo or Modotti's slip; it was probably written on September 27, the day after Rivera was expelled from the Party.

[246]Other radical publications were suppressed as well: *Defensa Proletaria* (organ for the communist trade unions); *Bandera Roja* (organ for the Workers' and Peasants' Bloc); and *Spartak* (organ of the Young Communist League, of which Frida Kahlo was then a member) (Freeman, "Painting and Politics," 23).

[247]A sense of the danger in Mexico during the summer of 1929 is evident in Freeman's dispatches to Kenneth Durant, the manager of the TASS office in New York, which begin in July (Joseph Freeman Papers, Hoover).

[248]In May, the Pacific International Salon of Photographic Art in Portland, Oregon, asked her to submit entries to their juried show. The same month, the editor of the Belgian review *Variétés*, who had seen her work reproduced in *transition*, wrote asking her to send photographs for publication. Two months later, the *British Journal of Photography* sent a similar request. Copies of letters are in the Tina Modotti Archive, Getty Center. I have found no evidence to suggest that Modotti followed through on any of these requests.

[249]Draft of letter from Joseph Freeman to Bertram Wolfe, January 11, 1963, Joseph Freeman Archives, Hoover.

[250]Stark [Rule], "Letters," 69 (Letter 29.3, September 17, 1929).

[251]Ibid.

[252]During the short period she stayed with Modotti, Robinson found the police outside Modotti's home most disquieting (Robinson, *A Wall to Paint On*, 91).

[253]The title comes from an inscription on the back of the photograph.

[254]Bunin stayed in Mexico until April 1930. For sources on Bunin, see letter from Joseph Freeman to Kenneth Durant, September 30, 1929; letter from Louis Bunin to Joseph Freeman, November 4, 1929; letter from Bunin to Freeman, July 6, 1933; all at Joseph Freeman Papers, Hoover; Louis Bunin Archive, CCP; Bunin, various interviews with author.

[255]On d'Harnoncourt, see Robert Fay Schrader, *The Indian Arts & Crafts Board: An Aspect of New Deal Indian Policy* (Albu-

querque: University of New Mexico Press, 1983), 124–26. My thanks to Anne d'Harnoncourt for her editorial comments.

256Stark [Rule], "Letters," 56 (Letter 28.3, September 18, 1928).

257Stark [Rule], "Letters," 67–68 (Letter 29.3, September 17, 1929).

258No written document has yet been uncovered listing which photographs Modotti showed. A photograph taken at the exhibition indicates that the following photographs were in the show: *Portrait of Mella; Campesinos Reading "El Machete"; Construction Worker; Stadium; Loading Bananas, Veracruz; Man with Beam; Hammer and Sickle; Woman with Flag; Stadium Exterior; Mella's Typewriter* or *La Técnica; Elegance and Poverty; Hands Resting on Tool; Tank No. 1;* and *Circus Tent.*

259Stark [Rule], "Letters," 62.

260Modotti, "On Photography," 196–98. Toor also wrote a short review: "Exposición," 192–94.

261Letter from Modotti to Beatrice Siskind, February 17, 1930, and letter from Modotti to Mary Doherty, n.d., Fondo Presidentes, Archivo General de la Nación, Mexico City. My thanks to Antonio Saborit for sharing these letters with me before their publication in Saborit, *Una mujer sin país*, 150–52.

262Letter from Katherine Anne Porter to Robert McAlmon, November 12, 1932, Katherine Anne Porter Collection. Although in a number of letters, Porter gives the impression that she was friendly with Modotti, the two never seem to have been in Mexico at the same time. Modotti's friend, Mary Doherty, was a long-time friend of Porter's and it was perhaps through Doherty's stories that Porter absorbed the character of Modotti. My thanks to Ruth Moore Alvarez for her insights about the possible connections between Modotti and Porter.

263Lewis, *George Grosz*, 101. In a recent interview, Manuel Álvarez Bravo recalls Modotti showing him a copy of Renger-Patzsch's *Die Welt ist Schön* (Hooks, *Tina Modotti*, 196).

264Unless otherwise noted, the description of Modotti's period in Berlin and all quotations are derived from the three letters she wrote Weston, April 14, May 23, and May 28, 1930 (Stark [Rule], "Letters," 71–75).

265Castano, "Mosca 1932," 22–25.

266Only six photographs seem to date from this period.

267The evidence that Modotti had a show at Jacobi's studio is from a statement by Egon Erwin Kisch ([Vidali], *Tina Modotti*, 31).

268Barr, "Russian Diary," 13.

269On the celebrations, see letter from Frances Flynn Paine to Mrs. John D. Rockefeller, August 13, 1930, Rockefeller Archives Center, Tarrytown, NY. Katherine Anne Porter writes that Pablo O'Higgins had written her: "Tina well and cheerful—Doesn't do photography any more because there isn't enough light" (letter from Katherine Anne Porter to [Eugene Pressley?], December 21, 1931, Katherine Anne Porter Collection).

270An announcement for the upcoming "All-American Photo Exhibit" was published in *New Masses* (5, no. 8 [January 1930]: 16) but there is no evidence, so far, the exhibit ever occurred; "Photography 1930," Harvard Society for Contemporary Art, Cambridge, MA, November 7–29, 1930; Potamkin, "New Eyes," 248, 251, 270; "International Photographers," Brooklyn Museum, Brooklyn, NY, November 8–30, 1932.

271Barckhausen, *Verdad*, 241–42.

272Immigration Records, 1939; Powell, *Mexico and the Spanish Civil War*, ch. 5.

273Constantine, *Fragile Life*, 189; letter from Mary Doherty to Katherine Anne Porter, February 28, 1942, Katherine Anne Porter Collection.

274See [Vidali], *Tina Modotti*.

275"Tina Modotti: Exposición de fotografía," Galería de Arte Mexicano, Mexico City, 1942. The single-page, folded sheet of paper accompanied the exhibition. Manuel Álvarez Bravo wrote a short statement and a list of the fifty prints was given. A transcription, with translation, and identification, if possible, follows. 1. Alcatraz (Calla Lily) 2. Cabeza de Cristo (Head of Christ) 3. Raníta de Atzompa (Little Frog from Atzompa) 4. Obrero Petrolero (Oil Worker) [Author's note: probably Tank No. 1] 5. La Carpa (The Tent) 6. Pajarito de Coyotepec (Little Bird from Coyotepec) 7. Arbol y Sombras (Tree and Shadows) 8. Arquitectura Tepoztlán 1 (Tepoztlán Architecture, 1) 9. Arquitectura Tepoztlán 2 (Tepoztlán Architecture, 2) 10. Arquitectura Tepoztlán 3 (Tepoztlán Architecture, 3) [Author's note: These are incorrectly identified as Tepoztlán, and were taken in Tepotzotlán] 11. Flor de Manita 12. Tendedero (Clothesline) 13. Arquitectura de Convento (Convent Architecture) 14. Niño de Barrio (Child of the Quarter, or Slum) 15. Cabeza de Niño (Head of a Child with Sombrero) 16. Cántaro de Guadalajara (Pitcher from Guadalajara) 17. Manos de Trabajador (Hands of a Worker) 18. Obrero Constructor (Construction Worker) 19. Elegancia y Pobreza (Elegance and Poverty) 20. Construcción (Construction) 21. Código Federal del Trabajo (Federal Work Code) 22. Abajo la Guerra Contra Rusia (Down with the War against Russia) 23. "El Machete" 24. Revolución Mexicana (1) 25. Revolución Mexicana (2) 26. Revolución Mexicana (3) [Author's note: These three photographs are most likely the "revolutionary icons" Modotti made in 1927] 27. Julio Antonio Mella 28. La Técnica [Author's note: This is also known as Mella's Typewriter] 29. Concha Michel 30. Niñita Mexicana (Little Mexican Child or Mexican Baby) 31. Niña Orozco Romero (Daughter of Orozco Romero) 32. Paisaje de Estaño (Landscape of Tin) 33. Copas (Glasses—Experiment in Related Form) 34. Luz Ardizana 35. María Orozco Romero, 1 36. María Orozco Romero, 2 37. Lupita Rivera (daughter of Lupe and Diego Rivera) 38. Cañas (Sugar Cane) 39. Miguelín (Little Miguel, Portrait of Miguel Velasco?) 40. Francisco Marín 41. Campesinos 42. Lola Velázquez Cueto 43. La Madre Azteca (Aztec Mother) 44. María e Hija de Tata Nacho (Maria Nacho and Her Daughter) 45. Azucenas (White or Easter Lilies) 46. Autorretrato (Self-portrait) 47. Retrato de Tina Modotti por Edward Weston (Portrait of Modotti by Weston) 48. Salvador Novo 49. Manuel Rodríguez Lozano 50. La última fotografía (The Last Photograph)

276Federico Marín, who became a medical doctor, was skeptical that Modotti died of heart problems and suggested that she arrived at the hospital alive, but dying (Fernando Gamboa, interview with Mildred Constantine). Bertram Wolfe obliquely points a finger at Vidali. His summary follows: "[Modotti's] end was tragic. According to the story told by her Communist friends, she died suddenly of a heart attack. According to the report in the Mexican press at the time of her death, revulsion at Commissario Carlos's [i.e. Vidali] purge activities in Republican Spain caused her to break with him upon their return to Mexico. He gave her a farewell party, from which she fled alone in a taxi, asking the driver to rush her to a hospital, and died on the way, some said of heart failure, others of poisoning. The Mexican press gave many details of the death, but none of the autopsy" (Wolfe, *Fabulous Life*, 195). Molderings is more direct: "Probably [Modotti] was liquidated by Vidali and his relentless band, because she started to lose her nerve and the GPU feared she would begin to speak" (author's translation; Molderings, "Tina Modotti," 103). Tina Modotti was 45 years old when she died. Her father died of stomach cancer at the age of 59; her mother died at age 73; and her siblings, Mercedes, age 73; Valentina, age 68; Yolanda, age 90.

277After her return to Mexico, Modotti did not resume her former profession of photographer. It was once thought that she took some photographs in 1940 for a book by Spanish writer Constancia de la Mora, who was exiled in Mexico. During that summer, Modotti did, in fact, work on the project, but as an adviser, not as the photographer (Hooks, "Assignment, Mexico," 10–11). In a newsy letter Modotti's friend Mary Doherty recounted that she had been trying to arrange for Modotti to get a camera through their mutual friend, Xavier Guerrero, and that Modotti was impoverished, had been looking for work, and wanted the use of a camera. She never found out whether or not Modotti and Guerrero spoke (Letter from Mary Doherty to Katherine Anne Porter, February 28, 1942, Katherine Anne Porter Collection).

Selected Bibliography

Ades, Dawn. *Art in Latin America: The Modern Era, 1820–1980*. With contributions by Guy Brett, Stanton Loomis Catlin, and Rosemary O'Neill. New Haven and London: Yale University Press, 1989.

Agostinis, Valentina, ed. *Tina Modotti: gli anni luminosi*. Pordenone, Italy: Edizioni Biblioteca dell'Immagine, Cinemazero, 1992.

_____, ed. *Tina Modotti: Vita, Arte, e Rivoluzione, Lettere a Edward Weston 1922–1931*. Milan: Feltrinelli, 1994.

"Art in Photography." *The Argonaut* (October 12, 1929): 16.

Barckhausen, Christiane. *Auf den Spuren von Tina Modotti*. Cologne: Pahl-Rugenstein, 1988.

Barckhausen-Canale, Christiane. *Verdad y leyenda de Tina Modotti*. Havana: Casa de las Américas, Ensayo Premio, 1989. Spanish translation of *Auf den Spuren von Tina Modotti*.

Barr, Alfred H., Jr. "Russian Diary 1927–1928." *October* 7 (Winter 1978): 10–50.

[Baskin, Lisa U.] "A Note." *Massachusetts Review* (Women: An Issue issue) 13, nos. 1, 2 (1972): 112–24.

Beals, Carleton. "Tina Modotti." *Creative Art* 4 (February 1929): xlvi–li.

Bell, Goeffrey. *The Golden Gate and the Silver Screen: San Francisco in the History of Cinema*. Cranbury, NJ: Cornwell Books, 1984.

[Bingham, Elizabeth.] "Camera Pictorialists at Museum." *Los Angeles Saturday Night* 7, no. 11 (January 22, 1927): 7, 9.

Blas Galindo, Carlos. "Nationalism, Ethnocentricism, and the Avant-Garde." *Latin American Art* 2, no. 4 (Fall 1990): 38–43.

Borough, Rueben W. "Art, Love and Death: Widow Must Sell Batiks." *L.A. Record* (May 1922): 22.

Brenner, Anita. *Idols Behind Altars*. 1929. Reprint. New York: Payson and Clarke, 1967.

Cacucci, Pino. *I fuochi le ombre il silenzio*. Bologna: Agalev Edizioni, 1988.

California Pictorialism. Exhibition catalogue. Organized by Margery Mann. San Francisco: The San Francisco Museum of Modern Art, 1977.

Caronia, Maria. *Tina Modotti: Fotografa e Rivoluzionaria*. Foreword by Vittorio Vidali. Milan: Idea Editions, 1979. English translation, *Tina Modotti: Photographs*. Westbury, NY: Idea Editions & Belmark Book Company, 1981.

Casanovas, Marti. "Las Fotos de Tina Modotti: El Anecdotismo Revolucionario." *¡30–30!* [Mexico City] no. 1 (July 1928): 4–5. Translated in *Frida Kahlo and Tina Modotti*, 32–33.

Castano, Silvano. "Mosca 1932: Tina e Angelo." *Cinemazero* [Pordenone, Italy] 11, no. 11 (December 1992): 22–25.

Chambers, Karen S. "Jane Reece: A Photographer's View of the Artist." Master's thesis, University of Cincinnati, 1977.

Charlot, Jean. *The Mexican Mural Renaissance: 1920–1925*. New Haven and London: Yale University Press, 1963.

Coleman, A. D. "The Photographic Still Life, A Tradition Outgrowing Itself." *European Photography* [Göttingen, Germany] 4, no. 2 (April/May/June 1983): 5–9.

Conger, Amy. *Edward Weston in Mexico 1923–1926*. Albuquerque: University of New Mexico Press, 1983.

_____. *Edward Weston: Photographs from the Collection of the Center for Creative Photography*. Tucson, AZ: Center for Creative Photography, University of Arizona and the Arizona Board of Regents, 1992.

_____. "Tina Modotti and Edward Weston: A Re-evaluation of Their Photography." In *Edward Weston 100: Centennial Essays in Honor of Edward Weston, Untitled* 41. Carmel, CA: Friends of Photography, 1986: 63–79.

Constantine, Mildred. *Tina Modotti: A Fragile Life*. New York: Paddington Press, 1975. 2d ed., New York: Rizzoli, 1983. Paperback ed., San Francisco: Chronicle Books, 1994.

Cordero Reiman, Karen. "Constructing a Modern Mexican Art, 1910–1940." In *South of the Border*, edited by James Oles. Exhibition catalogue, 10–47. Washington, D.C. and London: Smithsonian Institution Press, 1993. Texts in English and Spanish.

"Creative Photography on Exhibition at Berkeley Art Museum." *The Courier* [Berkeley, CA] (October 5, 1929): 10.

Cuesta, Jorge. "En la Exposición de Arte Moderno." *El Universal Ilustrado* [Mexico City] (October 14, 1926): 43, 63.

D'Attilio, Robert. "Glittering Traces of Tina Modotti." *Views* [Boston] 6, no. 4 (Summer 1985): 6–9.

_____. "Notes for Future Biographers of Tina Modotti: La Famiglia Modotti in San Francisco." Unpublished paper, 1993.

Diego Rivera: A Retrospective. Exhibition catalogue. Founders Society Detroit Institute of Arts. New York and London: W. W. Norton & Company, 1986.

Duell, Prentice. "Textiles and Interior Decoration Department: A Note on Batik." *California Southland* no. 23 (November 1921): 19.

_____. Review of *The Book of Robo*, by Tina Modotti-Richey. *California Southland* (June 1923).

Ellero, Gianfranco. "Gli allievi de Pietro Modotti." *Cinemazero* [Pordenone, Italy] (June 1993): 31–33.

_____. "The Childhood of Tina Modotti." Udine, Italy: Arti Grafiche Friulane, 1992. (Originally published as "L'infanzia di Tina Modotti." *Corriere del Friuli* [Italy] [October 1979].)

_____. "Nuove fotografie di Pietro Modotti." *Messaggero Veneto* [Udine, Italy] (April 18, 1993).

_____. *Pietro Modotti*. Udine, Italy: Ribis Editore, 1992.

Eskildsen, Ute. "Photography and the Neue Sachlichkeit Movement." In *Neue Sachlichkeit and German Realism of the 20s*. Exhibition catalogue, 85–97. London: Heyward Gallery, Arts Council of Great Britain, 1979.

Estavan, Lawrence, ed. *The Italian Theatre in San Francisco*. San Francisco Theatre Research Series, WPA Project, Monograph 21, vol. 10. San Francisco, 1939.

"Una Estrella de Cine que Ama y Conoce a México." *El Heraldo de México* [Los Angeles] (May 16, 1920): 7.

Evans, Ernestine. *The Frescoes by Diego Rivera*. New York: Harcourt, Brace & Co., 1929.

"Exhibition of Photography." *The Courier* [Berkeley, CA] (October 12, 1929): 10.

Fauchereau, Serge. "The Stridentists." *Artforum* 24 (February 1986): 84–89.

Foerster, Robert F. *The Italian Emigration of Our Times*. 1919. Reprint. New York: Russell & Russell, 1968.

Fotografie Lateinamerika von 1860 bis heute. Exhibition catalogue. Organized by Erika Billeter. Bern: Benteli, 1981.

Freeman, Joseph. "Painting and Politics: The Case of Diego Rivera." *New Masses* 7 (February 1932): 22–25.

Frida Kahlo and Tina Modotti. Exhibition catalogue. Essays by Laura Mulvey and Peter Wollen. London: Whitechapel Art Gallery, 1982.

Gallagher, Dorothy. *All the Right Enemies: The Life and Murder of Carlo Tresca.* New York: Viking Penguin, 1988.

Gómez Robelo, Ricardo. *Satiros y Amores.* Illustrations by Roubaix de l'Abrie Richey. Los Angeles, 1920. Facsimile reprint. Introduction by Fernando Tola de Habich. Tlahuapan, Puebla, Mexico: Premia Editora, 1984.

González Matute, Laura. *¡30–30!: contra la Academia de Pintura 1928.* Exhibition catalogue. With essays by Carmen Gómez del Campo and Leticia Torres Carmona. Mexico City: Museo Nacional de Arte, Instituto Nacional de Bellas Artes, 1994.

Gruber, Helmut. "Willi Münzenberg's German Communist Propaganda Empire 1921–1933." *Journal of Modern History* 38 (September 1966): 278–97.

Guerrero, Xavier. "A Mexican Painter." Translated by Tina Modotti. *New Masses* 2 (May 1927): 18.

Gumina, Deanna Paoli. *The Italians of San Francisco, 1850–1930.* New York: Center for Migration Studies, 1978.

Hancock de Sandoval, Judith. "One Hundred Years of Photography in Mexico by Foreigners." *Artes Visuales* 12 (October-December 1976): xi–xvi.

Higgins, Gary. *Truth, Myth and Erasure: Tina Modotti and Edward Weston.* History of Photography Monograph Series, School of Art, Arizona State University, no. 28 (Spring 1991).

Hooks, Margaret. "Assignment, Mexico: The Mystery of the Missing Modottis." *Afterimage* 19, no. 4 (November 1991): 10–11.

———. *Tina Modotti: Photographer and Revolutionary.* San Francisco: HarperCollins, Pandora, 1993.

Hunt, R. N. Carew. "Willi Münzenberg." *St. Anthony's Papers* [London] 9 (1960): 72–87.

Jacob, Livio. "Tina Modotti a Hollywood." In *Tina Modotti: gli anni luminosi,* edited by Valentina Agostinis, 211–22.

Justima, William. "Margaret: A Memoir." *Center for Creative Photography* no. 11 (December 1979): 4–19.

Kiessling, Wolfgang. "Das Weg nach Mexiko." Introductory essay to *Mexico/Auf den Spuren der Azteken,* by Alfons Goldschmidt. 1925/1927. Reprint. Leipzig: Verlag Philip Reclam jun., 1985.

Lavin, Maud. *Cut with a Kitchen Knife: The Weimar Photomontages of Hannah Höch.* New Haven and London: Yale University Press, 1993.

Lazitch, Branko, in collaboration with Milorad M. Drachkovitch. *Biographical Dictionary of the Comintern.* New, rev., and exp. ed. Stanford, CA: Hoover Institution Press, Stanford University, 1986.

Lewis, Beth Irwin. *George Grosz: Art and Politics in the Weimar Republic.* Madison, Milwaukee, and London: University of Wisconsin Press, 1971.

The Life and Times of Sadakichi Hartmann: 1867–1944. Riverside, CA: University of California, Riverside, University Library, 1970.

List Arzubide, Germán. *Movimiento Estridentista.* Jalapa, Veracruz: Ediciones de Horizonte, 1928. Facsimile reprint. Mexico City: Secretaría de Educación Pública, 1987.

Livingston, Jane. *M. Alvarez Bravo.* Exhibition catalogue. Essay by Alex Castro and documentation by Frances Fralin. Boston: David R. Godine, Publisher; Washington, D.C.: Corcoran Gallery of Art, 1978.

Lopez, Hank. "A Country and Some People I Love: An Interview by Hank Lopez with Katherine Ann Porter." *Harper's* (September 1965): 58–68.

Lowe, Sarah M. *Frida Kahlo.* New York: Universe Books, 1991.

———. "The Immutable Still Lifes of Tina Modotti." *History of Photography* (*Women in Photography* issue) 18, no. 3 (Autumn 1994): 205–10.

———. "Tina Modotti's Vision: Photographic Modernism in Mexico, 1923–1930." Ph.D. diss., The Graduate School and University Center, City University of New York, 1995.

Maddow, Ben. *Edward Weston.* Boston: New York Graphic Society, Aperture, 1978.

Mann, Margery, and Anne Noggle. *Women of Photography: An Historical Survey.* Exhibition catalogue. San Francisco: San Francisco Museum of Art, 1975.

Mella, Julio Antonio. *J. A. Mella: Documentos y articulos.* Edited by Eduardo Castañeda et al. Havana: Editorial de Ciencías Sociales, Instituto Cubano del Libro, 1975.

Mellor, David, ed. *Germany: The New Photography, 1927–1933.* Exhibition catalogue. London: Arts Council of Great Britain, 1978.

Messenger, Lisa. "Art and Political Intrigue: Diego Rivera and Early Twentieth Century Art in Russia." Unpublished paper. Drawing Department, Museum of Modern Art, New York, 1979.

Modernidad y Modernización en el Arte Mexicano: 1920–1960. Exhibition catalogue. Mexico City: Museo Nacional de Arte, Instituto Nacional de Bellas Artes, 1991.

Modotti, Tina. "Sobre la Fotografía/On Photography." *Mexican Folkways* 5 (October/December 1929): 196–98.

Modotti-Richey, Tina. *The Book of Robo.* Los Angeles, 1922.

Molderings, Herbert. "Tina Modotti: Fotografin und Agentin der GPU." *Kunstforum International* 9 (November 1982): 92–103.

Molina Enríquez, Renato. "Obras de Tina Modotti." *Forma, Revista de artes plásticas* [Mexico City] 4 (1927): 30–33. Facsimile reprint. Mexico City: Fondo de Cultura Económica, Revistas Literarias Mexicanas Modernas, 1982.

Moyssén, Xavier. "Una colección de fotografías de Tina Modotti y José María Lupercio." *Anales del Instituto de Investigaciónes Estéticas* [Mexico City] 12, no. 44 (1975): 139–40.

Naef, Weston J. "Edward Weston: The Home Spirit and Beyond." In *Edward Weston in Los Angeles.* Exhibition catalogue, 9–35. San Marino: The Huntington Library; Malibu: The J. Paul Getty Museum, 1986.

Neruda, Pablo. *Memoirs.* Translated by Hardie St. Martin. New York: Farrar, Straus and Giroux, 1976.

The New Vision: Photography between the World Wars. Exhibition catalogue. Essays by Maria Morris Hambourg and Christopher Phillips. New York: The Metropolitan Museum of Art and Harry N. Abrams, Inc., 1989.

Newhall, Beaumont, and Amy Conger, eds. *Edward Weston Omnibus.* Salt Lake City: Gibbs M. Smith/Peregrine Smith Books, 1984.

Ollman, Leah. *Camera as Weapon: Worker Photography between the Wars.* Exhibition catalogue. San Diego: Museum of Photographic Arts, 1991.

Orozco, José Clemente. *The Artist in New York: Letters to Jean Charlot and Unpublished Writings, 1925–1929.* Foreword and notes by Jean Charlot. Austin: University of Texas Press, 1974.

———. *José Clemente Orozco.* Introduction by Alma Reed. New York: Delphic Studios, 1932.

[Pacheco, José Emilio?] "Ricardo Gómez Robelo (1884–1924) El qui murió de amor." *Proceso* [Mexico City] 144 (October 8, 1984): 52–53.

Parmenter, Ross. *Lawrence in Oaxaca: A Quest for the Novelist in Mexico.* Salt Lake City: Gibbs M. Smith/Peregrine Smith Books, 1984.

Phillips, Christopher, ed. *Photography in the Modern Era: European Documents and Critical Writings, 1913–1940.* New York: The Metropolitan Museum of Art and Aperture, 1989.

Pinedo Barnet, Enrique. "Entrevista con el realizador Mexicano: Paul Leduc." *Cine Cubano* 104 (1983): 97–106.

Potamkin, Harry Alan. "New Eyes, New Compositions, New Conscience." In *Photographic Amusements,* 10th ed., rev. and enl., by Frank R. Fraprie and Walter E. Woodbury, 241–71. Boston: American Photographic Publishing Co., 1931.

Powell, T. G. *Mexico and the Spanish Civil War.* Albuquerque:

University of New Mexico Press, 1981.

Pultz, John, and Catherine B. Scallen. *Cubism and American Photography 1910–1930*. Exhibition catalogue. Williamstown, MA: Sterling & Francis Clark Art Institute, Williams College, 1981.

Reed, Alma. See Orozco, José Clemente.

Retamar, Roberto Fernández. *Caliban and Other Essays*. Foreword by Fredric Jameson. Minneapolis: University of Minnesota Press, 1989.

Reyes Palma, Francisco. "Arte Funcional y Vangardia (1921–1952)." In *Modernidad y Modernización en el Arte Mexicano: 1920–1960*, 83–95.

Rivera, Diego. "Edward Weston and Tina Modotti." *Mexican Folkways* 2 (April/May 1926): 16–17. Reprinted in *Frida Kahlo and Tina Modotti*, 16–17.

Robinson, Ione. *A Wall to Paint On*. New York: E. P. Dutton and Company, 1946.

Rochfort, Desmond. *Mexican Muralists: Orozco, Rivera, Siqueiros*. New York: Universe, 1993.

Ryle, James Martin. "International Red Aid: A Case Study of a Communist Front Organization." Master's thesis, Emory University, 1962.

Saborit, Antonio. *Una mujer sin país: Las cartas de Tina Modotti a Edward Weston, 1921–1931*. Mexico City: Cal y Arena, 1992.

The Sadakichi Hartmann Papers. Compiled by John Batchelor, edited by Clifford Wurfell. Riverside, CA: University of California, Riverside, University Library, 1980.

Schleimann, Jorgen. "The Organisation Man: The Life and Work of Willi Münzenberg." *Survey: A Journal of Soviet and Eastern European Studies* 55 (April 1965): 64–91.

Schmitt, Karl. *Communism in Mexico: A Study in Political Frustration*. Austin: University of Texas Press, 1965.

Schneider, Luis Mario. *El Estridentismo*. Mexico City: Ediciones de Bellas Artes, 1970.

Schultz, Reinhard, ed. *Tina Modotti: Photographien & Dokumente*. Berlin: Sozialarchiv e.V. Geschichte, Kunst und Kultur sozialer Bewegungen, 1989.

Stark [Rule], Amy, ed. "The Letters from Tina Modotti to Edward Weston." *The Archive* [Tucson, AZ] no. 22 (January 1986): 4–81.

Suchlicki, Jaime. *University Students and the Revolution in Cuba, 1920–1968*. Coral Gables, FL: University of Miami Press, 1969.

Tamburlini, M. Pia. "Tina promossa a pieni voti." *Messaggero Veneto* [Udine, Italy] (September 25, 1992).

Tibol, Raquel, ed. *Julio Antonio Mella en "El Machete."* Mexico City: Fondo de Cultura Popular, 1986.

Tina Modotti, garibaldina e artista. Udine, Italy: Circolo Culturale Elio Mauro, 1973.

Tirelli, Vincent J. "The Formation of the Italian-American Working Class." In *Fifty Years of Progress*, 2–23. New York: Italian-American Labor Council, 1991.

Toor, Frances. "Exposición de fotografías de Tina Modotti." *Mexican Folkways* 5 (October/December 1929): 192–94.

Turchen, Lesta Van Der Wert. "The Oil Expropriation Controversy, 1917–1942, in United States–Mexican Relations." Ph.D. diss., Purdue University, 1972.

Vera de Córdova, Rafael. "El Arte Moderno en México." *El Universal Ilustrado* [Mexico City] (October 14, 1926): 42, 66. Translated and reprinted as "Art in Mexico." *Art Digest* 1, no. 4 (December 15, 1926): 10.

———. "Photographs as True Art." In *Edward Weston Omnibus*, edited by Beaumont Newhall and Amy Conger, 13–16. (Originally published as "Las fotografías como verdadero arte." *El Universal Ilustrado* [Mexico City] 225 [March 23, 1922]: 30–31, 55.)

Vestal, David. "Tina's Trajectory." *Infinity* 15 (February 1966): 4–16.

Vidali, Vittorio. *Ritratto di donna: Vittorio Vidali racconta la sua vita con Tina Modotti*. Milan: Vangelista Editore, 1982.

[Vidali, Vittorio], Pablo Neruda, et al. *Tina Modotti*. Mexico City, 1942.

Weaver, Jane Calhoun. *Sadakichi Hartmann: Critical Modernist*. Berkeley, CA: University of California Press, 1991.

Weston, Edward. *The Daybooks of Edward Weston*. Vol. 1: Mexico and Vol. 2: California. Edited by Nancy Newhall. Millerton, NY: Aperture, 1961.

Willett, John. *Art and Politics in the Weimar Period: The New Sobriety, 1917–1933*. New York: Pantheon Books, 1978.

Wolfe, Bertram D. *Diego Rivera, His Life and Times*. New York and London: Alfred A. Knopf, 1943.

———. *The Fabulous Life of Diego Rivera*. New York: Stein & Day, 1963.

Zannier, Italo. *Fotografia in Friuli, 1850–1970*. Udine, Italy: Chiandetti Editore, 1979.

UNPUBLISHED DOCUMENTS

Immigration Records:
All records from Passenger Lists, National Archives Microfilm Publication, Records of the Immigration and Naturalization Service, National Archives, Washington, D.C.

1904: Francesco Modotti: SS *La Gascogne* Passenger Manifest, sailing from Le Havre, France, November 13, 1904, arriving New York, November 21, 1904; page [18], line 30.

1905: Giuseppe Modotti Saltarini: SS *La Touraine* Passenger Manifest, sailing from Le Havre, France, August 19, 1905, arriving New York, August 27, 1905; page [14], line 19, microfilm roll 2723.

1913: Tina Saltarini-Modotti: SS *Moltke* Passenger Manifest, sailing from Genoa, Italy, June 24, 1913, arriving New York, July 8, 1913; page 47, line 6, microfilm roll 2124.

1929: Benvenuto Modotti: SS *Monterey* Passenger Manifest, sailing from Veracruz, Mexico, August 4, 1929, arriving New York, August 11, 1929; page 11, line 1.

1939: Carmen Ruiz Sanchez: SS *Queen Mary* Passenger Manifest, sailing from Cherbourg, France, April 1, 1939, arriving New York, April 6, 1939; page 25, line 26; Record of Aliens held for Special Inquiry, line 9.

Census Records:
All census records from Records of the Bureau of the Census, National Archives, Washington, D.C.

1900:
James Richey and Household: Rose, Ruby, and Mara An Richey; Goesham Precinct, Multnomah County, OR

1920:
Joseph Modotti and Household: Louis Poggi, Mercedes Modotti, L'Abrie Richey, and Tina Richey; San Francisco, San Francisco County, CA

Rose Richey and Household: Roubaix, Tina, Marionne Richey, and Anna E. Booth; Los Angeles Township, Los Angeles County, CA

National Archives:
Civil Branch, National Archives, Washington, D.C.
Military Intelligence Division of the War Department General Staff, 1917–1941 (MID), National Archives, Washington, D.C.

Municipal Records:
Giuseppe Modotti: Death Certificate, March 14, 1922. Cause of death: cancer of the stomach. Department of Public Health, City and County of San Francisco, CA

Personal Papers:
Carleton Beals Collection, Muger Library, Boston University, Boston, MA

Albert Bender Collection, Mills College, Oakland, CA

Anita Brenner Archives, Private collection
Imogen Cunningham Papers, Archives of American Art, Washington, D.C.
René d'Harnoncourt Papers, Archives of American Art, Washington, D.C.
Miriam Lerner [Fisher] Collection, Bancroft Library, University of California, Berkeley, CA
Joseph Freeman Papers, Hoover Institution Archives, Stanford University, Palo Alto, CA
Joseph Freeman Papers, Manuscript Collection, Columbia University, New York, NY
Marion Greenwood Papers, Archives of American Art, Washington, D.C.
Sadakichi Hartmann Papers, University of California, Riverside, University Library, Riverside, CA
Peter Krasnow Papers, Collection of Aimee Brown Price, New York, NY
Tina Modotti Archive, Comitato Tina Modotti, Udine, Italy
Tina Modotti Archive, Special Collections, The Getty Center for the History of Art and the Humanities, Santa Monica, CA
Katherine Anne Porter Collection, Special Collections, University of Maryland, College Park, MD
Edward Weston Archive, Center for Creative Photography, University of Arizona, Tucson, AZ
Bertram D. Wolfe Papers, Hoover Institution Archives, Stanford University, Palo Alto, CA

Archives Examined:
Academy of Motion Picture Arts & Sciences, Beverly Hills, CA
Archivo General de la Nación, Mexico City, Mexico
Italian-American Collection, San Francisco Archives, San Francisco Public Library, San Francisco, CA
Labor Archives and Research Center, San Francisco State University, San Francisco, CA

Museum of Modern Art: Museum Archives; Artists' Files, New York, NY
Natural History Museum of Los Angeles County Archives, Los Angeles, CA
New York Public Library, Performing Arts Research Center at Lincoln Center, Theatre Division, New York, NY
Rockefeller Archives Center, Tarrytown, NY
Twentieth Century Fox Archive, Theatre Arts Library, University of California, Los Angeles, CA

Unpublished Interviews:
Amor de Fournier, Carolina. Interview with author. Mexico City, Mexico, February 22, 1989.
Bunin, Louis. Interviews with author. New York, NY, February 28, 1990, April 18, 1990, and March 9, 1990.
Gamboa, Fernando. Interview by Mildred Constantine. Mexico, January 20, 1974. In Modotti Archive, Special Collections, The Getty Center for the History of Art and the Humanities, Santa Monica, CA.
Greenwood, Marion. Interview by Dorothy Seckler. Woodstock, NY, January 21, 1964. Archives of American Art, Washington, D.C., Roll 85.
Knapp, Dee. Interviews with author. New York, NY, September 23, 1988, and March 16, 1993.
Krasnow, Peter and Rose. Interview by Harry Lawton. n.d. Tape in Sadakichi Hartmann Papers, University of California at Riverside, Riverside, CA.
Rosen, Roy. Interview by Harry Lawton. n.d. Tape in Sadakichi Hartmann Papers, University of California at Riverside, Riverside, CA.
Stallsmith Quintanilla, Ruth. Interview by Ross Parmenter, Mexico, February 11, 1974. Collection of Ross Parmenter, New York, NY.

Lenders to the Exhibition

Amon Carter Museum, Fort Worth, Texas
Mariana Pérez Amor
Karen Arrigoni
The Art Institute of Chicago
The Baltimore Museum of Art
Carleton Beals Collection, Boston University Libraries
Bokelberg Collection
Anita Brenner Estate
Center for Creative Photography, The University of Arizona
Centro Cultural/Arte Contemporáneo, A.C., Mexico D.F.
Zohmah Charlot
Cincinnati Art Museum
Mildred Constantine, New York
Stephen Daiter Photography
The Detroit Institute of Arts
George Eastman House, Rochester, New York
The Keith Fishman Collection
Mr. and Mrs. Steven H. Hammer, Los Angeles
The Manfred Heiting Collection, Amsterdam
Instituto Nacional de Bellas Artes/Museo de Arte Moderno, Mexico D.F.
The J. Paul Getty Museum, Malibu, California
Alexander Kaplen
Helen Kornblum
Andrew Masullo

Sam Merrin
The Metropolitan Museum of Art, New York
Mills College Art Gallery, Oakland, California
The Minneapolis Institute of Arts
The Museum of Fine Arts, Houston
Museum Folkwang, Essen, Germany
Museum of International Folk Art, Sante Fe, New Mexico
The Museum of Modern Art, New York
National Gallery of Australia, Canberra
National Gallery of Canada, Ottawa
New Orleans Museum of Art
Page Imageworks: Tony and Merrily Page
Philadelphia Museum of Art
Quillan Company
The Saint Louis Art Museum
The Sandor Family Collection
W. Michael Sheehe
Tamiment Institute Library, New York University
Throckmorton Fine Art, Inc., New York
Ava Vargas Photographic Works
Thomas Walther, New York
The Michael G. Wilson Collection, London
Gary Wolkowitz
And Private Collections

Acknowledgments

My experience working on this project has been truly extraordinary, and throughout the years of my research, just the mention of the name Tina Modotti seemed to charm everyone I met: doors opened, faded memories were recalled, invaluable documents were recovered, and hundreds of photographs have now come to light. I have encountered a wellspring of enthusiasm and support for my work from hundreds of people whom I thank en masse here. Some, however, must be singled out for their gracious cooperation.

First I would like to thank those people who knew Modotti and shared their memories with me: Carolina Amor, Manuel Álvarez Bravo, Lou Bunin, Fernando Gamboa, Leni Kroul, Yolanda Modotti Magrini, Brett Weston, Chan Weston, and Ella Wolfe.

Tina Modotti has attracted many scholars and writers whom it has been my great pleasure to know, and all of whom generously shared their research and thoughts on her with me. Thanks to Robert D'Attilio for numerous conversations which clarified some of the more byzantine political intrigues that surrounded Modotti; his perceptions of Modotti are always refreshingly original. Amy Conger was exceptionally helpful to me as I began my work on Modotti, and for that I thank her gratefully. Warm thanks to Elena Poniatowska for her gracious hospitality in Mexico and for her devoted encouragement. Christiane Barckhausen's steadfast support and unique perspectives on Modotti have been deeply appreciated. I would like also to thank the following people whose work on Modotti helped me formulate many of my ideas about her: Betsy Cramer Andrade, Mildred Constantine, Gianfranco Ellero, Dee Knapp, Herbert Molderings, Francisco Reyes Palma, Rosetta Porracin, Antonio Saborit, M. Pia Tamburlini, Riccardo Toffoletti, David Vestel, and Peter Wollen.

I have benefited enormously from the work and support of two art historians whose specialties intersected with the many aspects of this book. I would like to acknowledge my debt to Professors Linda Nochlin and Edward J. Sullivan.

During my work on Modotti, I have been fortunate to have met many people who shared their own insights and interests with me and who contributed to this project in a variety of ways. I would like to especially thank Beth Alvarez, Electa Arenal, Juan Antonio Ascencio, Maria R. Balderrama, Rosamund Bernier, Inge Bondi, Karen S. Chambers, Sarah d'Harnoncourt, Susannah Glusker, Sam and Gerda Katz, Lawrence Jasud, Ben Maddow, Dan Miller, Beatriz Guadalupe Moyano, Beaumont Newhall, Marion Oettinger, Jay Oles, Peter Palmquist, Sylvia Pandolfi, Ross Parmenter, Pilar Perez, Ruth and Lee Pollard, Sara Quintanilla, Carla Stellweg, Dominique H. Vasseur, and Carlos Vidali.

Special thanks to friends and colleagues upon whose personal support and intellectual insights I have depended and have been enriched by: Susan Aberth, Julia Ballerini, Aline Brandauer, Martha Buskirk, Terry Carbone, Monroe Denton, Susan Edwards, Elizabeth Ferrer, Kathleen Higgins, Maud Lavin, Terese Lichtenstein, Diana L. Linden, Sarah Moore and René Verdugo, Mignon Nixon, Kathy O'Dell, Rosemary O'Neill, Stacy Pies, Virginia Rutledge, Pam Scheinman, Adele Ursone, Anna Veltfort, and Beth Wilson.

Among these, Susan Fellemen and Luisa Sartori also graciously provided translations for a variety of texts, in German and Italian, respectively.

This exhibition evolved out of my dissertation, a catalogue raisonné of Modotti's photographs. Numerous curators at museums and archives were extremely helpful, allowing me to examine work in their collections. Among those, I would like to thank Trudy Wilner Stack, Center for Creative Photography; Victoria Blasco, Centro Cultural/Arte Contemporaneo; Luciano Lopez Zamudio and Arnoldo Martínez Verdugo, Centro de Estudios del Movimiento Obrero Socialista (CEMOS); Judith Keller, The

J. Paul Getty Museum; David Wooters, Janis Madhu, and Joe Struble, George Eastman House; Kathryn C. Sherlock, Librarian, Museum of International Folk Art; Susan Kismaric, Nicole Fiedler, and Tony Troncale, The Museum of Modern Art, NY; Enrique Mariño Reed and Angel Suárez Sierra, Museo de Arte Moderno; and Aurora Martínez Lopez and Juan Carlos Vadez, Museo del la Fotografía, Fototeca de INAH.

Warm thanks to the many private collectors of Modotti's photographs, all of whom were exceptionally accommodating.

Keeping track of art work that is continually on the market was helped immensely by, above all, Beth Gates Warren at Sotheby's, who kept me appraised of the movement of Modotti's photographs, as well as Julia Nelson-Gal at Butterfield & Butterfield and Rick Wester at Christie's. I would also like to thank David Fahey, Paul M. Hertzmann and Susan Herzig, Edwynn Houk, Alan Klotz, Simon Lowinsky, Nancy Medwell, Jill Quasha, William Schaffer, W. Michael Sheehe, Spencer Throckmorton and Yona Bäcker, Ava Vargas, and especially Tony and Merrily Page.

Many institutions provided me with personal assistance above and beyond the call of duty at all stages of my research. The following libraries and archives, and their personnel, were of immense help: The Museum of Modern Art, NY: Clive Phillpot, Janis Ekdahl, Rona Roob; Center for Creative Photography, University of Arizona, Tucson: the unparalleled help of Amy Rule; Library of Congress, Motion Picture Division: Patrick J. Sheehan; Los Angeles County Museum: Bruce Davis; American Italian Historical Association, Western Regional Chapter: Andrew M. Canepa; The Oakland Museum: Christine Droll; Mills College: Martin Antonetti; Academy of Motion Picture Arts & Sciences: Alison G. Pinsler; Library, University of California, Riverside: Peter Briscoe, Sidney Berger; Hoover Institution Archives: Sondra Bierre and Rebecca J. Mead; George Eastman House library: Rachael Stuhlman; Special Collections, The Getty Center for the History of Art and the Humanities: Brent Sverdloff.

This exhibition owes its existence to several people at the Philadelphia Museum of Art. My heartfelt thanks to Anne d'Harnoncourt for her resolute commitment to this project; to George Marcus for his insightful and practical suggestions; to Jane Landis for her conscientious assistance; and most especially to Martha Chahroudi for her unflagging enthusiasm and expertise.

It has been a pleasure to work with the dedicated professionals at Harry N. Abrams, Inc. I would like to thank Paul Gottlieb, Don Guerra, Judith Michael, Rachel Tsutsumi, and above all my editor Eric Himmel for their tireless and expert contributions to production of this book.

Finally, I must thank E.E. Smith, who magnanimously shared the burdens of this project, and whose presence and advice at every stage of preparation, quite simply, made it possible.

The Philadelphia Museum of Art joins me in thanking the following people for their generous assistance with loans.

INSTITUTIONS:
Peter Galassi, Susan Kismaric and Virginia Dodier, The Museum of Modern Art; Thomas W. Southall, Amon Carter Museum; Jan Howard and Jay M. Fisher, The Baltimore Museum of Art; Karen I. Mix, Boston University Libraries; Trudy Wilner Stack, Center for Creative Photography; Victoria Blasco, Centro Cultural/Arte Contemporáneo, A.C.; Ellen Sharp, The Detroit Institute of Arts; Marianne Fulton, George Eastman House; Weston Naef and Joan Gallant Dooley, The J. Paul Getty Museum; Maria Morris Hambourg and Laura Muir, The Metropolitan Museum of Art; Carroll T. Hartwell, The Minneapolis Institute of Arts; Ute Eskildsen and Robert Knodt, Museum Folkwang; Eleanor Voutselas, Museum

of International Folk Art; Angel Suárez Sierra, Museo de Arte Moderno.

PRIVATE COLLECTIONS:
Herschel Bernard, Anita Brenner Estate; Edwynn Houk, Houk Friedman; Merrily Page; Jill Quasha, Quillan Company Collection; William L. Schaeffer; Yona Bäcker, Malin Barth, and Spencer Throckmorton, Throckmorton Fine Art, Inc.; Norma Torres; Violet Hamilton and Carla Williams, Michael G. Wilson Collection.

IN MEXICO:
Ceri Higgins; Mariana Pérez Amor, Galería de Arte Mexicano; Yolanda Andrade; Pablo Ortiz Monasterio and Patricia Mendoza, Centro de la Imagen; Melisa Ramos de Hoyos.

Sarah M. Lowe

Index

Photograph Credits

Butterfield & Butterfield: fig. 12; Mark
Citret: pls. 7, 22, 24, 66; Jacques Gaël
Cressaty: pl. 5; John Dyer: pls. 35, 48;
Ali Elai: pl. 50; Agustín Estrada, Mexico
City: fig. 23; Richard P. Goodbody, Inc.:
pl. 79; Javier Hinojosa, Mexico: pls. 83,
88; Kate Keller: pls. 1, 19, 20, 43, 47, 67,
70, 110, 111, 113, 115, 119; Museum of
Fine Arts, Boston: fig. 1; Carmen H.
Piña, Mexico City: pls. 14, 15, 26, 27, 45,
56, 60, 61, 112, fig. 18; Philipp Scholz
Rittermann: pls. 39, 40, 41, 42, 52, 68,
89; Lynn Rosenthal: pls. 33, 37, 63, 73,
106; Helen Tandeta: pl. 25; Michael
Tropea: pl. 30; Dave Ulmer: pl. 109

Extracts from *The Daybooks of
Edward Weston*, © Center for Creative
Photography, Arizona Board of Regents,
1981; extracts from "The Letters of
Tina Modotti to Edward Weston,"
Archive no. 22, © Center for Creative
Photography, Arizona Board of Regents,
1986; extracts from previously
published letters of Tina Modotti at the
Center for Creative Photography,
© Center for Creative Photography,
Arizona Board of Regents, 1995; extract
from letter by Joseph Freeman, © 1995
Khyongla Rato